Time of Our Lives

Time of Our Lives

Celebrating Older Women

Maggie Kirkman

MONASH
UNIVERSITY
PUBLISHING

In memory of Dr Claire Stubber (1978–2020),
who would have made a wonderful old woman

Published by Monash University Publishing
Matheson Library Annexe
40 Exhibition Walk
Monash University
Clayton, Victoria 3800, Australia
publishing.monash.edu

Monash University Publishing: the discussion starts here

Time of Our Lives: Celebrating Older Women

ISBN: 9781922633729 (print)
ISBN: 9781922633736 (PDF)
ISBN: 9781922633743 (ePub)

Cover design by Les Thomas
Typesetting by Jo Mullins
Cover image by Midjourney
Author photograph by Karma Clarke

NATIONAL
LIBRARY
OF AUSTRALIA

A catalogue record for this
book is available from the
National Library of Australia

Contents

Foreword

Nicholas Dwyer

Most of us love our grandmothers and respect them for lives they have lived, bringing up their families and contributing to the history of their country. We often go as far as to say that they provide a model for how we should live.

But are we not being a little patronising when we do look at them in this way – as people of the past? Don't we overlook what they are doing today or could be enabled to do?

The purpose of this book is to understand the experiences of women in the last phase of their lives, illuminating how they have taken up new challenges after raising their children, retiring from paid roles in the workforce and, in some cases, losing their partner. With skill and sensitivity, Dr Maggie Kirkman interviewed women born before 1946 – members of the population cohort dubbed the Silent Generation – and in these pages she tells the stories of their lives and of what they are doing today, in their last chapters of life. She shows how they sought to develop new interests and passions once their domestic responsibilities lessened, and reveals how they have been helped in this by others.

These women have often undertaken very personal projects with limited resources, which they have assembled themselves. They have taken control of their lives using the skills they have spent a lifetime developing and the qualities that typify the Silent Generation: diligence, persistence, resourcefulness and humility. They have worked around the challenges of bureaucratic systems biased in favour of youth and adopted new technology. They have refused to accept that older age must mean a descent into 'invisibility'.

It is appropriate for society to invest in educating the young, providing opportunities for their advancement and supporting their physical and psychological development. This investment is driven not merely by economic imperatives but also by the desire to create a healthy community. Contrast this, however, with the lack of support that society offers people in the last chapter of their lives. Our expectations for older women are low and, too often, physical needs are all that are attended to. Why this discrepancy? Is it that we do not believe that older women can contribute meaningfully to the economic and social development of the country? Is it, perhaps, that we do not believe it is even appropriate for them to enter academic life, assume public roles or acquire new proficiencies?

I hope that these women's life stories, told adeptly by Dr Kirkman, will provide the reader with an insight into the lives of older women, the contribution they have made and how they can be supported.

One of the women in this book is Jacqueline Dwyer. After raising six children and supporting her husband's career for forty years, she completed a postgraduate degree and became a professional historian, publishing two books and several academic papers and appearing at international conferences. She was my mother, and her last twenty years were the inspiration for this study. I am pleased that her story has been told, along with those of all the other astonishing women in this book.

Introduction

My maternal grandmother was born in London in 1895. Her name was
Gertrude Wills. At her marriage, she became Gertrude Callander. 'Gertie'
didn't survive as a fashionable name, but friends she made in her sixties
called her Trudy and she liked that.

Trudy was a storybook grandmother: short, plump and cuddly, with
curly white hair and a warm smile. She was also capable of popping her
false teeth out and in at speed to shock and delight us. Grandma thought
her grandchildren were the best. She made me feel secure and happy.

Grandpa also loved me, but I was aware that he was moody and strict
with Grandma. Dinner always had to be on the table at 6.00pm. She
wasn't allowed to learn to drive. This was perplexing, because the family
story was that his father, a senior member of the police force, couldn't
drive and was chauffeured everywhere by his formidable wife.

As an adult, I came to recognise Grandpa's angry outbursts as a
symptom of post-traumatic stress disorder. He had fought with the
Australian Infantry Forces in France in the First World War. After two
years of mud and privations and carnage, he was shot in the knee. He
went back to the front as soon as he could walk again. I learnt this from
the Australian War Memorial archives, not from him.

My grandparents had met when Grandma's family hosted wounded
soldiers in London. They were married there at the end of 1918 and he
came home soon afterwards on a troop ship. Grandma, aged twenty-
three, said goodbye to her loving parents and twelve siblings and travelled
separately on a passenger liner, accompanied by a prodigious quantity
of furniture, including a large rosewood sideboard and matching dining
table, a Dresden clock and a copper bed-warming pan. I now have the
clock and the pan and treasure them for the memories of her they conjure.

I was eight when Grandpa died, in 1955, but even at that age I could
see that Grandma blossomed. She learnt to drive at sixty. She bought a

little red car, moved house, joined a bowling club, made new friends and joyfully demonstrated the effects of liberation. From this distance I can see how constrained she was by a troubled, demanding husband and a patriarchal society that maintained his gendered construction of family life. Grandpa's death and the support of her son, daughter and son-in-law enabled Grandma's emancipation. That might sound dramatic, but it is accurate.

One of the reasons for the research that led to this book was to find out what helped older women to come into their own: to pursue new interests or develop old ones. It was initiated by Dr Nicholas Dwyer, whose late mother undertook a master's degree in her eighties. A release from family responsibilities once her children were grown gave her the opportunity to research her family history, culminating in postgraduate study. I was excited to undertake this research and wanted to challenge the stereotypes of the old woman: either the bad-tempered, unpredictable crone or the weak and burdensome old dear. I planned to reveal that an older woman is more than she seems: she is a storybook, full of surprises, adventures, suffering and joy, if only we take the time to turn the pages.

The old woman is an enduring trope in literature, as I remember well from the alarming fairytales that were considered suitable for children in my youth. Illustrations of the black-clad witch or the hag, usually with a huge hooked nose topped by a hairy mole, were designed to frighten. Old women in film and television shows often occupied dilapidated houses that had to be avoided, especially at night. If they weren't actually evil, they definitely had a role in spoiling everyone's pleasure: the original superintendents of the fun police. Meanwhile, those who were not seen as wicked or disruptive were portrayed as helpless and foolish. 'Dear', 'the old girl' and 'young lady' are examples of the many patronising terms used to address a mature woman, language that serves to infantilise and demean.

These stereotypes and clichés persist. Casual ageism in our society is often combined with entrenched sexism. A man who expresses concern is told to 'stop being such an old woman'. The phrase 'having a senior

moment' has entered our lexicon and is often marshalled against women. My sister Cynthia is in her seventies, with beautiful white hair. Not too long ago she walked into a shop and suddenly realised she'd forgotten why she was there. When she told the assistant, his condescending response was, 'Are we having a senior moment?' But Cynthia was thinking about a grandchild about to be born in America, renovations being carried out at her house and her husband's severe cold. She was preoccupied. Cynthia is not troubled by fears of a failing memory because she has only to recall herself as a child being told repeatedly by our mother, 'You'd forget your head if it wasn't screwed on.' The notion of a 'senior moment' suggests that it is only the old who are absent-minded. In fact, it has long been known that forgetfulness is a feature of every age and that memory loss is not an inevitable part of ageing, as a research paper from 1987 attests.[1]

Menopause is frequently presented as the end of a woman's best years: the beginning of poor physical and mental health, a time of humiliation and failure. In contrast, men in their fifties and sixties are usually depicted in popular media as wise and in their prime, whether in command of a boardroom, driving a sportscar or dominating the golf course. I have attended too many presentations where researchers discuss their investigations of menopausal women and it's clear they have asked only about adverse effects. Why not see menopause as the beginning of a new phase of life, a time of sexual liberation and an invitation to wear white without fear? Of course, menopause can be distressing and disorienting for some. But the assumption that this is the universal experience casts a pall over life post-menstruation and risks creating a self-fulfilling prophecy.

Age is a social construct, as is gender. Constructs of gender have been challenged, especially since second-wave feminism in the 1960s and 1970s, although we still have a long way to go. But we have even further to go in tackling ageism and in disentangling it from sexism and outdated, patriarchal notions of weakness and strength. This book poses

a simple challenge: let's change the narrative. Why do we still choose to see old age as a dreaded tragedy when we could instead see it as an opportunity to continue learning, to build on the accumulated wisdom of a complicated life, and to develop unexpected interests and enthusiasms? Surely this is an idea worth exploring.

I first became aware of the pervasive disparagement inherent in the word 'elderly' – its use as a lazy dismissal of any woman considered past childbearing years – around the turn of the millennium. There was a headline in a local paper in Victoria's Macedon Ranges: 'Elderly pedestrian struck on crossing.' The story revealed that this decrepit old woman was fifty-five.

What do we mean when we use the word 'elderly'? In this case, it seemingly referred to anyone a few decades older than the subeditor who wrote the headline. As part of recoding what it means to be old in our society, I would like to abolish the word from the media and from research publications. If it's shorthand for 'someone over retirement age', let's be specific and state the age bracket. If it refers to people in need of supportive accommodation or other forms of care, let's say so. That will apply to people under sixty-five too and not to all people over sixty-five. And in news reports, if people aged in their seventies, eighties or nineties have done something notable or (especially) been injured, give them the dignity of stating their age if that's considered relevant. The word 'elderly' has connotations of decrepitude, dependence and expendability – poor old dears whose loss was only hastened.

I remember 'elderly' and 'senior citizen' being among terms recommended – perhaps in the seventies – to overcome the perceived insult of 'old'. Inevitably, these euphemisms have absorbed the connotations of the original term. I'd now like to rehabilitate 'old'. Being old is an achievement. It identifies years lived past the Biblical three score years and ten. Increasingly, there's no reason for those extra years to be lived in feeble uselessness. Nevertheless, I recognise that it will be tough to go

4

cold turkey in reinstating 'old', hence the comparative 'older' in the title of this book and in various places throughout its pages.

Whatever term we use, people who are no longer young or middle aged become invisible. Researcher Maria Edström reviewed the international literature on ageism and commented on the 'symbolic annihilation' of older people in the media. When she examined Swedish popular media in the years 1994, 2004 and 2014, she found that people over sixty were represented in only about 3 per cent of the content. This was true across print and broadcast media, fiction, billboard advertising and cinema. The invisibility was gendered, with older women far less likely than older men to be seen or heard.[2]

Older women will be familiar with the feeling of being invisible, not only in the media but also on the street, in shops and cafes, and in public forums. I am an enthusiastic walker. I'm quite tall and, it seems to me, noticeable. But I'm bumped into in the street as though I'm incorporeal often enough for me to wonder if I've faded away. Early in 2022, I was walking down Lonsdale Street in Melbourne to the supermarket. Coming towards me were four men, probably aged in their forties, walking abreast. There was no room for me to pass to the left of them. I would have had to step into the traffic to pass them on the right. The man who walked into my shopping trolley was displeased and told me loudly of his displeasure. I pointed out that I was capable neither of levitating nor of causing the ground to open up and swallow me. They all looked astonished, as though I had materialised out of nowhere.

The invisibility of older women also plays out at a societal level, with dire consequences. Melbourne author Melanie Joosten, in her book *A Long Time Coming: Essays on Old Age* (2016), writes about older people who are inadequately housed or homeless, experiencing the accumulated disadvantages of marginalisation as Indigenous Australians or women of colour, or suffering from ill health, including dementia. We know that women aged fifty-five and over are the fastest-growing cohort in the ranks of the homeless.[3] The Australian Human Rights Commission

attributes the dramatic increase to a lifetime of discrimination, including more time out of the workforce, lower pay and considerably less super-annuation than men. Experience of intimate partner violence is also a significant contributor to women's homelessness. It is an appalling reflection on our social support systems that the commission expects a continuing growth in the number of older women seeking shelter. The catastrophic failures in residential aged care, reported throughout the Covid-19 crisis and by the Royal Commission into Aged Care Quality and Safety, should alert policymakers and the community to the need for better services and for greater kindness to people who need such care, and their carers.

In 2019 my colleague Jane Fisher and I interviewed eighteen women living in Australia and born between 1946 and 1964 – Baby Boomers – as part of a research project.[4] It was evident that conditions throughout life had a profound influence on women's material circumstances and mental health in older age. Jane and I concluded that social structures that support and enhance the lives of girls and women at all ages will benefit not only older women but also the societies in which they live. It's therefore not a waste of resources to care about older women but an investment in social cohesion and universal quality of life. Among other things, Jane and I found that older women want to be treated with respect, which doesn't seem a lot to ask. Kindness and respect should be the basis for all social engagement.

In 2015, Mark Butler, federal Minister for Mental Health and Ageing in the Gillard government, published a book called *Advanced Australia: The Politics of Ageing*. He wrote mostly about the Baby Boom generation because we will form the hump in the ageing population, but what he had to say applies to anyone lucky enough to grow old and the society in which they live. Butler challenged the 'time bomb' narrative of ageing that appears entrenched in Australia. This gloomy forecast has it that, as the population ages, there will suddenly come a time when a minority of workers are burdened by a majority of dependent old people. Butler

provides plenty of evidence that old people won't necessarily be a burden on the community but can continue to contribute to its wellbeing. Among other well-tabulated conclusions are that old people are not a drain on the economy, are not set to dominate voting and, if we can ensure that those who want to stay in the workforce longer do so, won't overwhelm taxpayers. The women in this book illustrate this encouraging narrative.

The most visible and, for many women, defining aspect of ageing is looking old. Even if we are fit and healthy, our skin wrinkles, our faces sag and hair migrates from our head to our chins. The social construction of visible ageing is gendered: men look mature and distinguished, women 'lose their looks'. It's no wonder that women whose jobs, whether on television or as a CEO, depend (covertly, perhaps) on their looks seek cosmetic surgery.

I had an accidental temporary facelift a few years ago. Our extended family was in Spain for the wedding of my nephew Andrew to his Spanish partner Josep. We went to a theme park and were persuaded to take a ride that accelerated to 135 kilometres an hour in 3.5 seconds. There is, of course, a strategically positioned camera, with photos for sale at the end of the ride. The photograph of my sister Cynthia and me shows that she was captured mid-scream; her open mouth obliterates the rest of her face. It would be a great advertisement for a horror movie. My mouth has been welded into a benevolent smile and my skin pushed back. I have cheekbones, my little jowls have gone, and the high forehead I have always desired has been bestowed upon me. I love it. When other people see the photo, they ask me who it is. I must admit I have been tempted at times to turn myself into that image. I haven't done so mostly because of the principle of it: we should celebrate ageing. We should see these gravity-affected faces as symbols of an effective public health system, a society in which people can live long lives. It should in fact be a sign of hope.

Even though I understand that intellectually, like many women, my attitude to my own ageing isn't straightforward. I was born in 1947 and

am thus an early Baby Boomer. I have always enjoyed birthdays. My most recent was my seventy-fifth. Three quarters of a century! It's not only that I'm thrilled to be alive, but also that it seems like an adventure. 'The journey of life' is a cliché, but I can only conceptualise ageing as taking steps along the road to an unknown but promising future. I don't see my destination as death, inevitable though it is. Nor, as an atheist, do I have a vision of the afterlife; it's the travelling that matters, the stops and views and people encountered on the way. I experience growing old as feeling about forty but wearing a body that looks unexpectedly seventy-five. I like the sense of freedom that comes with ageing, of caring less about what people think. But my exterior, it seems, doesn't reflect the confidence that I feel. When I'm confronted with photographs of myself with younger family members, I sometimes try to work out what it is about my face that makes it look so different. My appearance is gradually being blurred – my features don't assert themselves as they once did. The disjunction I experience between the me in photographs and the me in my head could be classified as a type of body dysmorphia. The term is usually applied to people who see their body as flawed, such as an underweight person seeing herself as fat. Various therapies are available. However, I don't know that I want to find a cure for mine. I'm happy to continue feeling as I do despite knowing that my inner self doesn't match its packaging. I've not seen any research on the topic but, judging by the unrepresentative sample of my sisters, my friends and some of the women in this book, it's a common experience.

I hope that, if we can overcome the valorisation of youth and learn to appreciate that old age is a bonus, we might also come to accept and even enjoy a woman's lived-in face. That's a project for me, too.

The Australian Institute of Health and Welfare estimates that by 2056, 22 per cent of Australia's population will be aged sixty-five or older.[5] Baby Boomers have made a major contribution to the numbers, as has immigration, but the main reasons for our longevity are a reasonable public

health system and greater knowledge of what promotes good health. The World Health Organization points out that the ageing of the world's population should be considered a triumph, rather than seen as a burden to younger people who, if they're lucky, will themselves grow old.[6]

The cohort that preceded Baby Boomers – those born between 1928 and 1945, in the interim between world wars or during the Second World War – has been called the Silent Generation. They endured the catastrophic devastation of war and were expected just to get on with life afterwards, without making a fuss. Their parents' experience of the Great Depression meant that they were trained to be careful and thrifty. Members of this generation tended to marry young and have their children soon afterwards. Women were expected to look after their husbands, children, grandchildren and parents. As a result, it is often assumed that older men have had a career and have experienced the wider world, whereas older women have known only their families and the domestic confines of the home. It is often assumed, therefore, that older women are less wise than their male counterparts.

This is a misleading view of women's lives. Many women in this generation are far from silent, and the events they experienced mean that they have valuable perspectives on society and culture. Apart from wars, during the early and midlife of the Silent Generation the ABC was established (1932), the Sydney Harbour Bridge was opened (1932), Dame Enid Lyons became the first woman elected to the federal parliament (1943), Australian citizenship was created (1949), the first nuclear weapons tests took place at Maralinga (1956), television began in time for the Melbourne Olympic Games (1956), the oral contraceptive pill was introduced (1961) and, disgracefully late, Indigenous Australians were given the right to vote (1962).

In the 1940s and 1950s, few women in Australia worked. My mother, Yvonne, was born in Melbourne in 1922. She married in 1946 and moved with my father to his home state, Western Australia. My father took up the offer of further education made to returned servicemen and began

studying Medicine. Yvonne needed to work and found a job in a Perth branch of the Commonwealth Bank, long before its 1991 privatisation. Married women could not be employed in the public service, so Yvonne said she was single: Miss Kirkman. Towards the end of the year, when her accidental pregnancy with me was becoming obvious, she resigned and told her colleagues that of course she had been Mrs Kirkman all along. The mortification she felt at their intractable scepticism lasted for decades. Women I interviewed for this book who discussed being employed in the 1950s and even the 1960s were in the minority, as the ban on employing married women in the public service was not lifted until 1966. The Australian Bureau of Statistics reports that in 1954 women constituted only 23 per cent of employed people; by 1998, women made up 43 per cent of those employed.[7] After decades of campaigning by women, equal pay was granted by the Conciliation and Arbitration Commission in 1972. Genuine pay equality between women and men is yet to be achieved. However, as a sign that attempts were being made towards gender equity, in 1975 the Australian government committed to celebrating International Women's Day with other member nations of the United Nations, following a conference on the status of women.

This book will, I hope, contribute to establishing and maintaining the recognition that women of this generation deserve. When I embarked on my research, I sought participation from women who had had late-life achievements. I found them in various ways: advertising in a seniors' newsletter, notices on the Monash University webpage, word of mouth. My sister Linda knew a likely candidate and prompted her to volunteer. Word spread in a ukulele group. I saw one woman on television; another came to my attention after being named Senior Australian of the Year. Women were put forward by proud daughters and sons.

The initial interviews took place from April to December 2021. Covid-19 restrictions meant that almost all were conducted on Zoom. I continued to communicate with the women by email and occasionally through further interviews and telephone conversations. A few of those

who spoke to me were accustomed to being asked about their lives; most were not. I was touched when Bea Toews wrote to me, 'The chance to give an overview of my life was exciting. It's the first time it's happened to me, and I have told many people about how pleasing it was.' I hope their stories encourage more people to ask the women they know about their lives.

I elaborate on the women's lives to put their achievements in context. Some have had privilege; others have experienced hardship. Some were loved and encouraged by generations of family members; others were treated harshly. The stories combine to tell us about what helps us to live a satisfying life and what hinders wellbeing. They teach us of human resilience and determination. Most of all, they speak of the rich resource we can find in older women to benefit our society and communities.

Just seeing an older woman eagerly engaging with life can be inspiring. When I was an undergraduate in my thirties in the late 1970s and a tutor early in the following decade, I was inspired by seeing the distinctive figure of historian Dr Barbara Falk around the University of Melbourne campus. She would have been in her seventies. She wore a black leather jacket and could be seen in earnest conversation with much younger students and staff, who clearly admired her. She had retired as an academic in 1975 and used her freedom from formal employment to write a biography and important books on history, attending the university daily. She died in 2008 at the age of ninety-seven, still working and still influential in the lives of those who knew her and those who merely knew of her. When young women take an interest in old women, they can find models to assist them to navigate their own lives. It's an ideal interchange: old women are enlivened by the new perspectives and enthusiasms brought by the young. Now that I am in my seventies, I love having younger postgraduate students and colleagues. They stimulate me intellectually and give me joy.

These stories share certain themes but also offer us a range of older women's perspectives from across Australia. Since beginning my PhD in 1994 my research has often involved interviewing women. I have heard

sweeping narratives and intimate details of hundreds of lives. This is a magnificent privilege. Among the many things I've learnt from these encounters is that no two lives are the same. Even two people who have had what appears to an outsider to be the same experience will give different accounts of it, because the meaning it has in their lives will be shaped by personal and contextual influences. So it is with the women whose life stories are told in this book. As the psychologist and educator Jerome Bruner has argued persuasively, we can't understand our lives without telling stories about them.[8] We use stories to explain the significance of events, to establish a causal pathway to where we are now. These stories will change with time because we have new experiences and gain new tools for interpretation. Memory is dynamic; we understand the past through the present.

The women in this book might look, well, old. In person, some appear to be quite frail. But they carry in their bodies a rich history. They have a past worth knowing. They also have a present. Their stories affirm that ordinary women can do extraordinary things and that a long life is an opportunity to accumulate remarkable achievements. If we pay attention to what we read, these women's stories can teach us about how to live our own lives.

A Call to Art
Mig Dann
(b. 1941)

Mig Dann lives in a beautiful inner-city terrace in Melbourne. To reach the front door you pass under two luscious olive trees, which Mig tells me produce kilos of olives. The trees make for a grand entrance, conveying drama, abundance and a hint of Europe. Behind that front door, Mig's house is full of art and interesting objects.

Mig is one of the coolest people I've met, and not just because she dresses with artistic sophistication. Mig worked for David Bowie in Paris and New York in the seventies. She hung out at Andy Warhol's Factory in New York and mingled with the early postmodernist artists. Her partner for thirty-one years was the American actor Betty Bobbitt, known for her theatre work and for the *Crocodile Dundee* films, among other roles. And it's not just who she knows, it's what she does: in 2022, Mig became a Doctor of Philosophy at the age of eighty-one.

There were times when Mig was describing her glamorous past to me that I felt I should ask for her autograph. Mig told her story vividly and with excitement, but it was coloured by the grief of Betty's death just a few months before. Nevertheless, Mig was doing her best to apply herself to the creative and intellectual work of completing her PhD thesis on fine art. That triumph of will is even more deserving of the autograph hunter.

Mig was brought up in Perth, Western Australia, and always wanted to leave. She married at twenty-two, had two children very quickly and encouraged her husband to take a job in New York, the city that had shaped her dreams. Both children were under the age of three. Arriving in New York was 'glorious'. She immediately felt she belonged in that enormous city, such a contrast to Perth. She made friends fast, facilitated by the introductions and social engagements associated with having children.

However, Mig soon became restless in her marriage. She was beginning to question her sexuality. When one of her friends, who was working for David Bowie, asked Mig to join them in Paris as an assistant, she jumped at the chance. The circumstances sound magical: 'David was recording a new album in a place just outside Paris called Chateau d'Hérouville, where Chopin and Georges Sand had lived. It had been turned into a recording studio. Because I spoke French, I was invited to be a liaison for the group, as they were all living there, in the town of Pontoise. So, for instance, the piano was tuned every day. I picked up the blind piano tuner in a village near the chateau.' Her husband transferred to his employer's Paris office, so they could live separately and share care of the children.

Mig stayed in Paris for about three years, after which Bowie's focus turned to breaking into the US music scene. Mig returned to New York with her children in early 1973. She lived on the Upper West Side and threw herself into the counterculture. 'David really took off. He did concerts, he toured a lot, and he was rather brilliant in his ideas, his

concepts, his music. His manager helped get the best musicians around him. I was doing radio promotion, which meant that I flew all over the country. I hung out with disc jockeys in FM radio stations, because FM was just a new thing and they needed to break Bowie on the radio. I did that for a while, in a fairly luxurious way, because by that stage there was a lot of money around. I was picked up at the airport in limos, driven to hotels. I went to the concerts.'

Bowie's company had connections of a kind that today seem almost mythical. He was part of Andy Warhol's avant-garde circle of artists, performers, filmmakers, musicians and celebrities. Mig was mixing with people who were introducing pop art to the world. She loved that 'totally gay environment'. Given her direct experience of contemporary art movements, it's not surprising that academics Mig came to know in her seventies described her as 'living art history'. Just as she had felt at home in New York, Mig felt at home in the artistic milieu of The Factory, and she recognised that she belonged with the queer community.

Mig was still living in New York when she met Betty on a brief trip to Sydney in 1986, after spending time with her dying father in Perth. Betty lived in Melbourne but was working in Sydney. She had had a diverse career in the United States and Australia but was best known locally for her role in the television show *Prisoner*. From 1980 to 1985 she played Judy Bryant, an inmate of Wentworth Correctional Centre, appearing in more than 400 episodes. *Prisoner* hadn't then reached the United States and Mig knew nothing about Betty's background or fame, which was a relief to Betty. 'We just hit it off. Betty knew she was gay, but she'd had a very difficult time because she'd played a prominent role as a lesbian and it was impossible for her to meet anyone. The level of her fame as a result of that series never ceased to astound her, and me, because although I'd known quite a few actors in New York, they were all very off-off-Broadway and scrambling to get jobs. Betty was eighty-one when she died and, until that day, people would come up and talk to her and recognise her, and she was always so gracious.'

After time in Sydney, New York and Italy, Mig and Betty settled in Melbourne in the early 2000s. All this travel and glamour makes it sound as though they had plenty of money. However, Mig's income was unstable and, according to her, neither of them was financially wise. Mig had worked as a freelance editor and, for a time, a stage manager, but she had months on the dole. Despite these difficulties, Mig describes herself as 'gloriously happy' during that time.

While Mig was earning money in other ways, she was experimenting with artistic projects. She worked particularly with found objects: collecting ordinary items and putting them in a new context to change their significance. This is often called assemblage, which is how Mig characterises her early work. When she returned to Australia, she began to develop her art practice, not just assembling objects but also creating them. She began with birds' nests, boxes and textiles, and later transferred the complex themes they conjured to a larger work. The work, called 'dis/location', is a small wooden boat, like a rowboat, sitting on swirls of barbed wire. It evokes a sense of being uncomfortably out of place, while at the same time being a vehicle for escape. 'Dis/location' also references the harrowing plight of refugees.[9]

Observing Mig's commitment to her artistic practice, the girlfriend of one of her stepsons, a ceramicist, encouraged her to seek formal training. Mig's first response was, 'Don't be ridiculous!' She was persuaded to attend an open day, if only because art school would provide an excellent free studio. Mig checked out the sculpture department at RMIT University in 2011, when she was seventy. She told the staff that she was 'a very immature mature-age student', and they reassured her that teenagers straight from school would be in the minority. She decided to apply.

Mig had to find all her old education details to prove that she had finished secondary school and gained nursing qualifications. As other older women have discovered, it's not easy gathering the paperwork after more than fifty years. Furthermore, 'it seemed extraordinary to me to

revisit that life, which was so far in the past'. Mig also had to submit a folio of photographs of her work, and her family helped her to deliver one of her nests and the boat to the assessors. She was accepted to do a Bachelor of Fine Arts degree, which she began at seventy-one.

At first, Mig told herself that she wasn't really interested in the qualification. But some soul-searching revealed that she deeply regretted not having gone to university in her youth. Everyone she knew in New York had been to college and she'd felt inadequate. Mig had considered university from time to time, assuming she would study English, but she could never afford it. She wasn't in Australia during the years of free tertiary education.

When she became an art student, Mig found that it offered her much more than just a studio. She had been afraid of being out of place, but she made friends easily and experienced a profound sense of belonging. Despite being creative her whole life, she had never dared to call herself an artist. At art school she claimed that identity. It was wonderful.

Mig did well in her studies, conforming to the tradition of the conscientious mature-aged student, but she was stretched by the creative demands. She had previously made only what she wanted to; at university, Mig was encouraged to consider new ways of thinking, to learn how to produce material objects from concepts and emotions. It was exciting to discover that she could rise to the intellectual and practical challenges. She won all the available prizes and was invited to do an honours year.

All my research has involved people and words. I interview people, analyse texts and sometimes conduct surveys. The research questions I'm trying to answer are usually along the lines of, 'How do these people manage the vicissitudes of life?' I couldn't get my head around what an honours thesis in art, let alone a PhD, might be. From the depths of my ignorance I asked Mig if her honours and PhD theses were about art practice or the philosophy of art. Did she submit something she'd made, or deal with conceptual work, or examine her own art and write about it? The answer was, more or less, 'Yes.' She drew on contemporary

philosophy, including the work of Michel Foucault and Walter Benjamin, and on her intimate knowledge of contemporary art to interpret her own work and contemporary art movements. She held exhibitions of her work and submitted a folio of images of her creations.

The practical component of Mig's honours thesis was an installation, 'a video of clouds', projected onto a pool of water that she had constructed. Mig found this first experience of research and reflection on her own practice to be illuminating. She began to understand what her work was actually about, what she had been trying to express through her art: 'things about belonging, and about awe and wonder and escape'.

Mig graduated with first-class honours in 2015, then went to Germany to install a sculpture commissioned by her older half-brother. He co-owns the Wesenberg Sculpture Park, where she assembled her work and served as artist-in-residence for a few weeks. As Mig said, 'Hooray for nepotism!' This commission was a chance to prove herself as an artist. Her installation is made up of three fibreglass boats, representing a longing for something undefined. The boats, which are beside a lake, look like oversized children's bath toys. They symbolise childhood and escape and recall her father's time in the Navy. Betty went with her to Germany for the opening. It was a transformative experience. Mig visited the park again in 2017 and, to her great joy, in 2022.

During Mig's honours year, when one of her mentors had invited her to put in a proposal for a PhD, she had to consider not only what she would do but whether she wanted to do it. She thought about this during her residency in Germany. 'I recognised that a lot of the work I did was about memory. I began to see those threads that went through it, and I recognised belonging as a very large, very abstracted and conceptualised part of what I was doing. So I thought, yes, memory, time and identity are probably areas of focus. I knew it was going to be personal and – I didn't know the word "autoethnographic" then – autobiographical.'

Mig decided that she felt ready to attempt the research for her PhD and to confront what her work was teaching her about herself. She understood

that her search for belonging had ended with Betty, who also provided the emotional safety that Mig came to see had been missing for most of her life. She wrote a proposal for her PhD research that set out how she planned to develop these themes in theory and practice. The next step was to take a folio of her work to her potential supervisor. She was shocked by her supervisor's response. As she showed examples of her art, Mig talked about memory, time and identity. Her supervisor saw something else. 'She said, "Trauma." I was like, "Whoa!" I had made a work in response to the findings of the Royal Commission into Institutional Child Abuse, because I had been abused as a child.'

You can see that work on her website. It's called 'Hung Out to Dry' and is a calico figure, rather like a doll, with breasts and pubic hair. On her chest is an embroidered poem. The figure looks vulnerable, exposed and defenceless. 'The work was about those of us who were abused in our own homes and our own beds, as opposed to the justice, hopefully, that institutional survivors were getting. So my work became about memory and trauma. I found out so much more through my research about why I was the child I was.'

Mig was sexually abused by a friend of her father's from when she was eight years old until she was twelve. Five years. She told no one, including her parents, until she confided in a friend in New York. She wasn't angry; she was ashamed, feeling responsible for what was done to her, a child, by an adult. Mig is appalled that the culture of the time made it impossible for her to contemplate telling anyone about her suffering. We can't be sure, even now, that children are able to muster the confidence to seek comfort from appropriate adults and protection from predators.

Although the years of sexual assault constitute Mig's most profound trauma, there is another that comes close. She discovered that she was adopted.

Mig had felt like an outsider since she was a child. Her home life was unhappy even aside from the sexual abuse. She left home at seventeen. Because she had no idea what she wanted to do next, Mig joined friends

who were studying nursing. She understands it now as pursuing a need to belong within her peer group.

The story of Mig's adoption began to be told when Mig was in her mid-forties and needed to renew her passport. She had gone to Perth to be with her parents for her father's final days, not long before meeting Betty. Knowing that she had been born in Melbourne, she asked a friend who lived there to go to Births, Deaths and Marriages for her birth certificate (a much easier proposition in those days). The day after her father's death, Mig and her mother were sitting at the kitchen table when the phone rang. It was Mig's friend. She had been unable to find a listing for Mig, although she had found one for a person born on the same day, in the same hospital, with Mig's two given names but a different family name. The family name was the same as Mig's older half-brother, whom she had seen only when he visited on weekends during her early life.

Mig knew that her mother had been married before but had asked no questions about her past. That day, after the phone call, she sought an explanation. Her mother's story reflected 'dreadful Victorian-era morality'. She had been only nineteen when her first child, Mig's half-brother, was born. When he was a toddler, she sought to divorce her abusive husband, but a divorce was granted only if a couple had been separated for five years. Her husband was so affronted that his wife wanted to divorce him that he went to live with his mother and fought for custody of their son. Shockingly, he won. A mother who had to go out to work was no match for a grandmother at home. After losing her child, Mig's mother had to wait five years for the divorce. In that time, she met Mig's father and conceived Mig.

So Mig was told that her pregnant mother followed Mig's father to Melbourne, where he was training at Flinders Naval Base. She lived in a boarding house in South Yarra, earning money by sewing cushions and curtains: a creative woman with no satisfying outlet for her creativity. Crossing the country to give birth to Mig meant that the baby would not be known as illegitimate and that the divorce would not be even

more damaging for Mig's mother, who need not reveal to her husband that she was pregnant to another man while still married. On the birth certificate, the baby was given the name of the man who was still her husband.

It all seemed pretty straightforward. Mig's father moved for war service; Mig's mother went with him. For a couple of decades, Mig thought she had the whole story. Then her mother died and Mig took responsibility for sorting her possessions. She found a collection of small black-and-white photos of herself as a young child and used them in her creative work. On the back of one she discovered her first name, written in an unfamiliar hand, and the word 'Camberwell'. It triggered a memory of her mother mentioning the Presbyterian Babies' Home in Camberwell. Mig was intrigued, and contacted Uniting Care, the organisation that now holds the home's archives. Her record revealed that she had lived there from the age of six weeks to a year, until her parents' marriage. She was adopted when she was a year old by her biological parents.

This cataclysmic discovery suddenly illuminated Mig's obsession with memory and trauma. Mig believes her profound sense of feeling out of place, of not belonging, stems from that year in an orphanage. She might not remember the period in any detail, but the emotions experienced in infancy have coloured her life. Mig's mother had told her none of this. She thinks that her mother was warped by having to keep that terrible secret. Her mother's trauma was amplified in Mig's life, demonstrating the profound effects of the inheritance of suffering. Mig doesn't think her parents would have married had it not been for her; they were not happy together and didn't create a happy home.

Until the comment from her supervisor, Mig hadn't discerned the trauma in her work. It was a revelation. She was astounded at her own blindness to it because she knew what happens to traumatised children. Among the sad effects of childhood trauma, as Mig understands it, are a fragmented identity and lack of belief in oneself. It wasn't until Betty became part of her life that Mig felt her identity to be whole.

By this stage, Betty was becoming increasingly incapacitated. When she wasn't cooking or playing the piano, she spent a lot of time in her favourite chair, looking at the small back garden. Mig made the garden flourish and turned the tiny outdoor shed into an art studio, which they called the shedio.

One night in late 2020, without warning, Betty had a catastrophic stroke. She was unconscious in hospital for five days. The only good thing amid all the grief was that Mig was able to stay with her – so many others died alone during that time because of pandemic-related health restrictions. Nevertheless, it is Australia's shame that, even now, people in same-sex relationships are grateful to medical staff, as Mig was, for treating them as partners of the sick or dying person.

After her death, Betty was cremated. Mig is making an artwork for the garden to hold her ashes.

Mig contemplated stopping work on her PhD thesis when Betty died. She didn't feel much like doing anything. However, while sitting next to Betty in hospital, she found out that she had won an award. A few months earlier, Mig had applied to the City of Melbourne for a competitive grant to make and exhibit masks and to produce a film called *Just Breathe*, incorporating some of the themes flowing through her art practice. Artists must apply for so many grants that the details often slip from consciousness. When Mig read of her success, it felt bittersweet. After Betty's death, she realised that deferring the exhibition and her PhD thesis would be bad for her. Working towards a goal gives a sense of purpose; it says that you have a reason for getting out of bed each morning and something to look forward to, despite grief and loss.

I came to understand more of Mig's work when I attended her exhibition at the Queen Victoria Women's Centre in April 2021. To reach the room in which the film was screened, the audience walked through an avenue of masks representing the historical silencing of women. Some were rough hessian; others were made of gossamer fabric: silencing can be done gently as well as harshly. It is fitting that a woman from the

Silent Generation was protesting against the silencing of women. When contemplating Mig's work, including *Just Breathe*, I was reminded of Emily Dickinson's poem 'Because I could not stop for Death'. It wasn't so much the presence of death but the vulnerability Mig conveyed, especially in the diaphanous textile pieces. Dickinson describes vividly that sense of defencelessness:

> The Dews drew quivering and Chill –
> For only Gossamer, my Gown –
> My Tippet – only Tulle –

It was satisfying, when I went to a second exhibition of Mig's work, in February 2022, to see on the wall in large letters several lines from another Dickinson poem.

Just Breathe, which is set in the Old Melbourne Gaol, is both ethereal and confronting. Women wearing black rectangular garments and rough masks dance in the cold stone rooms as though trying to escape the anonymity of their existence. Mig used the fact that female prisoners in the nineteenth century were compelled to wear masks to prevent them from communicating with each other as an illustration of more general oppression. Mig's website reveals it was no accident that the masks in the film and along the avenue recall the pandemic that has reshaped our lives.

When we spoke in 2021, still so soon after Betty's death, Mig was finding the future difficult to contemplate. Her life seemed to be circling back to the same state of loss as her early years. She said, 'I'm not saying it's ending, but the truth is I wouldn't care if it did.' Mig was not afraid to die – in fact, she had wished a few times that Death might stop for her – but she acknowledged the possibility that she could live to be a hundred. In her art, she was glad to have something that demanded her time and attention. Mig had a collection of birds' nests that she was looking forward to incorporating in her art practice and was eager to collaborate with her younger brother, who is a furniture maker. Mig was

also engaged in the lives of her children, stepchildren and grandchildren, and was planning travel.

I asked Mig if she had advice for other women taking up study late in life. 'Go for it! Put aside your fears, which probably have to do with the way society has viewed you as an ageing woman, and say, "Fuck them!" Women for so long, particularly our generation and generations before, have bowed to the patriarchal society, but also to smaller communities and societies, and the expectations around what women should and shouldn't do. Just blast through. Thankfully it didn't happen in my life, but I know situations where people really devalue women's interests and call them hobbies.'

The completion of Mig's thesis was delayed by the pandemic restrictions, but in July 2022 she was able to tell me, with a mix of excitement, relief and understatement, 'I passed!' Her two examiners' reports were laudatory.

Mig's discovery of herself as an artist and intellectual, her determination to pursue her passion and her ability to find people and places where she belongs have given her not only a way to understand her life, but also to make it worth living.

An International Powerhouse

Bea Toews

(b. 1944)

In 2020, 76-year-old Bea Toews was cooking an Italian dinner, a favourite cuisine, for her son and daughter-in-law. She picked up a jar of passata to use as a base for the sauce. Despite summoning all the force she could muster, she failed to open the jar. Many of us would have remedied the problem by acquiring an implement to open jars. I have two. Bea, however, didn't turn to tools to solve her problems; she transformed herself. That recalcitrant jar encouraged her to take up strength training. Now, at seventy-eight, she is becoming a competitive powerlifter.

Although she is clearly fit, Bea doesn't look like the stereotypical gym junkie who throws barbells to the floor with a shuddering crash. At 156 centimetres tall – just over five feet – she could even be called petite. Because strength competitions are graded by weight, I know how heavy

she is: between 50 and 52 kilos. This is more a snippet of data about her athletic profile than an intimate disclosure. She has beautifully thick, straight white hair, cut in a bob, and wears stylish glasses and bright clothes. She also has hearing aids.

Powerlifting has three components. There is the bench press, where you lie on your back and lift a loaded bar above your chest with arms outstretched. There is the squat, where you put the loaded bar on your shoulders, squat so that your hips are lower than your knees and stand up again. And there is the deadlift, where you lift a loaded bar from the ground and stand up straight with your knees locked. By March 2022, after eighteen months of training three or four times a week, Bea could bench-press 27.5 kilos, squat with 47.5 kilos and deadlift 70 kilos.

Bea's upbringing may go some way to explaining how she can set such punishing goals for herself and be disciplined enough to achieve them. She is the eldest of four daughters born into a Mennonite family in Manitoba, Canada. Mennonites are Christians whose origins lie in sixteenth-century Reformation Europe. They practise adult baptism and refuse military service and public office. They dress plainly, like the Amish. Alcohol, cigarettes and premarital sex are forbidden to Mennonites.

Sarah Krasnostein's book *The Believer* begins with a vision of a Mennonite choir in a New York subway. Krasnostein was startled by the members' extraordinary, anachronistic homogeneity in physical appearance and clothing, and the women's severe, scraped-back hair. Their profound sense of mission and their dedicated proselytising inspired her to investigate belief and how it shapes us in divergent ways. One of the formative contributions to Bea's life is the Mennonite conviction that family is everything and that each individual must be subservient to the family's needs, seeking their permission before making a decision. Although Bea's parents were not old-school Mennonites, they accepted the Bible as literal and unerring, her father as indisputably the head of the family, and family as more important than friends. With two living great-grandparents, four grandparents, and five aunts and uncles on

her father's side and eleven on her mother's, there was a lot of family to honour. It was an ideal environment for both instilling discipline and instigating rebellion.

Bea describes her family during her childhood as 'the rural poor'. Her father was a farmer but not a very good one. Her mother was a good domestic manager with limited options. Girls were expected to take on a service role before marrying: Bea had a choice of being a nurse, a missionary or a secretary before becoming a housewife. Attending university was out of the question. But Bea seems always to have been able to resist being diminished. 'I had a teacher who, when I was in grade Eleven, said to me, "Why bother finishing school? You're just going to get married and have kids anyway." Said the man. I said, "I don't think so." And that changed my life. He did.'

In 1963, when Bea was in the middle of her final year of school, her grandfather had a heart attack. Bea's father decided to send her to help her grandmother, who lived in a town about 30 or 40 kilometres away. This required a change of school, so Bea shifted from a one-room schoolhouse for grades nine to twelve to a modern high school in a small town. What could have been a lonely Grade Twelve was salvaged by the school guidance counsellor, who encouraged her to apply for a bursary that covered all expenses and made no demands. That bursary took Bea to university, where she enrolled in a double degree: a Bachelor of Arts and a Bachelor of Education. She never returned to her family.

After Bea left home, her father re-trained as a teacher. He had finished Grade Twelve when Bea was in Grade Nine, the two in the same classroom, which, as you might imagine, she found unsettling. There was a shortage of teachers in Canada and, as a result, her newly graduated father was appointed principal of a small school in an isolated town in the province of Manitoba. To his limited experience he added her complete inexperience by inviting her to teach at the school. Bea had finished only a year of her degree, during which she had enthusiastically celebrated everything university had to offer: men, alcohol, tobacco. She

was nineteen when she accepted the offer, condoned by the school board, that she now describes as disgraceful, to teach students her own age. Bea attended summer school until she graduated from university in 1970.

During the next few years of teaching and studying, Bea married and gave birth to a son. She had met her husband during her first year at university, while she was working as a carhop – that wonderful North American phenomenon – delivering food to cars at a drive-in restaurant. He, a non-Mennonite physics teacher, was one of the customers. Her family was irate at her choice.

In 1971, she left the country with her husband and child. Her son was seven months old. They left mostly to escape her family, but some warmer weather was a welcome side benefit; Manitoba was literally freezing. They chose Australia because, as the Karmel Report – a review of education in Australia launched by the Whitlam government in 1972 – would soon prove, Australia needed more teachers. They also wanted to avoid conscription for their son when he came of age and thought they were heading to a country without conscription.

American conscription to the Vietnam War had propelled floods of young men to Canada to escape the draft. Bea hadn't heard of the so-called birthday ballot introduced in Australia in 1964, in which birthdates were drawn out of a barrel to decide which 20-year-old Australian men were to be conscripted. I remember vividly being at a twenty-first birthday party in 1967 Melbourne and seeing a young man trying to dance on two prosthetic legs, clinging to his girlfriend. He had lost his limbs as a conscript in Vietnam. No wonder parents like Bea wanted to protect their children from being sent to fight a war. The lottery ended, after national protests and the election of the Whitlam government, in 1972.

Bea and her husband arrived in Adelaide and taught there for two and a half years. They returned briefly to Canada but found that Australia suited them better. In planning their return, they were disappointed to discover that South Australia now had enough teachers, so they went

to Queensland. 'Our marriage fell apart there. In the mid-eighties, we reconciled and went to Canberra. Our marriage fell apart again and we tried again. Moved to Melbourne. Tried again, for a year; didn't work. And I haven't had a drink for fifteen years because I'm an alcoholic, which runs in our family.'

And so, in a startling non sequitur, we come to Bea's other great triumph of will: recognising and overcoming alcoholism. It wasn't the kind where she had her first vodka before breakfast; Bea was a binge drinker. She is convinced that, had she come from a family used to being around alcohol, it would have been evident to them from her first beer that she had a problem. Immediately, she felt that she could fly. And she couldn't stop at one drink. When she was at university, Bea began having blackouts that became progressively worse. She used to take photographs at parties so she'd know what had happened there once she had them developed. Twice she asked men 'who should have known better' if she was an alcoholic. One was himself an alcoholic. Both assured Bea that she wasn't because she was holding down a job.

It's disturbing that Bea knew that something was wrong yet her anxious requests for confirmation were dismissed. She wasn't then aware of the role of binge drinking in alcoholism. Bea credits her Canadian upbringing for making her a well-behaved drunk; her restraint persuaded her Australian friends that she couldn't possibly be an alcoholic. No one supported her to overcome her problem.

Bea's drinking continued for many years. The end of her addiction came about almost accidentally in 2004, the year of Bea's sixtieth birthday. She weighed 72 kilos and felt unfit. Bea decided to transform herself in the nine months leading up to the event. She undertook to exercise, to eat less and to stop drinking alcohol, solely to lose weight. She sealed the lids of bottles of spirits with tape and avoided places where alcohol was served. That September, she rented a resort for the sixty invited guests and had a huge party. She decided not to drink at the party because she wanted to remember it. She had great fun.

According to Bea, binge drinkers can control their drinking more easily than those who drink all the time, as long as they don't have that first drink. At Christmas that year, Bea had one drink and managed to stop there. In March the following year, she had a drink at a conference and didn't stop. The next morning, she had no memory of what happened that night. Bea resolved that it would be the last drink she ever had. She remains committed to that resolution, made when she was sixty-one.

After separating from her husband in the late 1980s, Bea travelled the world, teaching in international schools around the globe. She began in Thailand, where she stayed for seven years. Then she went to Malaysia. She found the school there particularly wonderful because it had been purpose-built, informed by the teachers' advice on the best environment for students. Nevertheless, Malaysia was not an easy place for women. Bea felt safe at work, but when she drove through the *kampongs* (villages) alone, she kept the doors locked and the windows up. I commented that she was clearly intrepid. Bea responded, 'Or naive? Or optimistic.'

Teaching in Moscow, which she did for a stint from about 2006, turned out to be a surprisingly lucrative experience. The school had only Canadian, British and American teachers, as these were the only passports that granted entry to the country. The support staff were Russian. The teachers all had diplomatic passes and went straight to the front of the line at the airport, and the school paid the teachers' taxes and every expense except electricity and telephone bills. The school no longer exists. 'It survived the Cold War but didn't survive Putin.'

I wondered how Bea had discovered these schools all over the world. She told me she went to job fairs, which she imagines are something like speed dating. Interested teachers submit their resumés at the stands of the schools they'd like to join and the chosen are interviewed the following day. If you make it through, you're offered a contract on the third day. Bea found it 'scary as'.

'So,' I said, 'you're naive, optimistic and brave?'

'And sometimes stupid,' she replied with a grin. Bea tends to underplay her determination, her ingenuity and her sense of adventure, even though these qualities clearly contribute to her achievements.

In 2002, Bea married a second time, at the age of fifty-eight. Peter was a chemical engineer she'd known in Australia. He went with her to Malaysia. While she worked, he wrote books. 'Then he decided to come back to Australia. He worked for a mate of his, in the carbon industry, that I just completely disapprove of. And he stayed here.

'We met for holidays, wherever I was in the world. We met in London, and we met in Thailand a lot. We met in Vietnam. We met in Greece one year, went to Africa one year. We weren't divorced, but we weren't together. He said they were the best five years of his working life, and they were the best five years of my working life! We were old enough to do it, and secure enough.'

Bea has had a distinguished and varied teaching career in Australia and overseas. She has also managed bookstores in Melbourne (for a major chain and for a school), commissioned articles for a magazine for expatriates in Thailand and written two books on how to succeed in business in Thailand and Australia, among other varied accomplishments. Along the way Bea has gathered two master's degrees: in Education and in Business Administration. She describes herself as a lifelong learner and someone who values curiosity. She is interested in the world and in other people. But in 2011, Bea thought it was time to retire from education.

Bea's decision came about because three friends, including the principal of the Moscow school where she was working, were leaving. Bea hated the thought of 'breaking in' a new principal and a new director, and Peter suggested a very attractive alternative: retiring to Thailand together. So they did. They built a house with a pool. By March 2014, Bea felt like the happiest woman in the world. It wasn't because she was just lazing by the pool; she had begun doing humanitarian work in Nepal with a non-government organisation called Sansar Nepal, which gave her life new purpose. Sansar Nepal provides support and education for street

children, and Bea knew that her skills and experience would allow her to contribute to improving the lives of those most disadvantaged.

In Thailand, Bea also became an examiner for the International Baccalaureate. She was aware of the privilege of those studying in the program, both in the resources their families brought to it and in the international status the IB conferred on them. She was even accepted to embark on a PhD examining the inherent inequities of the IB. Then, in June 2014, Bea's son rang her to say that he had been diagnosed with lymphoma. Bea and Peter rushed back to Melbourne.

To Bea's immense relief, in early December 2014 her son told her that all signs of his cancer had cleared, even the spots in his lungs. *Spots in his lungs?* He said that he didn't think she'd needed to know about those. Bea felt a weight had lifted and, to celebrate, she and Peter, with dashing originality, went to Prague to house-sit a cat for six weeks. The whole time they were there, Peter kept asking Bea, 'How come you're fitter than I am?' 'I said, "I'm not. You're as fit as a trout."'

He wasn't. It was the beginning of the end for Peter. 'By May 2015, we knew what it was: pulmonary fibrosis. We came back to Melbourne. And in 2016 he was gone.'

Pulmonary fibrosis is a horrible disease. My father died from it, so I've seen the effects close up. Your lungs become fibrous and inelastic, progressively preventing you from breathing. Pure oxygen and other palliation – perhaps even a lung transplant – can postpone the inevitable, but there is no cure. Bea cared for her husband until he died. Peter's loss was devastating. She didn't return to Thailand but she did travel obsessively, as a literal and metaphorical means of escape. From 2016 to 2020, she travelled at least six months of the year, knowing that she was trying to outpace her grief.

Then came the pandemic, and Bea was grounded. It forced her to face her demons, but she didn't resort to alcohol to avoid them, even during the fifth Melbourne lockdown, when she was sorely tempted. Maintaining sobriety is Bea's proudest achievement. I asked her where

she found the psychological strength. After a long pause, Bea replied, 'My mum? My dad was a depressive. We didn't know it. When he went back to school, Mum put up with all that entailed. She did all the budgeting and she did all the planning, and she preserved things for the rest of the year. So in autumn we had supplies to last us until the next time crops came in or the garden came in. We sold her short. As girls, we sold her short. It wasn't until we were grown up that we realised. I'd say, from my mum.' With the necessary distance, Bea now thinks that she was wrong to leave Canada to escape her family, but she doesn't regret the life she's had in Australia.

There were also benefits to the pandemic. In September 2021, three hours before a long lockdown began in Victoria, Bea moved from her coastal home to stay with her son and his family in Melbourne, thinking the restrictions might last a week. We had our first conversation seven weeks into that lockdown. She was enjoying contributing to her seven-year-old grandson's remote learning. We spoke the day after a magnitude 5.9 earthquake had added to Melbourne's woes. Bea had serendipitously run a lesson on earthquakes with her grandson only the previous week.

It was also during lockdown that Bea took up serious strength training. After the incident with the jar, her son had suggested the farmer's walk exercise, in which you pick up the heaviest thing you can carry in one hand and walk with it. You then change hands and walk the same distance back again. Bea tried this for a while and then decided that she needed to follow a more organised program. She had come to know all kinds of interesting people on her travels and so contacted an American friend who powerlifts for Thailand. This friend suggested a trainer who lives in the United Kingdom. Given that life was online anyway, the distance wasn't a problem.

Bea has been working with that trainer ever since, making steady progress. When she can do more repetitions using her goal weights, Bea is going to buy herself a weightlifter's belt and learn how to use it to help her to brace her muscles. She knows she might need to take special

precautions with one knee, which she broke a few years ago taking her grandson to kindergarten.

Bea trains only four days a week because 'this is not my life yet'. Her family is what gives her life meaning and purpose. Nevertheless, she has a powerlifting goal that is important to her. 'When I'm eighty, I want to enter a powerlifting competition and I want to win it. That keeps me going on days that are really dark.' There are competitions all over the world, so Bea can combine strength with travel: heaven.

Powerlifting has made a difference to Bea's health and the way she feels about herself. 'I don't have to worry about climbing stairs anymore,' she told me. 'I don't have to worry about walking to and from the beach, and I don't have to worry about hanging out laundry or making beds or doing any of the thousand things that one has to do in daily life. I am dancing again! I can play with my grandson. Manage my suitcases. These activities don't require a great deal of strength, but they do require agility and balance and judgement. And I have regained these qualities with my strength training.'

There are other benefits from strength training, including stronger bones. 'I've actually reversed osteoporosis. I now have osteopenia only. This has been measured by two bone density tests.'

Perhaps the best effect is less tangible. 'I feel powerful and I am almost visible again. You know how after a certain age women become invisible? I feel that people are beginning to see me. My sense of self and my sense of self-worth have improved enormously.'

And she can open any jar.

Cultural Connections
Miriam Rose Ungunmerr Baumann AM
(b. 1950/1)

There is a book by Alan Marshall called *People of the Dreamtime*. It was first published in 1952, but the edition that captured my interest was published in 1978. I had enjoyed his autobiography, *I Can Jump Puddles* (1955), so when, in the early 1980s, I discovered this book of Aboriginal origin stories, I bought it. The book was beautifully illustrated by an Aboriginal artist whose paintings told the same stories without words. At the time, the artist's name was unfamiliar to me. I recently came across an article about the artist in *The Australian Women's Weekly*, March 1979 edition, and was thrilled to discover that she is Miriam Rose Ungunmerr Baumann.

Miriam Rose was then only in her early twenties. She smiles shyly from the page of the magazine, holding an artwork painted in earth tones of ochre, yellow, black and white. She looks lovely in her red dress, and so young. Despite her youth, she was not only an established artist but also

an adviser on Aboriginal art for the Northern Territory Department of Education. Throughout her life, Miriam Rose, as an artist, educator and activist, has been committed to maintaining the culture of her people.

Miriam Rose describes her parents and their generation as 'traditional people', members of the Ngangiwumirr language group. She was born at Daly River, near Katherine, in 1950 or 1951, the second of 'about seven' children. Miriam Rose isn't sure of the year of her birth, let alone the day and month. The priest used to come round and ask the women when they thought each child had been born. They would reply, 'In the wet season' or 'In the dry season'. Children were allocated birth dates to conform to bureaucratic needs; Miriam Rose chuckles as she compares it to giving a birthdate to racehorses.

Miriam Rose is four or five years too young to be included in a book with women born before 1946. However, Aboriginal Australian women have a life expectancy of 75.6 years; non-Indigenous Australian women can expect to live to 83.4 years.[10] That gap of almost eight years more than justifies Miriam Rose's inclusion, were any such justification needed. It's important to know her story, which culminates in being named the 2021 Senior Australian of the Year.

Before European invasion, the Daly River area was an important meeting place for trade and cultural ceremonies. It is now a popular Northern Territory tourist destination, only a few hours' drive from Kakadu National Park and Katherine Gorge, sharing some of their spectacular features. The region has a dry season from about May to October and a wet season from about November to April, with monsoon rains mostly from December to March. I wish I knew it from personal experience. The Songlines that Alan Marshall wrote about were from Arnhem Land, but Miriam Rose was able to illustrate them because, she said, they are similar to the Songlines of her country.

When she was only about four or five, Miriam Rose's father died. Indigenous cultures don't revolve around nuclear families but consider every person as situated within a broad extended family with attendant

obligations. Her mother's sister and brother-in-law took care of Miriam Rose and her older sister because 'in cultural ways, they were my mother and father'. Miriam Rose's Aunt Nellie and Uncle Attawoomba Joe became Mum and Dad, while she continued to visit her birth father's grave and to stay in touch with her mother.

Miriam Rose's cultural father was a well-regarded police tracker. His family moved with him when he was needed for work, and Miriam Rose changed schools each time. She jokes that living next door to the police station meant that she could never get away with wagging school. Miriam Rose is glad that, along with her formal schooling, she learnt traditional ways from her Uncle Joe. Miriam Rose was reading books and being inculcated into the Western canon in parallel with reading Country and absorbing her people's culture. This bicultural education continued after Uncle Joe retired from the police force, when he became the gardener and general handyman for a woman who owned a roadside inn on the Stuart Highway. Aunty Nellie was a housekeeper there.

This phase of Miriam Rose's life came to an end upon Aunty Nellie's death, when Miriam Rose was about fourteen. It was culturally inappropriate for girls to stay with a lone man, so Miriam Rose and her sister returned to her birth mother on the Daly River, where she attended the St Francis Xavier mission school. The school services the Indigenous community at Nauiyu, on the banks of the Daly River, where the Jesuit mission was established on Mulluk Mulluk territory.

Miriam Rose was baptised into the Catholic faith at fifteen. Her faith is part of her birthright, along with her Indigenous cultural heritage. Her mother was one Elder among many who valued the work of the Church. 'After the 1800s, when the mission was first here, there were brothers who were in charge of the mission's three stations, and they came from Sevenhill in South Australia. There were also Austrians as well. Then they went back, because of the floods, and remoteness, and sickness. I think they left a legacy behind to the older people, and the older people talked among themselves and said, "We should bring us the

Church in Darwin." The district supported the Catholic Church in the Top End of the Territory. They asked the Catholic Church in Darwin to send more missionaries.'

In the 1950s, the missionaries returned. When I asked whether her family found the Jesuit missionaries to be a beneficial presence in their lives, Miriam Rose replied, 'Yes. I'm the result!' Miriam Rose's birth mother had worked on the mission, helping the nuns, who had set up a boarding school on land that the government had helped the Church to buy. According to Miriam Rose, it was planned from the outset that the local Indigenous people would assume responsibility for looking after their community, and arrangements were set in place to ensure that it happened.

After she completed primary school, Miriam Rose and her peers were encouraged to take up employment. She appreciated that the nuns gave her an opportunity to learn about work, but the first few jobs they suggested for her didn't suit. Finally, she accepted an offer as a housemaid to a teacher at the high school. Miriam Rose hadn't been there long when the teacher came home one day and found her reading a book, which was not expected of Aboriginal children at the time. The teacher asked Miriam Rose to read aloud and was impressed by what she heard. She appointed her an assistant teacher. That set the young woman on the path to becoming the first fully qualified Aboriginal teacher in the Northern Territory.

Miriam Rose went to Darwin and attended Kormilda College (now the Haileybury Rendall School), a day and residential secondary college run by the Anglican and Uniting churches. Its teacher assistant course qualified her to work as a teacher's aide at her former school, St Francis Xavier, where she soon became committed to pursuing a career as an educator. In 1971, Miriam Rose went to Melbourne to train as a teacher. During her final year, she discovered a talent and a passion for painting that coincided with her realisation that Aboriginal art was neglected in the school curriculum. Miriam Rose, barely out of her teens, demonstrated such ability in both

art and education that, in 1974, she received Commonwealth sponsorship to take a secondment from St Francis Xavier to partner with art teachers in Victoria in encouraging children to express themselves through visual art.

Miriam Rose returned to the Daly River in 1975. She was soon appointed as an art consultant to the Professional Services Branch of the Northern Territory Department of Education, a position she held for decades. This entailed travelling to schools all over the Territory to promote the importance of artistic practice. She is still independently engaged in this work.

Miriam Rose continued to gain qualifications: a Bachelor of Arts in 1988 and a Bachelor of Education in 1993, both from Deakin University. According to Miriam Rose, it took her mother a long time to understand why she kept going away to study. It was outside anything her family had experienced. Gradually Miriam Rose's mother recognised that her daughter was becoming highly regarded as an educator in Western culture and that this was her passion.

In that year, the woman who began as a domestic servant for a teacher was appointed the principal of St Francis Xavier Catholic School. The school continues to hold Indigenous culture at the centre of its educational philosophy. Every teacher at St Francis Xavier is Aboriginal. In keeping with her commitment to promote knowledge from both Indigenous and non-Indigenous cultures, Miriam Rose undertook a Master of Education in 1999, writing a thesis on the integration of traditional Indigenous and Anglo education models. Miriam Rose also epitomises the ideals of good leadership, encouraging others to follow in her footsteps and providing opportunities for advancement. She has trained seven local people as teachers. One of those is her daughter-in-law, who now teaches at a Catholic school in Darwin.

It is almost impossible to accept that Miriam Rose achieved so much, especially at such a young age, without confronting significant obstacles. It was only in 1971 that Aboriginal and Torres Strait Islander peoples

were counted in the census for the first time. I remember the campaign in the 1960s to include Aboriginal people in the census and my horror that, as the common story went at the time, they were classified instead under a so-called *Flora and Fauna Act* (a misapprehension that perhaps pointed to a deeper truth about discrimination).[11] Faith Bandler was a powerful Indigenous advocate for civil rights whose dignity in the face of racist opposition was extraordinary. As a teenager in the 1960s, I joined the Beaumaris branch of the Aborigines Advancement League, an organisation begun by Pastor Doug Nicholls. Its objectives, as I understood them, were to achieve citizenship rights for Aboriginal people and to work for their welfare and wellbeing. I'm sure we were often patronising, despite meaning well. I had met only two Indigenous Australians: Aboriginal children who used to stay with a neighbour every summer when I was a child. Miriam Rose must have encountered the widespread ignorance and fear that dominated white Australia then, but she acknowledges few difficulties when asked about this. Her focus has always been on bringing people together, and unity appears to be the lens through which she sees the world.

Miriam Rose did encounter some misunderstanding from within Indigenous culture when she first became a teacher, she says, but was able to overcome it easily. 'I did a lot of art work with the children, to try and instil in them the things that you pass on. I'd say, "Okay, this is the story." It could be a Dreamtime story or a true story; some stories are passed on from generation to generation. "What in that story excites you? Just paint that little section." I'm trying to instil in them what you're wanting to pass on. And some of the Elders – not all, one or two of them – said, "Hey! You shouldn't be doing that with the kids." Anything new that happens in the community, it takes people a while to understand what it all means. They thought I was getting the children to paint sacred rather than non-sacred stuff; non-public things. And I said, "No, it's just things that you could tell to me, like Dreamtime stories, or true stories about their families and their family tree, that sort of thing. So that they

know what their dreaming is, what tribe they belong to, where's their homeland, things like that." We've got to continue to talk to the children about who they are and where they belong.'

When she was a child, Miriam Rose learnt about cultural matters, including belonging and identity, not only from Uncle Joe but also from sitting around a campfire with the Elders during school holidays. In her travels, Miriam Rose has urged Indigenous Elders to work with young people in schools and other settings to bring that campfire education to Aboriginal and non-Aboriginal children. 'I go to the colleges down south and work as an artist-in-residence there for a week and talk to the whole school or to different classes. I'd have them sit down and I'd say, "Do you want to ask me a question?" And they say, "Who are you?" And I say, "I know who I am." I tell them, "I grew up with that language. This is my homeland. This is my dreaming. I know my family; I belong to a certain family group at home." And I say, "Who are you?" "Oh, I'm Mark Smith." Then I say, "So, how do you know who your family are?" And they say, "Oh, I just go on Google and find where Smith originated from." You know, their surname and so on.' But, as Miriam Rose points out, the non-Aboriginal children often don't know the story of who they are and how they are embedded in a family or a culture.

As part of Miriam Rose's determination to maintain and pass on cultural traditions, she helped found the Merrepen Arts Centre at Nauiyu in 1986 with a small government grant. She took a year off from the school to get it started. The centre was designed to encourage adult and lifelong education, especially through the visual arts. Miriam Rose jokes that she now has the Elders occupied at Merrepen 'painting their lives away!' The 120 or so artists who are members of the centre include several with international reputations, among them Miriam Rose herself.

One obstacle that Miriam Rose acknowledges, cursorily, is that she was a woman doing a man's work. In addition to being a senior educator, she was president of the Nauiyu Nambiyu Community Government Council for several years from 1982. 'The Elders were concerned that what

I was doing was not accepted by men. Like taking a role and working with the children, and helping them, and teaching them, all that sort of thing. The men have been so slow in getting educated! It was always the women taking the lead. With those qualifications, it can help you to become better if you're wanting to continue. The fellas just thought it wasn't a good idea for me to be in that position because I was a woman.'

Now men are following the women's lead; as Miriam Rose puts it, women are the stepping stones. Men are starting out as classroom assistants, being trained how to teach, and bringing their skills back to the school as qualified teachers.

A knowledge of where and how she belongs is clearly the foundation of Miriam Rose's strength, but I wanted to know more about what she thinks enabled her to be a pioneer in both Indigenous and non-Indigenous cultures. She named her education and her awareness of the urgent and continuing need to improve the lives of Aboriginal children. 'Our kids, from whichever community, they wag. They don't attend classes as often as they can, and families are not as forceful in encouraging kids to come to classes. So I guess it was the Western way of being educated that was a very deep influence in my life, to be where I thought would be the best place to be in for my people. Also learning to walk in two worlds, to understand the way you live in your towns and cities. That's an education in itself, for me. We've got kids going to schools in your cities around Australia now and we've got a lot of success stories. The young ones that have completed high school, a couple of them have stepped into universities down there as well.'

Miriam Rose's husband, Ken Baumann, whom she married in the early 1970s, has also assisted with her work. He prepared the board and frames for her paintings in *People of the Dreamtime*. He's been a builder for more than thirty years and built most of the houses now occupied by the local community, using bricks made predominantly from locally sourced sand. The houses are well constructed and have survived flooding during the monsoon season. Miriam Rose says that people don't need to

lock their doors, demonstrating a level of community trust unimaginable to someone from a city.

Miriam Rose and Ken's relationship exemplifies the cross-cultural understanding she espouses. He was born on the Gold Coast to parents who migrated from Germany. 'That's why I've got a German surname, Baumann. Sometimes I get letters from Germany, in German, thinking that I'm a German person, and I'm laughing at them and saying, "Oh my God!" I'd want to see their face, if they come and meet me and they see an Aboriginal German!' Neither of them speaks German, although Miriam Rose speaks five local languages as well as English. Her early bicultural education means that she not only moves in the worlds of Aboriginal and white Australia but can serve as a bridge between them.

Just as Miriam Rose benefited from strong traditional family connections when she was a child, she now practises the same communal open-heartedness. Her son and grandchildren are in Darwin, but two of her sister's friend's grandchildren live with Miriam Rose and Ken: 'Culturally, I'm their nanna as well.'

In 2013, Miriam Rose established the foundation that bears her name, prompted by a terrible sequence of events: seven young community members committed suicide in a single year. 'One of them was my nephew, my sister's boy. He was twenty-two when he took his life. He's the baby that Pope John Paul held. You come across a photo of him holding an Aboriginal baby? That was him. We went to Alice to meet him. We went on a pilgrimage to Alice. Standing in the portioned-off area as he was walking past, all the paparazzi, all the media, they were saying to the Pope, "Look!" And they motioned him to come over towards us, and he took the baby from my sister's arms and he kissed the baby. And the baby kissed him back!' Miriam Rose laughs with delight at the memory of this cheeky, affectionate boy, who should have had a blessed existence. Instead, he became profoundly depressed.

Miriam Rose knew that she had to take action. Suicide is the second-ranked cause of death for Indigenous men, whose suicide rate is almost

double that of non-Indigenous men in Australia.[12] She set up the Miriam Rose Foundation to provide support to children and their families; to tell young people of all ages 'we're here to help you'. Other Elders are members of the foundation's board.

It was through the Miriam Rose Foundation's website that I located her, towards the end of her term as Senior Australian of the Year. She had an assistant to help her manage the demands on her time, and I assumed that she was similarly assisted in the running of the foundation. I envisaged her sitting in an office. When I asked what her role was in the foundation, she told me that she stood in the street and talked to young people. 'I just hang out on the streets with them and, as often as I can, talk to them and say, "Hello. How are you? I'm here if you want me. If you've got issues, any concerns, if you want to talk. If you want food, I can get you food." I organise activities with the older young people. I get a lot of equipment donated to the foundation, like sporting equipment. The older fellas that work for the foundation, they take them onto the oval here in the community and organise activities. I always get persistent and say, "Hey, listen. Otherwise you could go wandering off and, you know, choose the wrong thing to do and you're going to get into trouble." There have been young ones that have been just on the verge of going to the detention centre in Darwin and we will attach ourselves to them so that they belong. Belonging is an important term that we use here. Because they do. They do belong to us.'

Miriam Rose is no longer the principal of St Francis Xavier School, although she sat in the school for our Zoom conversation. She serves on the school's board with other local Elders. She and two other board members are also on the Catholic Aboriginal Leadership Team and travel to Darwin from time to time to meet with officials there. Members of the school board are drawn from the local population and from the nearby communities of Wadeye and Maningrida, as well as from their surrounding small towns.

Miriam Rose sees her future as continuing to do all she can for Aboriginal children and encouraging the next generation to carry on her work. She acknowledges the contribution the local community association has made to her work with children. 'I said to the general manager of the local association, "Can you order a plane?" And he said, "What?" I said, "I want to take some of these boys over to Tiwi Islands and Arnhem Land and see what the people are doing there with arts and crafts." Then the plane pulls up at the airstrip, and I say, "Come on, you mob's coming with me."

'Once it flew away, I said, "Look, this is what we're going to do. There's men and women doing art there, and we can talk to the coordinator there and say, 'What do you do with the art from these people? Do they make money out of this?'" That's work for people. This is what I'm doing. I'm an artist. This is going to be after me, when I'm gone. We've got to continue to work with our kids to be the next budding artists. Then we flew to Arnhem Land, to one of the communities there. The same thing – we just flew around for the day and came back. And I said to them, "You can do that [make art] too."'

Senior Australian of the Year is only the latest formal honour that has been awarded to Miriam Rose. In the middle of the wet season in 1998, she heard that she had been made a Member of the Order of Australia. Flood water nearly disrupted the ceremony. The citation says the award is for her 'role in promoting Aboriginal education and art'. In 2002, acknowledging her extensive contributions to the people of the Northern Territory, Charles Darwin University made her an honorary Doctor of Philosophy.

But when Miriam Rose took on the title of Senior Australian, her work went into hyperdrive. She was asked to address conferences all over the country and speak to groups large and small, often composed of women, as well as organisations, such as the police and the army. Miriam Rose welcomed the opportunity and is committed to improving the lives of Indigenous people and to developing understanding between

Indigenous and white Australia, but she thinks it's well past time for the latter to take responsibility. When she spoke at the Australia Day awards ceremony, Miriam Rose told non-Indigenous Australia that it's our turn to understand First Nations peoples – who have worked to understand us for the past two hundred years and more – and how First Nations peoples live on Country. That seems more than justified.

In September 2022, Miriam Rose was chosen as one of only ten Australians to take part in the official Australian government delegation to London to attend the funeral of Queen Elizabeth II. There could hardly be a more powerful symbol of the encounter between the coloniser and the colonised, or of Miriam Rose's work in advancing mutual understanding. She was nervous about this trip; she'd never been to Great Britain, so far away from home, but she accepted the invitation because it was important for her to represent her people.

Miriam Rose has seen the very different ways in which older people function and are treated in Indigenous and non-Indigenous societies. 'In your way of doing things, when you reach this age, it's retirement. But for us as Aboriginal people, we're classed as Elders, and you've got to win that title, I guess, from everybody around you. That's when our work starts, when it comes to looking at the young ones and in passing on knowledges that were passed on to us from the Elders previously. I'm not retired yet! A lot of the Elders in Western society, they've got a lot to offer to the young ones around them. They're the sort of things that I've been talking to the people in the Territory about, especially in the Top End, in Darwin, saying, "You're also, in my eyes, classed as an Elder. You're just as important as I am in passing on the knowledge that you know, and the history of where you are and who you are. And that's important."'

Many of us in non-Indigenous cultures are careful to acknowledge Country at the beginning of our speeches and to pay respects in the signature blocks of our emails to the 'Elders, past and present' of the traditional owners of our land. It is bizarre that we forget to do the same

for our own elders. Learning from Miriam Rose Ungunmerr Baumann might help us all, young and old, to think about how to create a more respectful society.

The Bromeliad Queen
Olive Trevor OAM
(b. 1932)

I am not a gardener. It's true that my second husband and I planted more than 3000 trees and shrubs on our Mount Macedon property after it was incinerated in the 1983 Ash Wednesday bushfires, but the surviving plants owe little to my care. If I've spent hours weeding a garden bed, I expect it to stay weeded, not to require the same attention again in a few weeks. Gardeners take pleasure in nurturing their plants. I do not. Nevertheless, I enjoy seeing beautiful gardens and appreciate the work done by those with greener thumbs. I am a committed viewer of the ABC's *Gardening Australia*, which is where I first saw Olive Trevor.

The segment featured Olive's granddaughter Rebekah, known as Becky, and lauded her achievement in running a large plant nursery at the age of twenty-five. But Becky was sitting with her grandma Olive, and credited her with starting the nursery after raising her five children. Olive reminded me of my much-loved grandmother: cuddly, curly white

hair, clearly proud of her granddaughter. Olive was in her late eighties. Their affection and respect was just what I needed to see in the middle of a pandemic. I contacted Becky through the nursery's website, and she helped me to set up a meeting with Olive.

Olive was born to parents who ran a citrus orchard, so her love of gardening was nurtured from an early age. They also grew all their own fruit and vegetables, meaning there was plenty to do. Her mother and father worked the orchard together and Olive joined them after school and at weekends. She recalls working *with* her parents, equally committed and almost as knowledgeable. Although the orchard was sold when Olive was in high school, she retained her interest in growing things.

At the end of Year Ten, Olive won a bursary to teachers' college, which would have meant moving away from home. Her mother couldn't bear the thought of losing her, so Olive instead did a commercial course that led to work in an office, which she hated. After she had been there for six months, her mother said, 'Why don't you stop that? You don't like it. Why don't you make dresses for your friends instead?'

Until about the late 1970s, it was common for women to make their own clothes. Dressmaking patterns were big sellers in the department stores. Olive was good at it; her mother's encouragement was all that she needed to become a dressmaker. I think this demonstrates at least two things. The first is the value of drawing on your skills and interests to earn an income. The second is that, although from today's perspective Olive's mother could be seen as thwarting Olive by limiting her chance of further education, she loved and valued her daughter and wanted her to be happy. She provided the support that made sense to her, and Olive accepted it in the spirit in which it was intended. She felt supported.

Olive was twenty when she married Len, whom she had met in high school. 'Len said, "Well, you're not making dresses anymore. I'm not having people come around having fittings at all hours of the day and night." So I said, "I could get a job," and he said, "My wife doesn't need to go to work." So I stayed at home. I grew lots of vegetables and, being a

dressmaker, I made all the family's clothes. We loved our five kids. It was a great time of our life, having all the littlies.'

There was a span of fifteen years between the oldest and the youngest child. When all but the last child was in school, at the tail end of the 1960s, Olive decided to make a business out of her domestic gardening and took some of her plants to a weekend market. It wasn't long before Len's attitude to having a working wife underwent a dramatic transformation. I was startled when a disembodied male voice was heard off-camera in my Zoom call with Olive: 'She was earning as much money in a day as I was earning in a week.' Len continued to contribute to the conversation to endorse what his wife was saying and emphasise her triumphs.

From that early success on, Len supported Olive's growing business as a plantswoman. He helped her set up at markets, built a shadehouse in the back garden with their eldest son and took responsibility for the bookkeeping. He continued building shadehouses as Olive filled each one rapidly with plants: she grew anything she thought she could sell at the markets. Olive's success inspired Len, who also started selling their plants at different weekend markets. Olive then began to sell to nurseries and eventually to garden centres and major chains all over Queensland and northern New South Wales. They began to make serious money.

Olive joined several gardening clubs and took up floral art. She entered a floral art competition and won. 'I brought home this big trophy and the kids thought I was marvellous.' That sense of affirmation and support – first from family, then from friends and colleagues – seems always to have sustained Olive.

Olive began her business with orchids and begonias, but gradually became more interested in bromeliads. They were difficult to acquire – most growers guarded their plants closely – and there was a ready market for them. Olive joined the Bromeliad Society to find out more about where to buy them and what to look for. This was typical of Olive: if she was thwarted at one turn, she would take another and go right to the source.

Bromeliads are flamboyant tropical plants that seem to appeal to people who would not necessarily describe themselves as flamboyant. They are colourful and cheerful, with beautiful foliage as well as spectacular flowers. The foliage can be purple, orange, yellow or red, as well as green, with colours in spots, stripes and patches. I was surprised to learn that a prominent bromeliad is the pineapple. That, of course, is not commonly grown in a pot as an indoor plant. Olive didn't love bromeliads more than any other plant she grew; she was attracted by the fact that they were so hard to come by. It was a business opportunity. At garden shows the Bromeliad Society would set up a table and, as soon as the plants appeared, sales staff would grab them before anyone else had a chance. Their scarcity and popularity were obvious.

A member of the society who respected Olive's entrepreneurial skill suggested that she import them, so Olive wrote away for catalogues. The strategy was a success from the beginning. By the time Olive began importing plants, she had moved a long way from taking her home-grown orchids to a weekend market. Importation requires a knowledge of government regulations, meticulous management and specialist care. Quarantine is essential to avoid importing exotic pests and diseases. At first Olive used the government quarantine house. Then she discovered a colleague with his own quarantine house who was prepared to share. That was much more convenient.

The business grew so big that Olive began looking for a new house with land on which to set up a larger nursery and her own quarantine facility. She found five acres on the outskirts of Brisbane. The previous owner had kept racing dogs under the house and Len said they would never get rid of the pungent smell. Olive persuaded him. She bought the property, fumigated the house and rented it out while they prepared the land. The soil had to be cleared of weeds before they could build anything permanent. They constructed a shadehouse and drilled a bore for water. Olive drove to the property each day in her market van and did hard physical labour; Len came to help on holidays and weekends.

Len's father accompanied Olive on weekdays because, he told her, 'it's not good for a woman to be out there on her own in the country'. Olive didn't mind being chaperoned, appreciating his care and support. They parked a caravan among the trees. It was a cool place for lunch and somewhere for her father-in-law to rest. Her youngest son was in high school and she would pick him up from school each afternoon on her way home. Olive loved everything about the venture. When it opened, she named her nursery The Olive Branch.

In the late 1980s they sold the old house, which emanated not a whiff of its former canine inhabitants. It was carted away by its new owners. Olive and Len built the house of their dreams in its place. They live there still, surrounded by plants. They had the foresight – and the means – to design the house to accommodate them as they aged. They live on the ground floor and Becky lives upstairs, from time to time with another grandchild. Access to all rooms, including the bathroom, is easy, even now that Olive and Len have mobility problems.

In 1996, when she was in her mid-sixties, Olive took her first trip outside Australia. She and a friend spent three weeks touring bromeliad farms in Texas and Florida, where they became fascinated by the country and its hospitable people. They bought plants everywhere they went and boarded the plane home with seventeen boxes of flora, booked through to Brisbane: her largest importation. Everything sold, and gradually other plants in the nursery were edged out by bromeliads. Olive soon became the largest bromeliad importer in Australia, with her own certified quarantine facility. Bromeliads, once rare in Australia, are now sold in nurseries all over the country, many for only a few dollars but some for hundreds of dollars. Olive was a pioneer.

In 2000, Olive persuaded Len to go with her to the World Bromeliad Conference, held in San Francisco. It was his first international trip and her first conference. While she was there, she heard about a school for bromeliad judges and decided to enrol. They went to a conference every two years and Olive attended the judging school until she qualified as

an international judge. At the same time, she was working her way up in the local Bromeliad Society, eventually becoming its president.

Olive wanted to share her knowledge and her passion. To enable her to teach, she and Len built the equivalent of a conference centre, which holds about fifty people, on the side of their house. They started with classes over breakfast, before work at the nursery began, as Olive taught others how to grow bromeliads from seed.

I commented that she was very entrepreneurial, and Olive replied that she'd had good support. When I asked what kind, Len said, 'I came behind and carried the bags.' Olive added, 'Once we started, he enjoyed the trips over there as much or more than I did. He would go to the auctions, and they'd auction rare plants, and he'd be up there leading the auction. He did that so well. And we'd have sales here at The Olive Branch. We'd advertise them and we'd set up in the big packing shed. I would prepare tea and coffee and sandwiches for everybody, and he'd talk. He's got the gift of the gab and can talk much better than I ever could.'

Olive began to open her garden for charity as part of a national scheme and used her business and her property to raise money for CareFlight, an Australian emergency medical rescue service. In 2019, Olive and Len were appointed joint patrons of the Bromeliad Society of Queensland, and in 2020 Olive was awarded the Medal of the Order of Australia for her contributions to horticulture.

Olive was thrifty and fed her profits back into the business. Once she had paid off the nursery, she used her savings to buy other properties, renting and selling to her advantage. She trained her children to be as fiscally minded as she was.

Olive told me about an employee she had tried to guide in the same way. This young woman had complained of her many debts. '"You're earning good money," I said. "Get rid of the credit card."

'She said, "Why would I do that?"

'And I said, "Doesn't it worry you?"

'"No," she said. "Why would I go without anything when I can get it on a card?"

'Why would I go without anything when I could get it on a card! She lived in a rental property and never got ahead and, of course, you don't. That's not the way you get ahead. We brought the kids up differently, so that they are responsible for their money and how to save. What you teach your children shows up in later life. We did everything we could for them. They were well educated, they learnt musical instruments. We took them all over Australia in a caravan, and they still talk about their holidays. In fact, some of them have got caravans and motorhomes now that they go on holidays in.'

Olive's thrift and caution didn't protect her from all misfortune. When a storm smashed the nursery in 2009, the bond with her children went a long way to mitigating disaster. The storm was terrifying, with wind, rain and hail, tearing down shadehouses, uprooting trees and shrubs, and damaging their water system. At least their house withstood the onslaught. Olive's youngest child, Wesley, was holidaying with his family in Tasmania and flew back with his daughter Becky to help his parents rebuild the nursery. Wesley's whole family then rented a house next door, helping Olive and Len until they could manage on their own. Becky loved the plants so much that she stayed when her family returned to their own plant nursery on the Gold Coast. She lived with her grandparents, went to bromeliad shows and sold her own plants. When Becky was twenty, she bought the business from her grandparents.

Apart from the storm, Olive acknowledges very few trials in her life. There have been men who resented being told what to do by a woman, and she knows of at least one business competitor who employs only women because he thinks he can control them. She has walked out of plant societies because of argumentative men. But she's also had problems with the occasional woman. Olive's advice to women who want to initiate or continue their ventures in later life is to 'go for it' and be persistent.

In her experience, the hardest part of running a business is managing the staff. She is glad to have had Len's expertise with personnel and has tried to be a kind employer, heeding individuals' personal problems as well as their work problems. She's paid medical and dental bills for staff members and – with extraordinary generosity – even the occasional deposit on a house.

But Olive's health is now not good. It was when her health began to fail that she enacted her succession plan and encouraged Becky to take over. Relinquishing control was difficult. Olive wanted to give her granddaughter help and advice, but Len said that it was time to let go and the wise Olive did so. 'I still walk through the nursery and say, "I would do this" or "I would do that." Sometimes she comes to me for information. Certainly, when it comes to names and identification and that type of thing, she comes to me. I still go down every day. I've got a golf buggy I drive around the property, because I can't walk very far, and I meet people who come to buy. They want to come to me for information but, as soon as Becky speaks, they know that she's the one who has all the information now. She's very good and she's doing it differently.'

Letting go, however, didn't mean giving up. If Becky now has the bromeliads, Olive has aroids, a family of flowering plants of which the best known is the peace lily. I have two near me as I type, with lush green foliage and strong white flowers. Monsteras and philodendrons are also in the aroid family. Olive, who has long been interested in aroids, attended the first meeting of the Australian Aroid Society in 2017. She has examples on her property that were planted in the 1970s and 1980s, when they were last popular. Clothes aren't the only things that go in and out of fashion.

While Olive supports Becky, she doesn't expect her to remain com-mitted to the business to which her grandmother has devoted her life. 'I've said to Becky, "If you want to do something else with your life, you do it. Don't feel as though you should stay with plants because of me, or because of us." At the moment she loves them, and she's enjoying them,

and she's successful, but she has other interests. She's a youth leader at the church and she's very good, and she's realised she's very good at everything she does. We've got lots of success among our grandchildren. We've got a lawyer, we've got an engineer, we've got a vet. I'm proud of them all.'

Becky is now a bromeliad judge and is spending her early twenties doing what Olive did decades later. But Olive doesn't wish she had started sooner and doesn't yearn for the teacher training she was denied. She thinks it would have been nothing more than a dead end. Three of her children trained as teachers and none has remained in the profession. Two now run their own nurseries, including a daughter who is an expert in salvias. Olive is very satisfied with her life, as is Len with his: 'It's been a wonderful life and everything has been successful,' he says. They clearly make a good team. On *Gardening Australia*, Becky told viewers, 'Grandma has the passion for plants and bromeliads. Granddad has the passion for Grandma.'

It's heartening to see that Olive is giving Becky all the encouragement and opportunity she needs to be part of the next generation of ordinary women doing extraordinary things. Olive thinks that Becky now grows plants better than she did but, in Becky's eyes, 'No one will take Gran's place as the Bromeliad Queen.'

Drawn from Life
Anne Hetzel OAM
(b. 1930)

When Anne was a child, she had a pet dog, a sweet little scotch terrier named Sidney. Anne and Sidney were inseparable. The vision Anne paints of herself and her dog recalls the cover of the 1950s children's reader *John and Betty*, with Scottie the dog. But Anne's story takes a sudden swerve from this conventional mid-century scene: Sidney was eaten by a leopard.

That same leopard later stalked her family's camp in the wilds of Southern Rhodesia (Zimbabwe) on a night when her father was away. 'My father got a borer in his ear, an insect in the roof beams. It fell out of the roof and into his ear and went on boring. My mother managed to kill it by pouring oil into his ear, but she couldn't get it out. He had to walk down to the river, swim across, take the old car and drive about sixty miles to get the doctor to take the borer out.'

This was the first night Anne's father had left his family alone on the farm. The family's African cook came and slept in the kitchen. 'We lived in a half-circle of tiny huts. The kitchen was a separate hut. My rather fierce grandmother was staying with us. She was in the habit of getting early morning tea on a tray at the crack of dawn. When the morning tea didn't come, she got up to see what had happened. She found the cook inside, waving his arms at her and shouting what she thought was "Locusts!" She woke my mother up and said, "I don't know what Jonas is saying. I can't see any locusts." Then Jonas emerged from the kitchen in great agitation: "Not locusts. Leopard!"

'We children said that if my grandmother – who, actually, we realise, must have walked very close to the leopard – had seen the leopard, she would have simply said, "Sit!" in a very fierce voice and he would have sat. But a hunter, Chikaponya, who had also come to stay nearby, went off with the big rifle that my father had left with him and shot the leopard – which was sad in one way, but in another way inevitable, especially in those days. I remember very clearly seeing this big leopard with a mob of Africans round him, all chanting and singing, and the leopard was hanging from a big pole, tied by its four paws. My poor father, who got back in triumph in the early morning, the borer gone, was expecting a hero's welcome but found a leopard on the lawn and the entire place in turmoil.'

It would be impossible to predict the trajectory of Anne's life from her beginnings.

Anne was born in England in 1930, a year after her parents were married. Both sets of grandparents had emigrated to Africa some years before. Anne's birth came amid the Great Depression and high un-employment. Her father found work in Borneo, leaving his pregnant wife behind in England. After Anne's birth, Anne's mother took her to visit family in Africa before joining Anne's father in Asia. Amid the humid rainforests in the Malaysian state of Sarawak, both parents caught tropical diseases, including malaria and dengue fever. They survived, although Anne's father would later die at only fifty-four from the after-effects.

Anne's brother was born in Sarawak when Anne was nearly two. His birth was badly managed and Anne's mother suffered injury. She returned to Africa, this time with a toddler and a baby, to seek medical assistance. Once she had recovered, she was advised to leave her children in Africa with their grandparents and rejoin her husband. The wisdom of the time was that the tropics were unsuitable for European children. So a now four-year-old Anne and her brother were sent to live with her father's parents, then her mother's parents. 'My mother was in anguish at the thought of leaving her two children. But she went back to Borneo and for three years my parents had a very adventurous life, travelling all over the country, going up the rivers, staying in different places, while he made survey maps.' By 1937 Europe was teetering on the brink of war, so Anne's mother returned to Africa to retrieve her children. Anne still vividly remembers the emotional reunion.

It had been hard for the young Anne to understand why she wasn't with her parents. Now, when she looks at photographs of herself aged seven, she sees 'a rather forlorn little child'. This separation began a series of losses throughout Anne's life: of people she loved, of familiar places and of her own interests and passions. But she learnt courage from her pioneering parents, and she continues to look at the world through kind and generous eyes.

When her father returned from Borneo, too old to fight in the Second World War, he was granted a Crown selection of land in a remote part of Rhodesia to establish (Anne says regretfully) a tobacco farm. It was bushland, not jungle: rolling countryside covered in trees and bordered by mountains. She was nine and her brother was seven when they moved to the farm. All their possessions were piled onto a wagon with an African driver pulled by six oxen. It was almost twenty kilometres from the neighbouring farm, where they had been staying, to the river that divided the two properties. Anne's father and the farm workers piled stones across the river to allow the ox cart to cross; Anne still remembers the noise as the wheels ground over the stones. The family's ancient Ford had to be left near the bank.

For the first few months, everyone had to camp out. The only building was a small grass hut to protect the farm machinery. The family slept on stretchers under trees with mosquito nets strung between. 'My mother used to line up the deckchairs at night and put them on the ends of our beds with all the bits sticking out, so that, she said to me, "If any lion comes it will get a poke in the eye." I think my parents were extraordinarily brave, but we remembered it as the most marvellous fun and adventure. They read aloud to us at night as we sat around a campfire.'

There was much work to be done. In preparation for their first crop, the land had to be cleared and ploughed before the rainy season began. Anne and her brother enjoyed helping the African workers make mud bricks to build a homestead, and they explored the property, building their own little campsites and having adventures that few parents could now contemplate for their children. The only rule was that they had to leave a note for their mother saying where they had gone.

Anne and her brother were tutored by their rather severe maternal grandmother, who had been a school principal. Correspondence lessons arrived in big yellow envelopes once a fortnight. A hut was built for their paternal grandmother, who also came to stay. 'She was round and short and cuddly and a wonderful, extra-loving person to have about,' Anne says. The children felt secure and nurtured by close family. But this idyllic time on the farm came to an end far too soon. Their grandmother couldn't oversee their secondary schooling, so at the age of twelve Anne was sent to the capital, Salisbury (Harare), to attend school.

For the next year or so, Anne was a day girl at the Girls' High School Salisbury and stayed with family friends. Then she boarded at the school until she was eighteen, forced to overcome intense homesickness along the way. Being so far from Europe, the war had little direct impact on her. Most in Southern Rhodesia were confident that no one would bother to bomb the middle of Africa. Without television, there wasn't the constant reminder of the death and suffering on the other side of the world. When Anne went home to the farm for the holidays, there wasn't

even a telephone. Even so, Anne recalls witnessing the grief of a woman whose fiancé had been killed, and her French teacher weeping the day that Paris fell.

Anne had hoped to study art, but her family was adamant that she concentrate on mathematics, Latin and French. Her parents wanted her to apply to Oxford, so a good score in Latin was essential. However, she hated Latin and refused to spend the necessary extra year at school to improve her skills. Instead, she persuaded her family to let her go to London to study music. She had a good singing voice and was accepted into the Guildhall School of Music in 1948, at nineteen, to be educated in singing, music theory and the history of music.

Students were expected to work hard at Guildhall but Anne found it was less rigorous than a university degree. She now sometimes regrets her choice. However, she has never regretted the three years spent living with a friend in London pursuing her passions: music, art and literature. The two young women took advantage of all that London had to offer, which was a great deal, despite the extensive damage from the war, their spartan accommodation and their limited finances. 'We'd both grown up in wartime in a remote country. I only ever saw one film in all the time I was at school: *Henry V.* There was a lot to learn, and there were museums and art galleries and so on there. So, in a rather naive way, but perfectly sensible, really, two young women set about seeing and learning everything that was on. We didn't end up with a degree but we did learn an awful lot, which has stood me in good stead for the rest of my life.'

It was in London that Anne met her husband, Charles Fisher, at the Red Cross Ball. It was held at Harrow School, where Charles taught. His mother chaired the Red Cross fundraising committee; his father was Bishop of London, soon to become the Archbishop of Canterbury. Anne thinks her parents would have preferred her to have married the boy next door and settled nearby, but instead she married a poverty-stricken English schoolmaster. 'One would think he might be well paid at Harrow, but people were not well paid. Charles had been a soldier from

the age of eighteen to twenty-four, away at the war. He was the third of six boys. His mother said she'd gone on trying for a daughter and after six gave up in despair.'

All six Fisher boys had fought in the war and, remarkably, all had survived. Charles never forgot, however, that he was one of only two survivors of his whole sixth form at school. Anne thinks that was what made him such a compassionate teacher.

Anne and Charles were married early in 1952, and their first child was born in February 1953. Anne was still breastfeeding in June that year and was thus unable to use her seat at the coronation of Queen Elizabeth II, where her father-in-law placed the crown on the new Queen's head. There was, in some circles, prestige attached to being the daughter-in-law of the Archbishop of Canterbury, but there were no associated riches.

Charles taught at Harrow until 1955, when he took a job at the newly established Peterhouse Boys' School and moved the family to Southern Rhodesia for about five years. Around 1960 he was invited to be head-master of Michaelhouse, a boarding school in South Africa, but decided that he couldn't live under apartheid. Anne and Charles returned to England with their five children, unemployed and in need of lodgings. Anne says, with some understatement, that it was 'a fairly tough time in our lives'.

After securing temporary work in England, Charles responded to an advertisement from Scotch College in Adelaide and was appointed headmaster. The Fisher family once more packed up their belongings in 1962 to travel far from family and friends. 'Emigrating to Australia was tough, but my life experience had shown me that I could survive, and it was very important to the happiness of the whole family. My major concern was that my husband was happy. He passionately wanted to be a headmaster. So, to fulfil that dream, we came out to Australia.

'I've always been lucky in making friends easily, and I've made and kept a lot of wonderful friends in Australia. But emigrating is difficult because you've got to dig your children up like small carrots and replant

them, and they don't always plant easily. Helping them to settle into new schools, to find a new place, to make some new friends, takes quite a toll, and we had to do that several times. But we were lucky; we could speak the language. People who come unable to even read the road signs have a real stress. We were also very lucky we came to a ready-made community, which was open-armed about welcoming and helping us, and we found ourselves swept up not only by kind, interesting people, but by an exceedingly busy life. You simply don't have time to sit around wondering whether you're homesick. You've got to get on with it.'

When the Fishers arrived in Adelaide, they had two daughters and three sons. Charles said to Anne, 'Why don't we have just one more, to make ourselves feel at home?' Their fourth son had the desired effect and both parents loved having a baby in the house again.

The family spent eight years in Adelaide, where Charles's job was to revive the school's reputation after it had been used as an army hostel and the previous headmaster had died of a heart attack. Anne used her dressmaking skills, previously employed in making her own and her children's clothes, to make costumes for school plays. She saw this as part of her role as a headmaster's wife, but notes that life is different now for women, who can cultivate a career of their own.

Anne also indulged in her love of art with her children. She recalls drawing with or for them on many occasions, and she illustrated her diaries and stories about her childhood to share with them. This was a custom that would eventually extend to her grandchildren.

The children had to be uprooted again when Charles was appointed headmaster of the Church of England Grammar School in Brisbane in 1970. Anne went reluctantly. The city had startling houses on stilts and was a long way from Adelaide and her friends. 'I can remember saying to myself, *Well, these are very nice people and it's not their fault that they don't live in Adelaide.* I was the person who had to change. And I did end up with a lot of very good Queensland friends and got to like Queensland very much. When, four years later, we moved from Queensland down to

Victoria, I was just as tiresome and shed tears and groaned and moaned about moving house again!'

In 1974, Charles became headmaster of Geelong Grammar. This time the children were older and reluctant to move. It fell to Anne to deal with their unhappiness.

In Geelong, Anne continued her practice of working hard to fit in, adapting and attending to her husband and children. They all became Australian citizens. Although the move took its toll on her family, Anne says that all her children 'survived and turned into perfectly good adults'.

After the older children left home, Anne felt ready to focus on her own future. In her mid-forties, she enrolled at Deakin University and completed a Bachelor of Education. She studied art as a component of her degree. Her main reason for seeking a teaching qualification was that she was nearly ten years younger than Charles and planned to continue earning an income after he retired.

It didn't work out as Anne had planned. Charles died in a car accident in December 1978 on the way to Timbertop, Geelong Grammar's alpine campus. Charles was fifty-seven and Anne forty-eight.

Anne and Charles's second daughter was due to be married ten days later. As if preparing for a wedding and a funeral wasn't enough, the school needed Anne's house for the new headmaster. The family had six weeks to vacate. Anne and those of the children still living at home had to pack up amid their grief. Luckily, Anne had just found a job teaching art. Anne credits this job with helping her to survive the year after Charles's death.

By 1980, the children had dispersed around the world. Anne didn't want to stay alone in Geelong but couldn't seem to find work elsewhere. She was still looking for a teaching position when she received an offer out of the blue: to become Principal Private Secretary to the wife of the Governor-General. She would be employed by the protocol section of the Department of Prime Minister and Cabinet.

While they were in Queensland, the Fishers had become friends with Zelman Cowan, then Vice-Chancellor of Brisbane University, and

his wife, Anna. He had since been knighted and made the nineteenth Governor-General of Australia. Lady Cowan had to travel without her husband to give speeches all over Australia, and it was thought that she would benefit from having a companion to help her through what were often trying circumstances. They invited Anne to come to Canberra and take on that responsibility. 'I decided, *Yes, why not?* The children were all off doing other things and it wasn't a bad idea to go and do something quite different and new for myself. It was also quite stressful, because I hadn't lived on my own since my student days. I had to find a flat in Canberra and settle myself into a new job which I didn't really know how to do. But the Cowans were enormously kind to me, and helpful, and gradually I got more used to it, and better. You survive after the loss of a partner, and you discover that, whether you like it or not, you're going to have to go on.'

Anne was responsible for arranging and facilitating all the meetings, travel, charitable engagements and other activities of the Governor-General's wife. She found the work hectic but invigorating. 'People were always anxious to help and to show you round, so we did everything, from climbing down the walls of big dams in Tasmania to going to an abattoir in Far North of Western Australia.' There were great treats, too, including accompanying the Cowans to the opera in Canberra and Sydney. The job was much more than standing a few paces behind the Governor-General's wife.

Towards the end of her three years with Lady Cowan, Anne became reacquainted with Dr Basil Hetzel. The Fishers had known the Hetzels in Adelaide. Basil's wife had died of cancer in 1980, and the widow and the widower soon found they had more in common than their sadness, including a determination to enjoy their lives. They married in 1983. Basil had five adult children to add to Anne's six. He was a medical researcher who had made a major contribution to combating iodine deficiency all over the world. Lack of iodine has devastating consequences, causing congenital hypothyroidism (once called cretinism) in children and goitre in adults. Iodised salt is the simple solution. When they married, Basil

was about to embark on a series of extended international research trips to improve iodine supplementation around the world. The couple decided that, as they shared no children and no history, it was important to share this experience, rather than Anne staying behind in Adelaide to teach. Anne feels it was the best decision they made, despite the financial implications. Travel enriched their relationship and introduced Anne to friends around the world. It also enabled her to indulge her lifelong passion not only for writing but also for drawing, and to become the artist that she had always wanted to be.

Everywhere they went, Anne took a small sketchbook and black fineliners. She drew and wrote about the people and places she saw, aware that accompanying Basil and his medical team was an extraordinary opportunity. She went to remote parts of southern China usually closed to tourists and saw magnificent scenery and the ornate costumes of the Miao people. She witnessed the many contrasting lives in India. Anne's warm humanity extended to people everywhere. 'I was struck by the very common human attributes that we all shared; that families in Indonesia and families in China and families in India were all just the same as families in Australia,' she says. 'They all minded about and needed the same things. There are marvellous people all over the world who cope with huge problems with courage and humour and strength. It was that, as much as anything, that I found so impressive.' These sketchbooks eventually became a book, *A Traveller's Needle* (2001).

Travel also gave Anne the opportunity to get to know textiles. She was captivated by their colours, shapes, textures. Although she had followed her mother's example in making garments for her family, that was, as she said, 'just clothing'. In countries such as Indonesia, Thailand and India, Anne was exposed to traditions of weaving, embroidery and textile art of every kind. She was enchanted by the superb woven patterns and ceremonial elements of their creation.

Back in Australia, Anne joined the Embroiderers' Guild in Adelaide and, inspired by a fabulous monastery and temple she had seen in the

remote Qinghai province of China, she 'drew like one fevered' and started embroidering figures of monks in that exotic setting. She took examples of her work to a gallery to see if they would display them. The gallery heartily urged her to provide them with twenty items, enough for an exhibition. By then she had completed only two pieces in this series, but she committed herself to the task. A few months later, she sold every single piece in an exhibition. She was amazed.

This was the first of many exhibitions of textile art based on drawings from Anne's travels. In her sixties, she began to receive commissions from people and organisations for her illustrations, embroidery, fabric collages and other textile work. She enjoyed making retirement gifts, which generally involved learning about people's lives so that she could draw something appropriate. She was also commissioned to make a large wall hanging for the Adelaide Naval and Military Club to mark fifty years since the end of the Second World War. Anne found that task fascinating and educational. Because she was in Africa during the Second World War, she wasn't familiar with events such as the Battle of Balikpapan and the Kokoda Track Campaign and read about them avidly in the club's library.

Two particularly challenging commissions involved making copes, one for the Geelong Grammar chapel and another for a new Anglican Archbishop of Adelaide. Copes are ceremonial church garments, huge semi-circular capes that fall from the wearer's shoulder to the ground, requiring a lot of fabric and decoration. For the Geelong Grammar cope, Anne embroidered four female and four male saints to acknowledge that the school had become coeducational. What is now called The Adelaide Cope was even more ambitious, and not only because the man who would wear it was around 185 centimetres tall. 'The cope that I made for him had images of all the churches that he had been involved in from the time he was a boy. I went around Adelaide and drew about a dozen different churches. Then I set about choosing fabric that might look like trees, or stone, or earthenware. It became an exciting venture, and of

course I had help from others who were intrigued and wanted to be part of such a big project. Each church had to be sewn and stitched on with trees or mountains or shapes of some sort, to give it relevance. It did look magnificent. It was interesting to make something that was worn on official occasions, and it became meaningful in a new sense. That in itself is rather an unexpected pleasure.'

In 2005, Anne was awarded the Order of Australia Medal for her services to arts and crafts, especially through the Embroiderers' Guild.

Anne not only loves working with textiles but is proud of her pieces, despite being aware that this form of art is frequently denigrated by male artists as 'women's work'. 'A lot of the best weaving and the best hand embroidery is done, in India for instance, by men, but most fine hand embroidery or fine sewing is done at home by women all over the world. They are all textile artists. They're not painting on board, that's all. I have this argument with male painting friends who think that artists mainly are men who paint in oils.'

In 1992, Basil became Lieutenant Governor of South Australia, which committed Anne to many community activities. She remained with the Embroiderers' Guild but could not devote as much time to it as she would have liked. She was also a member of the Friends of the State Library in Adelaide and gave public service to other organisations, both in a private capacity and as the Lieutenant Governor's wife. That role extended for eight years, until 1999.

Basil died in February 2017, aged ninety-four, leaving Anne a widow for the second time at eighty-six. Basil had been increasingly frail for some time, so both he and Anne were living in supported accommodation. Anne continued with her drawing, painting and embroidery, making up for the time consumed by the needs of her husband and children.

Art has remained an absorbing interest and a huge source of pleasure for Anne. She wrote and illustrated a delightful book for her grandchildren describing the family's move to the farm and their first year there. The book is named for the farm, 'Chidikamwedzi', which means, in the

Shona language, 'The Valley of the Moon'. Anne wanted her family to understand what a beautiful part of the world had shaped her childhood. To her regret, she has recently had to limit her embroidery because of the practical difficulties of threading needles, although her grandchildren help her from time to time. She now works more with a pen and brush, painting watercolours, and takes great pleasure in attending weekly art classes.

Anne thinks that women in their senior years can benefit from attending classes and seizing opportunities to learn new skills, be that in art, cooking, literature or anything else that interests them. She embodies the lifelong learner, showing that spirit of resilience that helped the forlorn seven-year-old she once was to make the most of life's opportunities.

I began working with one of Anne's daughters, Jane, in 2000, and have enjoyed meeting Anne over the years on her visits to Melbourne. She has always been warmly interested in her daughter's friends: what they are reading, how their research is progressing, what other endeavours engage them. It's easy to understand how Anne has created not only art but also friendships around the world. She loves to hear other people's stories and has plenty of her own to tell. The tale of Sidney and the leopard is just one unexpected adventure from Anne's rich life.

Me and Uncle Joe
Sally Baker
(b. 1940)

There was a time when Sally Baker thought that Joseph Stalin lived with her family. She was brought up in a house on a hill in South London with her parents, Mabel and Ronald; her younger sister, Tina; and her Uncle Joseph. Uncle Joe was an honorary uncle. This used to be a common status; among my parents' friends were people we children called Auntie June and Uncle Max, Auntie Loris and Uncle Norm, and Auntie Val and Uncle Alec. Sally's attempts to classify all her aunts and uncles would have been replicated in many households at the time. 'I asked my mum, "Is Auntie Marjorie just a friend?" "No, she's my sister." "What about Auntie Betty?" "No, she's my friend." I remember sorting out all these uncles and aunties: who were friends, who were relatives? Uncle Joe used to confuse me because Joseph Stalin was also called Uncle Joe. So I grew up not being sure whether my Uncle Joe was Uncle Joe or this Joseph Stalin.'

Uncle Joe was, in fact, far from the Russian dictator in every way imagin-
able. An anti-fascist fighter from the Spanish Civil War exiled from his
country, he arrived in England in 1939, profoundly traumatised after a
hazardous journey across the Pyrenees. At first he spoke no English. Sally's
parents, who were members of a communist network, gave him a home.

Almost all the women in this book were born before or during the
Second World War. The older women lived in families affected by the
First World War, often with parents experiencing economic hardship
and what we now know as post-traumatic stress. Sally was born in the
middle of the Battle of Britain and vividly remembers, at the age of four
or five, sitting with her parents and Uncle Joe in an indoor bomb shelter
called a Morrison shelter, with the noise of bombs all around and the
shelter rattling more and more loudly as they got closer. The violence
and insecurity intrinsic to warfare can destroy lives, although children
are often remarkably resilient. That was Sally's experience. She grew up
in the ruins of London, amid daily reminders of bombs and death, yet
faced life with a sense of optimism. This was the iconic spirit of London
during and after the war, conveyed by so many black-and-white films of
the era, often made as propaganda: think *Mrs Miniver* (1942).

Sally's parents were intellectuals, the first in their families to go to
university. They had been students at the London School of Economics,
where they both joined the Communist Party, which was flourishing in
response to the right-wing extremism personified by Mussolini, Franco
and Hitler. Being born into the working class and then exposed to radical
ideas of social equality changed their politics and their expectations,
although their lives were not limited to earnest discussion and activism.
The stories Sally's mother told her were about the fun they had at wonderful
parties with the comrades.

Sally's parents had high expectations for their daughters, including a
good education, and were less than pleased when Sally became engaged
at sixteen. She says she did it just because she could. Her engagement
lasted only a week. A few years later, when she said she wanted to marry

her boyfriend, David, they insisted that she must first gain a qualification. Sally complied, and trained as a primary-school teacher.

After marrying David, Sally taught for a few years and gave birth to a son and then a daughter. By this time, Sally's mother had left her father for a woman lover, a poet. Sally found this confusing and for this and other reasons, including being persuaded by advertisements of warm weather, sandy beaches and plenty of jobs, moved her family to Australia. Today, Sally recognises her mother's strength and profound influence on her life. While Sally was still at home, her mother, then in her forties, went back to university to complete a music degree and teacher training and, in her fifties, embarked on a new career as a music teacher. This example, Sally believes, prepared her to take advantage of any opportunities that came her way.

Sally and David arrived in Australia in 1968, when her son was five and her daughter was three. Sally had a godmother in Perth who had sponsored the family to migrate, and they lived with her for a few months before David found a job in Melbourne. Sally followed him across the country with the children and a cat in the car, feeling very adventurous as a Pommy migrant driving from Perth. At Kalgoorlie she put the car on the train to Port Pirie, where David met them. The family then drove almost 1000 kilometres, through huge open spaces and under an endless sky, all the way to Melbourne.

And here is where I discovered that, during my twelve months spent as a kindergarten teacher in Black Rock, Victoria, in 1969, Sally's daughter had been one of my students. I had a wonderful year, working with interesting children and interested parents. It was a time when so many previously unimagined things seemed possible. One July day, after hours of deferral, the afternoon class and their parents watched the moon landing with me on a borrowed television. The images were grainy and shadowy, but we could see a man in a space suit bouncing on the moon in slow motion. I doubt that the children appreciated its significance, though the parents and I were awe-struck.

The following year, with both children in school, Sally resumed teaching. She began in primary schools, then moved to Child Migrant Education Services. Sally loved her work. When the Education Department began to require teachers to have degrees, she saw it as an opportunity to upgrade her two-year diploma. In 1978, encouraged by the prospect of a free university education (the Whitlam government had abolished university fees in 1974 to make tertiary education widely accessible), Sally enrolled at Monash University in a Bachelor of Arts. She chose mostly late afternoon and evening classes. David would have dinner on the table when she came home, but he couldn't make sense of what she was learning and had no interest in education. 'I can remember reading him assignments that I'd done for the English literature course, which I loved. He'd sit there sort of flummoxed. Then he'd say, "You sound like one of those critics out of the newspaper." I just felt I'd left him behind.'

Sally's was not the only marriage that didn't survive a woman's further education. The couple divorced in 1982.

She met her second husband, Rupert, at a wine and cheese evening at university. Rupert was a research chemist, born and bred in Mildura. Unlike her first husband, he wanted to hear about Sally's ideas and interests, and he borrowed her anthology of Keats' poems to get to know her better through the multitude of notes she had written in the margins.

Their lives together were dominated by work and travel; Rupert had never been past New Zealand. Sally retired in 1996, in her fifties, because it seemed like the right time to initiate something new. They bought a bush block in Victoria's Strzelecki Ranges and began to grow and sell blueberries. They revelled in the beautiful bushland and listened to the lyrebirds while they gathered fruit.

This idyll was disturbed by the familiar dramatic trope of the unexpected telephone call at seven o'clock one morning in September. It was 2004 and Sally was sixty-four. 'My mum said, "Darling, I've got something to tell you." If anybody ever says that to you, make sure you're sitting down. She said, "It's about Joseph." I said, "Did he die?" "Oh," she said. "I have

no idea. We've lost touch." I said, "Well, what is it?" "Well," she said, "He's your father." It was a terrible shock. But it was a wonderful shock.'

Not all react with joy and enthusiasm, as Sally did. I've seen such disclosures become a festering sore that makes life a misery. When adults or teenagers find out that the father they have always known is not their biological father, it can provoke anger and distress – a sense that parents have been concealing an important truth about their identity. The dangerous power of intimate family secrets has long been discussed in the research literature on adoption and sperm donation. I have a chapter on the topic in a book called *Sperm Wars* (2005), presenting the arguments for and against parental secrecy and urging early disclosure.[13] As genetic testing becomes commonplace, it is less and less likely that someone will never find out about their conception through an illicit liaison or clandestine sperm donation.

Many children dream of having more interesting parents than their quotidian mother and father. I admit that I did. My daydreams tended to favour royalty. To be fair, it was during the coronation year of Queen Elizabeth II and I was only four. Sally's childhood fantasies of exotic forbears, unlike mine, came true and enriched the rest of her life.

Uncle Joe was really José-Luis Castillo. In 1945, after five years and a Cambridge University degree, he had left the family and the *ménage-a-trois*, as Mabel later described it to Sally, to marry Teresa from Valencia. Sally, who was close to him, had felt bereft. But the families remained in contact, with the two sisters developing close friendships with the three Castillo children. For twenty years they shared outings, vacations and celebrations. At the age of sixteen, Uncle Joe's eldest son was invited to be Sally's daughter's godfather. But, Sally says, 'All I knew as a child of the history of Uncle Joe and Aunty Terry was that there had been a war in Spain, their side had lost and they would never be able to return.' The relationships faded away after Sally came to Australia. The last time she had spoken to Joe was on a trip to England in 1986. She telephoned his old number and, to her delight, he answered. He was thrilled to hear her

voice. Sally asked if she and Rupert could visit him, but he said he wasn't well and asked her to call another day. Sally was busy on that short trip, visiting friends and old haunts; she meant to call him again but time got away from her. She regrets that missed opportunity.

It took years for Sally to learn about how Joseph became her father, and some serious detective work to uncover all the ramifications of his paternity. It seems that, when José-Luis turned up on Mabel and Ronald's doorstep, it was clear to Ronald that he was depressed. Ronald asked Mabel – a cheerful and optimistic woman, according to Sally – to try to make him happy. 'Whatever it takes,' he had said. Just over nine months later, Sally was the result. The assumptions we tend to make about the sexual reserve of previous generations, especially before the Swinging Sixties, are sometimes shown to be seriously wrong.

Mabel told Sally that after Uncle Joe had visited her in the maternity ward, he went home and wrote in his diary, in Spanish, 'Without a doubt, she is my daughter.' When Sally was christened, Uncle Joe gave her the second name of Nena. It wasn't until she was in her seventies and filling in an official form that Sally registered its significance. 'I remembered asking my mother, "What's that word?" Because it wasn't Nina. It wasn't Nana. It was Nena. N.E.N.A. And she said, "Oh, Joseph gave you that name." Because he was my godfather. What a lot of hypocrites, or turncoats! They'd all been raging communists only three years before, and there they are, fronting up at the Church of England, having me baptised as a good little Christian baby. And it didn't ever click: Joseph gave me the name because he was my father. It means Little Baby, an affectionate Andalusian nickname.'

Why, I asked her, did her mother choose that time to tell her? In fact, why did she tell her at all? Doubts about Sally's paternity had been raised in the past. Sally recalls Tina asking her years before the truth came out, 'Do you ever wonder whether we have the same father?' Tina's insightful question had not shaken Sally's belief that Ronald was her father, and she didn't interrogate her sister about the reasons for her suspicions. And

neither she nor Tina heard from Mabel before she died in 2006, at the age of ninety-two, what had prompted the revelation. Sally treated it as a joke. When people asked why Mabel had left it so late, Sally's favourite reply was, 'Maybe she thought I was old enough to deal with it by the time I was sixty-four.'

Between them, though, Sally and Tina found an explanation that satisfied them. It involved Mabel's new life with the poet. Mabel and the poet had started a weekly poetry-writing group at which each member would read their original work. After Mabel's death, the sisters were going through her papers and found a poem she had written with the memorable line, 'So I have sinned, and shall I be shriven?' Tina decided that members of the poetry group, some of whom were very religious, had encouraged Mabel into Quakerism and then the High Church of England. Along the way she was led to reassess her dalliance with José-Luis as a sin and to believe that confessing to Sally was an essential step on the way to forgiveness. She was tidying up her life as she approached its end.

Whatever the reason, when Uncle Joe became 'my father, José-Luis', Sally saw the possibilities of an entirely different family story. As soon as she was told of Uncle Joe's new status, Sally wanted to visit him. It's easy to imagine her excitement and apprehension. Fortuitously, she had a trip planned to England only three weeks later. As soon as she arrived, she looked up 'Castillo' in the London telephone directory. There was still a Castillo at the same address but the initial was T, not J-L. After nearly twenty years with no communication, Sally rang Teresa, who said delightedly, 'Oh, you must come and see me. I'm moving back to Spain in two days.' Sally can't believe how close she came to losing the thread that led back to Uncle Joe.

It was wonderful to talk to Teresa, but Sally was despondent to discover that Joe had died of a brain tumour in 1996. Sally and the oldest son, Luis, helped Teresa with her packing. At the end of the day, Luis offered to drive Sally to the station in London. Before she got out of the car, Sally couldn't resist blurting out, 'I'm your sister!' She describes Luis's astonished

reaction as very gratifying. Luis restarted the engine and drove Sally to Tina's house in Hastings, ninety minutes away, while they talked. Luis recalled his father saying to him once, his tongue loosened by alcohol, 'You've got a sister somewhere.' José-Luis told him nothing more.

Luis didn't know much about his grandparents, but his younger brother, Pablo, did. He gave Sally their grandmother's name – Dolores García-Negrete – and a location: Dolores had lived in, a city called Jaén in Andalusia. With this information, Sally headed to Google. Nothing could have prepared Sally for what she found there. Dolores, her paternal grandmother, had been an important activist in the anti-fascist movement in Spain. She was captured, found guilty of rebellion, and executed by firing squad.

Sally found a website about Jaén's role in the Spanish Civil War, set up by a local historian, Luis-Miguel Sánchez Tostado. There were stories about the Castillo family and, to Sally's delight, a brief biography of Dolores, along with a beautiful photograph. Dolores was said to have been convent-educated and married to Federico Castillo when she was eighteen. She had given birth to fourteen children; José-Luis was the sixth.

Dolores had been executed aged fifty-three on 1 March 1940. The date was a revelation to Sally. 'The year I was born, in the September! I've sometimes thought about this. Transmigration of souls? She was executed while I was a foetus and I thought, *If I was deeply religious and spiritual, I could tell myself that her soul had transmigrated to me.* But I've never had her courage.'

In 2009, Sally realised that the following year would be the seventieth anniversary of Dolores' death. She, along with her husband, both of Uncle Joe's sons (Luis and Pablo) and Luis's wife, decided to go to Jaén to visit her grave. Sally thought she'd burst with the thrill of it all. She emailed the historian who had written about the Castillo family, Señor Sánchez Tostado. He turned out also to be an author of detective fiction, which did not encourage the Castillo family to welcome his interest. Sally met José-Luis's last living sister, who was in her late eighties. She couldn't

separate Sally from the historian, whom she accused (in indignant Spanish) of trying to make money out of the family, and refused to cooperate.

Nevertheless, Sally and her entourage went with the historian to the cemetery and located Dolores' grave. Sally had envisaged crowds paying their respects to a great heroine, but no one else was there. She was afraid that Dolores's story had been lost to history. It was heartbreaking.

Sally's determination that Dolores be remembered led her to enrol in a Master of Arts in history at Monash University. From the beginning, Sally was thrilled by the idea of Spanish history and culture. She began to have flashes of memories of conversations with Uncle Joe, about how bullfighting and flamenco had originated in Andalusia. She soon realised that, to do her subject justice, not only did she have to progress beyond the familiar stereotypes, but she'd need to learn the language. She enrolled in Spanish classes at the Council for Adult Education in Melbourne and later in further language studies at Monash University. Sally can now read and speak Spanish, although she finds it frustrating trying to keep up with conversation usually conducted at breakneck speed, and she doesn't want to ask people to speak more slowly because it's tedious for them. Sally also joined a flamenco school and for a while took her flamenco shoes and her flamenco skirt, bought in Valencia, to a weekly dance class.

In the several years that it took her to research and write her thesis, Sally returned to Spain to interview people and examine documentary evidence. She loved doing this research. She is justifiably proud of what she has achieved and of her sense of adventure, reflecting on particular moments: 'Getting on the local bus from the regional capital of Jaén to the village of Castillo de Locubín in the olive-growing region to meet a man I had only previously known from his emails and website – as a seventy-something woman with an uncertain grasp of Spanish travelling alone to chase up threads for the story which he held in trust for the family. I wondered how many of my friends back in suburban Melbourne would have done the same. Alone? I must have been mad.'

She submitted her thesis in 2015, when she was seventy-five. It is an evocative account of her own story, the history of her grandmother and the historical context of Spain.[14] It looks particularly at the ways in which Dolores's gender and her elevated social status led not only to her execution but also to her erasure from historical memory.

Today, Sally has found two activities, both by chance, that have continued to keep life interesting. The first is embroidery, made possible by cataract surgery that suddenly brightened the world. She doesn't know what prompted that creative impulse but she loves discovering the 'fascinating women' (they are mostly women) who belong to the Embroiderers' Guild of Victoria, many in their eighties and nineties. Sally finds the process of embroidery conducive to contemplation, almost meditative. She showed me a piece of her art that had been part of an exhibition. It is a beautiful, detailed allegory of time, made of fabric and pieces of an old watch: the product of embroidery, applique, collage and found objects. She has also embroidered a lampshade for her first great-grandchild using figures from *Where the Wild Things Are* and *Possum Magic*.

The second is connected to her Iberian heritage: Sally is learning to play the ukulele. Two friends who were members of a local musical group encouraged her to take it up before the pandemic. The group met online twice weekly over the years of pandemic lockdowns, and Sally found the social contact an invaluable lifeline. Although she can now play the ukulele adeptly and is even composing music for it (having taught herself notation for fretted instruments), Sally is no fan. She describes it as sounding like tunable rubber bands. Her goal is to make her ukulele sound like her favourite instrument, the Spanish guitar, so she is working to develop her skills in finger-picking the melody rather than just strumming chords. But she knows she will never be mistaken for Andrés Segovia.

An unexpected experience can change one's direction. So much of Sally's life has been coloured by Mabel's confession – even the decision to take up the ukulele. At times in our conversation, Sally describes Joe as her 'real father'. In her thesis, she writes, 'To know that he was in fact

my father gave me a glowing sense of joy.' The language is interesting. Does the contribution of genes make someone a father, or is a real father someone who raises you, cares for you? I have found, in my research on donor-assisted conception, no consensus in the answer.[15] A genetic history gives access to a whole new set of ancestors; a caring parent gives access to love and support. Sally seemed to share this dual approach, saying, 'It didn't diminish my attachment to Ronald, who brought me up, and who had died many years before.'

At eighty-one, Sally said she felt no older than sixteen, the age at which she first felt grown-up. She was grateful for the good fortune of robust health. Most of all, though, she was thrilled to have been led on adventures in her later years by her courageous grandmother, Dolores.

A Story to Tell
Annie Young
(b. 1939)

Annie Young was diagnosed with breast cancer on the day that her grandson Nicholas was born. It was Christmas Eve. Annie's first thought was, *I will be here for you. I will be here.* She was jubilant about his birth and terrified by her diagnosis, at only sixty-five. That emotional day revealed Annie as a writer.

When I spoke with her, Annie was eighty-one and Nicholas was in his late teens. Annie radiates health, energy and enthusiasm. She talks with animation, her small features lighting up. She is a physically slight person with a big personality.

For most of her working life Annie was a teacher-librarian, a passionate reader but not a writer. In 1958, at eighteen, with a Trained Primary Teacher's Certificate in hand, she embarked on a career as a classroom teacher at a rural school in Victoria. She lived with her widowed mother and would drive to school each day in her mother's Austin A30.

There were forty-five children in her class, accommodating grades prep, one and two. It was an alarming responsibility at first, but Annie soon settled in and grew to enjoy teaching.

By 1961, Annie yearned for greater excitement than rural Australia could provide. On a whim, at the age of twenty-one, she applied for and gained a job with the British Phosphate Commission. She left the school, and Australia, to teach in Kiribati. The job was on Banaba (Ocean Island), a small coral atoll in the Central Pacific. She arrived on the boat *Triastor* after a journey of several days. Almost everyone on the island would come down to the pier to greet the boat, which brought fresh food, other provisions and mail.

Annie taught at a school for the children of English, Australian and Chinese workers, using the Victorian Education Department curriculum. There were about forty pupils and two teachers. Once more, Annie taught prep and grades one and two; the other teacher taught grades three to six.

Annie describes Banaba as 'totally alien' from the rest of her life, before or since. Single employees each had their own small house and a 'house boy' who cleaned it. Communal meals were provided in the mess. There was no telephone or television on the island; communication home was by letter, with mail and newspapers arriving on the boat every six weeks or so. Annie remembers perfect tropical weather and swimming in warm, clear water every day. The time she spent on the island introduced her to friends who have remained part of her life.

Before Annie returned to Australia, she was thrilled to be taken in a tiny boat to the atoll of Tarawa, capital of Kiribati, where she stayed with friends for two weeks travelling around the thirty-two atolls that, along with Banaba, make up the country of Kiribati. These were the islands Robert Louis Stevenson wrote about in *Treasure Island*, and Annie felt as adventurous as Jim Hawkins.

When Annie returned, she married Rob Young, whom she had known before going away, and they settled in Drouin, a town in the West Gippsland region of Victoria. There Annie taught in a high school – at

Neerim South – as primary teachers could in those days. Inspired by second-wave feminism, Annie was outraged by having to work beside a male teacher straight out of teachers' college who was earning more than she did with her years of experience. She became an activist, taking a day away from school in 1964 to march with other teachers demanding equal pay for women. Parity in pay for women and men was eventually achieved in Australia in 1971. However, it was not until the following year that women were permitted to be principals of primary schools.

Married women were allowed to teach but pregnant women were not. Annie had to resign at twenty-five when there was visible evidence of a pregnancy. Sadly, the pregnancy ended in miscarriage. However, to their delight, Annie and Rob went on to have three girls and then a boy. Their fourth child was conceived as a means of making friends when they moved to Bendigo, in central Victoria. Annie was told by a psychologist that this was an odd reason for adding to her family, although Anne Hetzel recounts a similar experience. In any case, it worked, and Annie is still well embedded in that community. Their son appears not to resent his unorthodox origins. According to Annie, Richard's three older sisters ensured that his feet rarely touched the ground for his first few years.

In Bendigo, when Richard was two and a half, Annie found a job at the resource centre of the School of Education. The woman in charge of the centre, Edith Perry, mentored Annie as they both guided student teachers in their choice and use of reference books, children's literature, class sets and any other aids that they might need to contribute to their teaching. Edith and Annie were experienced teachers who were available to the students long after the lecturers had gone home, sometimes until 7.00pm or later. They loved their work and helped thousands of students. Annie describes working with her mentor as the most wonderful four years of her professional life.

Edith encouraged Annie to go to university. These were the Whitlam years, when tertiary education was free. Like Annie and many other

women, I benefited from the goal of making education accessible to all, undertaking my first degree in my thirties. Unlike Annie, I had no children. It took Annie seven years to complete her degree while working part-time and raising four children, whom she praises for managing their circumstances so well. Annie graduated with a Bachelor of Education (School Librarianship) at the age of forty-five. Her eldest daughter was then at university and enjoying the freedom of living in a hall of residence rather more than her studies. She told Annie how exciting it was to witness her mother's success and that it inspired her to dedicate herself to finishing her degree.

It had always been important to Annie and Rob that their daughters were well qualified and need not be dependent on a man to support them. She valued an independent income for herself and instilled that same attitude into her daughters. Rob also encouraged other women to challenge prescriptive gender roles. He was the Acceptance Officer for the Arts faculty at his university, and each January would interview more women than men, many of them anxious about being mature-age students. Annie describes them as 'Girls who had married young in the country, had their children and then suddenly thought, *I want something more*. Rob used to say to them, "My own wife has gone back and she's managed to do this and you can do it too." He was very encouraging to women, and always very supportive of whatever I wanted to do. I was very lucky, wasn't I?'

One might think that this is what should be expected of a husband; that luck should have nothing to do with it. But Annie saw the attitudes of men who wanted to keep their wives financially dependent. She spoke of a neighbour undertaking tertiary study whose husband would deliberately spatter his egg-and-bacon breakfast all over the assignment she was about to submit. In those days before home computers, her work would have been either hand-written or typed and it would not have been possible to re-do it before the due time. Annie notes with satisfaction that this woman eventually left her husband.

When I was an undergraduate at the University of Melbourne in the late seventies, there was another full-time mature-age student, in her forties, who was achieving very good marks. She invited a few of us to her house for dinner, and I said to her husband how proud he must be of her achievements. This very successful professional man was dismissive, saying that his wife was playing at learning and was only a part-time student. It became clear that he had 'allowed' her to go to university only on condition that it didn't disrupt his life, which meant she continued to complete all household duties to a high standard, serve meals at the usual time, continue with all her existing parenting responsibilities and host his guests to dinner. This remarkable woman did it all, including maintaining a pretence of part-time study. I have often wondered how that relationship fared.

Annie and I both have a few more stories of this kind and I think they are worth telling. We need to remember the past in order to avoid making the same mistakes. We can't afford to stop fighting for gender equality. 'In those early years, when a few of us started to trickle back to teaching, I remember we were in a friendship group that actually fined us,' Annie says. 'The men fined us for going back to work instead of being housewives. They were solicitors, a couple of doctors, professional people in Warrnambool. And one month, when a friend and I were back into teaching, they fined us both because we were working. It was a joke, but it was clear that they didn't approve. Another friend of mine was told if she planned to go back to work, her boyfriend wouldn't marry her. He was a solicitor. Another solicitor, whose wife was a very clever nurse, wouldn't let her go back to work. Eventually she left him and went back into nursing. Bravely, she took her two girls and left. They learnt the hard way in the end. It was so against women in those days.'

When I told my then husband that I had achieved a first-class honour in my first-year philosophy subject, his response was, 'They must have lowered the standard since my day.' I loved my time as an undergraduate: the intellectual stimulation and the friendships. But it took a conscious

effort of will to overcome such undermining of confidence, and I have never forgotten that moment and how deflated I felt. So yes, Annie was lucky.

Annie and Rob attributed his feminism to his upbringing by a strong mother and care from good teachers. She is concerned that there is not enough incentive for young people now to commit to teaching. 'The smart young people from the country in the fifties, sixties and seventies were able to escape their country towns and go to the city because they had scholarships for teaching or for nursing. Rob was one of those kids. He was a miner's son, his mother was a widow and they had no money. He was a brilliant student at Wonthaggi High School and the teachers nurtured him every inch of the way. They got him to Melbourne University; they were wonderful. Those kids went back to the country towns, as I did too, and they became involved with those communities. They were presidents of football clubs, they were involved in everything in the country. They were so valuable. Well, that's gone, that sort of quality. The brightest and the best go into other things now, not necessarily teaching. It's not paid enough to be prestigious.'

While Annie was studying, she worked part-time in a small primary school as a teacher-librarian. After graduation, she was briefly at an eminent private school, then found a place in a Catholic school where she felt that her contribution would be greater, as those students needed her more. She worked at the junior campus for fifteen years and loved running the school library for well over a thousand students, with a staff of six. Annie mourns the apparently inexorable decline of the specialist teacher-librarian and the school library.

Annie retired a month before she turned sixty. Rob had already retired and they both wanted to travel. She spent three years doing things other than teaching, including travelling and voluntary work for an organisation supporting women with breast cancer, the Otis Foundation. This was before Annie's own diagnosis. A friend aged only thirty-six had died of breast cancer and her husband had started the foundation in her memory. Annie and her fellow volunteers raised more than a million dollars to

build accommodation for women needing respite from arduous cancer treatments. The first two houses have been followed by many, all around Australia; there are now twenty-one. Annie was exhausted at the end of three years of almost full-time work for the cause. It was not what everybody would call retirement.

Annie found that she missed the connection with young people she'd had in schools, so just before she turned sixty-four she applied for a position as a school librarian at Bendigo Senior Secondary College. At the end of her first year of full-time work at the college, Annie was diagnosed with breast cancer. Because she was given the news on Christmas Eve, she was told that she couldn't be operated on until January. Annie didn't think she could commit to signing a new contract as a full-time librarian because she had no idea about what the ramifications of her treatment would be, nor her prognosis. She loved the work and the students and agreed to return as a casual worker when she could. The outcome was much better than she had feared: Annie remained a librarian at the school until she retired for a second time, at seventy-two.

It was breast cancer that prompted Annie to take up her next career. Such powerful experiences and their attendant emotions have to be expressed. Some might talk about them, to intimates or to the community or to a diary. Others sing, or paint, or make music, or dance. As a passionate lifelong reader, Annie wrote about them. She came home from hospital and prepared an article for *The Beacon*, the quarterly newsletter of Breast Cancer Network Australia. 'I just sat down at the computer and wrote about how it happened: the phone call, the call back, the various needles they put in to do biopsies, the diagnosis with Rob beside me, the arrangements for the operation. I still tear up over it. I didn't even know I could write. I hadn't had time to write with four children and a busy household, so that was the first time.'

Annie wrote more articles for *The Beacon* and then started sending articles to *The Age*, which published her contributions. She also became an ardent letter-writer to local, state and national papers. Finally, after

a few years of mostly unpaid writing, at the age of seventy-two Annie was invited to contribute a weekly column to *The Bendigo Advertiser*. Over nearly five years, the Addy, as it's known locally, published 204 of Annie's columns. Annie wrote engaging, often chatty pieces about topics that interested her: the pleasures of shopping, the value of book clubs, marriage equality, women in leadership, immigration, ageing, asylum seekers, her fiftieth wedding anniversary, the scourge of loud music in restaurants, dying with dignity and the importance of screening for breast cancer. Her column was called 'Young at Heart' and her columns were later collected into a book of the same name.

Although she could study in a lively, noisy household, Annie came to realise that she needed peace and quiet to be able to write, just as Virginia Woolf had asserted in her treatise *A Room of One's Own*. One of Annie's columns urged older people to move to smaller and possibly supported accommodation while they could manage the transition themselves, without needing others to organise it for them. She and Rob did that in 2014 while she was writing for the Addy, and they looked forward to more adventures over the next decade or so.

Sadly, their adventures were cut short when Rob was diagnosed with pancreatic cancer. He was eighty-one. It took him five months to die, and Annie nursed him at home, assisted by an excellent palliative care team and the support of their children. She found him to be an undemanding patient who soothed his suffering by immersing himself in books. He read about Icelandic murders and mayhem: 'escapist stuff, nothing deep'. Rob's death provoked another writing binge. Annie's work was featured in a double-page spread in the Addy and she kept a diary about Rob's dying that she revised after his death and sent to her children. Annie initially raged at the injustice of terminal cancer; Rob was more philosophical. She recalls him saying to his oncologist, 'I've had a wonderful career. I've had a wonderful marriage. I've got four terrific children and ten beautiful grandchildren. What more do I need?' Annie now agrees. 'I've been so lucky. All of us have challenges along the way. Breast cancer was a bit of

a shock. Rob's illness probably qualified as a challenge. We're not trained to deal with death very well, but Rob taught me a lot about that because he was so gracious.'

When I asked Annie how she had become so strong and determined, she said that her mother was her role model, despite her thoughtlessness in giving birth to her on New Year's Eve. 'I've always been rather cross that my mother just couldn't hang on until after midnight and I could say I was a 1940s child.' Her mother's life was marked by tragedy. Her father died when she was a child, leaving no money behind and his widow with four young children. Annie's mother was sent to New Zealand to live with extended family for two years. She felt bereft. Later, more grief followed. 'My older brother was run over and killed when he was four, and in those days that was rare. Then Dad went to the war, and he died young, seven years after the war. I was twelve when he died of lung cancer; soldiers were given cigarettes in their rations. I remember my mother walking in after Dad's funeral and saying, "Well, we're all going to have to change. I'm going back to work full-time." In those days mothers didn't work. All the mothers were in the school mothers' group, but my mother worked. She was an amazingly stoic woman.' Despite all the loss and hardship in her life, Annie's mother ensured that Annie and her two surviving brothers lived in a house full of fun, laughter and music. Annie's mother died when Annie was pregnant with her fourth child, and Annie drew on her mother's example in dealing with grief and hardship. 'Hard times, you just get through and you just do it,' she says. Her children have commented on this extraordinary self-control.

Annie has a long history of voluntary work, including as a board member of the local Centre Against Sexual Assault; as president of Zonta, an international organisation working for women's rights; and as an usher at the local community cinema for several years. She was active in the Women's Electoral Lobby during its years of greatest prominence. She belongs to two book clubs and a choir. Annie enjoys life at her retirement village but has directed her activism towards the men who run it. 'Here

we are still fighting for equality, still trying to get men to acknowledge the importance of women in any organisation. I was watching a group of black-suited men walking around the village recently. They're writing their information down, looking at the various houses. Not one woman. I went home and checked out their website. The board consisted of two men. The team of management consisted of six men and one woman, who probably did the secretarial work. So I wrote a letter to them and I said that corporations are required to have women on their board. In this village there are ninety couples; ninety single women, all widowed or single; and thirteen single men. So there are 180 women and 103 men and yet we have no representation on their team of management. How can they possibly represent their clientele? They said that this is a private company; they can do what they like. This group of men reminded me of the old days in the fifties when football clubs didn't allow women to go into the changing rooms or the social rooms. They're country men and maybe that's something to do with it. They aren't in touch with what I presume is happening in the city, where men are starting to realise they need women on their boards. They really do.'

As well as making life uncomfortable for the men on the board of her retirement village, Annie contributes to enriching the lives of the residents. She has developed a ten-week program called Write My Own Story, in which she leads people to write their life stories for their children and grandchildren. She runs groups of about twelve at a time, and they write for an hour, have a coffee break and then read their work to the group. That has provoked tears and a lot of laughter. As an example, Annie shows them her mother-in-law's exercise book, where she recorded her life in lead pencil. Annie doesn't tell people what to write but has a set of questions to prompt ideas, and she changes the questions as she learns about what works best. Her students love the opportunity to revisit their childhoods and to write stories about their escapades and achievements. These amateur memoirists make new friends and become closer to old friends. They also come to appreciate their own lives as interesting and

to see that others are interested in them. Annie is an enabler of others' wellbeing.

Annie now sees her world as 'quite small'. Her water aerobics, her book clubs, her teaching and her regular social engagements add up to a pleasantly busy existence. She remains intellectually active and politically aware. She attends plays, the opera and the ballet. She runs a discussion group in the retirement village where about fifteen members meet weekly to discuss current affairs and other topics that interest them. Her hope for the future is 'keeping as well as I can and dying quickly'. She has learnt from Rob not to be afraid of death.

Annie's enthusiasm, her determination to make the most of every day and her strong engagement with her community all contribute to keeping her life full and fulfilling. She has had many role models, mentors and loving relationships. She is now generous in encouraging others. 'I looked around at Happy Hour one night and I saw these marvellous people. They're at the end of their lives. To them, they're old. They hobble around, some of them. Some are fitter than others. Some have had diagnoses and all of this stuff; they're carrying all sorts of things. And I just think they've all got a wonderful story to tell, because if you get to that age, it's been an amazing life.'

Coming Into Her Own
Jacqueline Dwyer
(1925–2020)

There are two events that symbolise Jacqueline Dwyer's path through life: winning a cooking competition when she was fifty-four and becoming a Master of Philosophy when she was ninety. The foundation of both her domestic skills and her academic achievements was her French heritage.

A story in *The Australian Women's Weekly* on 28 May 1980 sets the scene: 'No wonder Mrs Jacqueline Dwyer, of Sydney, won the title of best cook in New South Wales. Her father was a French wool-buyer and she spent her youth tripping back and forth on French ships between France and Australia sampling the best of French cuisine.' Her capacity to achieve, especially in older age, was fostered by a lively interest in the world, a desire to do the best for people she loved, and support from her family and organisations.

I wish I had met Jacqueline, but she died before this book was conceived. Instead, I have glimpses of her from her writing and several

laudatory obituaries, as well as from her eldest child, her first grandchild and a friend she made in her eighties. When I spoke to these three people, all conveyed a consistent picture of Jacqueline: she was warm and gregarious; she was a good friend but not sentimental; she was intellectually curious and passionate about the arts; she was persistent and she was remarkable.

In the 1870s, the beginning of the period when Australia was said to ride on the sheep's back, Jacqueline's maternal grandfather came from France to the colonies to buy wool. In the early 1890s, her paternal grandfather, Georges Playoust, settled in Sydney, also to buy wool to export to France. He was the founding president of the French–Australian Chamber of Commerce.

Jacqueline's parents were Jacques and Evelyne Playoust, both born in France. Jacques had already spent years in Australia when he brought his wife to live in Mosman, New South Wales, in 1919. They retained their strong French connections, with the extended family distributed across both countries. Jacqueline's frequent trips to France ensured that she understood the importance of its culture and history in the lives of its people. She revelled in being a citizen of two nations, although her strongest links were in Sydney, where she was born and lived most of her life. She identified most strongly as Australian, albeit French–Australian.

Counterbalancing the French influence in Jacqueline's life was the Playoust family's cook, Minnie, with whom Jacqueline had a close relationship. Minnie was from Nimmitabel, a small country town in the Monaro region of New South Wales. She joined the household when Jacqueline was an infant and immediately declared that her employment would be short because she didn't like foreigners. She ending up staying with the family until she died in the 1960s. Learning about Minnie's life showed Jacqueline the complexity of culture and experience and how they influence our attitudes to the world.

Jacqueline completed her schooling with the Loreto nuns in Kirribilli, many of whom were born and raised in Ireland. She could see early on

that the Irish were telling one story and her English–Australian textbooks another. Her family and French history books gave her the French version of history. This awareness of diverse perspectives on history coloured her life, although she took full advantage of it only in her late sixties.

Jacqueline's parents wanted her to marry well. Her mother was adamantly against her attending university, but her father prevailed and Jacqueline and her older sister, Annette, graduated from the University of Sydney. Annette became a microbiologist and had a long career as a scientist. Jacqueline was a university student during the Second World War. Her interests were English and History, but she felt compelled to study Social Science out of a sense of responsibility to contribute to Australia's postwar needs. Jacqueline soon concluded that she was not mature enough to be a social worker and, after a few years, found a position as a personnel manager of a city retail store.

Jacqueline's father died in 1947, when Jacqueline was twenty-one. Evelynne took her two daughters to France to seek comfort from her extended family. Jacqueline found life in provincial France limiting; her family was scandalised by her city ways. Nevertheless, she and Annette were delighted by Paris, which was emerging brightly from the gloom of war. They were thrilled to attend the launch of Dior's 'New Look' at the brand's glorious premises, 30 Avenue Montaigne, in February 1947. The New Look was feminine and glamorous: the dresses designed by Christian Dior featured a cinched waist and a full skirt. After the austerity of the war, it represented a return to more opulent living. The sisters went to the sunny Riviera for the second Cannes Film Festival, where they sat near the exiled Duke of Windsor (formerly Edward VII, known to his family as David) and his Duchess (Wallis Simpson), overhearing her admonish him, 'Do hurry up, David!' Despite the excitement of Europe, Jacqueline was pleased that her mother decided to settle in Australia with her daughters.

In 1951, Jacqueline married Brian Dwyer, whom she described as 'my best friend'. He was almost literally the boy next door in Mosman.

It was accepted that she would cease work upon marriage. They soon moved to Oxford so Brian could undertake specialist medical training and, in their five years there, the first two of their six children were born.

When the Dwyers returned to Sydney in 1956, Jacqueline devoted her life to supporting her husband and raising their children. Brian worked long hours as a pioneering anaesthetist. Each evening, Jacqueline would feed the children, change her clothes and have dinner prepared to eat with her husband at a time that suited him. She sounds like the kind of wife idealised in the women's magazines of the time and represented in popular television shows such as *Father Knows Best*.

According to her eldest child, Nicholas, Jacqueline ran the household and the finances, subject to her husband's preferences. Doing Brian's books was effectively a part-time job, at least one day a week. She continued to manage every dollar with rigorous thrift until she was admitted to hospital just before she died, when Nicholas took over her financial affairs. 'Mum didn't really think she was dying, but she knew it was all too much for her. We had these shares, and when you have to hand over shares to somebody to manage, they want to know the cost base for capital gains and so on. I said to Mum, "I'm just going to pass these Woolworths shares over, and I can see that you bought them for $6.82, and they're now worth this." And my mother said, "Don't forget, in 1998 there was a share issue which reduced the ..." and so on. This is all from her mind; it was all in there.'

Her six children were taught from infancy that there were immutable social rules of behaviour and etiquette. Nicholas links these prescriptions to Jacqueline's grandparents' peasant origins; perhaps, it occurs to me, peasants who joined the bourgeoisie had to study how to pass. The rules extended from having an informed appreciation of history, literature, music and art to how to arrange the cutlery on a dining table, noting the difference between English and French custom (tines pointing up in England, down in France). It reminds me of the marvellous book *The Rituals of Dinner* (1991) by the anthropologist Margaret Visser, which

demonstrated both the arbitrariness and the great significance of rules about dining. Jacqueline laughed at herself while enforcing those rules.

Minnie was an excellent cook, which might explain why, at her marriage, Jacqueline was not. She bought a cookbook in France (French cuisine being the ideal at the time) and taught herself. Nicholas says she entered the *Women's Weekly* competition because she was looking for something to do and the children urged her to do that.

The *Women's Weekly* described her three-course meal: 'As an entrée, Jacqueline Dwyer chose Fresh Artichoke Bottoms stuffed with Tarama Mousse. If artichokes are out of season, she suggests substituting large mushrooms. For main course she crumbed a baby leg of lamb and served it with Spinach Puree and a fluffy baked potato cake. This was followed by the Strawberry and Toffee Choux.'

The *Weekly* was particularly interested in how she filled her choux pastry without leaving an obvious incision and learned that Jacqueline used one of her husband's syringes, an innovation that is now commonplace in television cooking shows.

The prize for her New South Wales win was a set of Wedgwood china. Nicholas recalls it as an occasion for thrift, because it was the year in which he was married. Jacqueline said, 'This will make a wonderful wedding present for Nick and Jane!'

The final round to discover the best cook in Australia involved representatives from the five states. It was held in Centrepoint Tower in Sydney. Nicholas was there, spending his lunch break in the audience. The hot and humid day had defeated the air conditioning, and Jacqueline couldn't persuade the crust to stay on the lamb or her choux pastry to form properly. Jacqueline made several attempts at each, but finally had to concede defeat. She adapted the menu and produced a meal that wasn't up to her usual standard but was good enough to beat Tasmania, if not the other states.

Jacqueline was philosophical about the outcome. Nicholas saw her perseverance and adaptability as typical of the way his mother worked.

'She was a very persistent person. If there was something that needed doing, she would do it. She used to refer to herself as the old French peasant. You had to get up every morning, no matter what the weather was like, and go out and deal with the cows and everything else. She laughed about it. I think that came through from her French grandfather's childhood. He grew up on a farm but left the farm as soon as he could and joined the army, eventually going into industry. I think that was very much part of her. And having six kids, you had to be pretty persistent and dogged.'

Jacqueline was eventually able to pursue her love of history when her youngest child left home. By then she was in her fifties. She had acquired some of her father's artefacts when her mother died: the watch he wore in the trenches during the war, his Croix de Guerre medal and, most intriguingly, his war diary. She began to investigate her family history. Then, in 1983, Annette gave Jacqueline a bundle of letters written by their father during the war, detailing not only his horrific experiences but also aspects of his life that she had not known about. This was the impetus for her first book, *Flanders in Australia: A Personal History of Wool and War* (1998).

The book is a lively account of Australia's relations with France between 1880 and 1960, driven by the wool trade, as seen through the lens of the Playoust family. It is especially poignant in its portrait of Jacqueline's father, Jacques, who in 1914 was conscripted from Australia into the French army, where he fought in the trenches in Northern France before being transferred to the Australian Army as an interpreter. He survived not only warfare but typhoid and even a shipwreck. (I was amazed to read that he shared a lifeboat with my second husband's great-uncle, Norman Brookes, a well-known tennis player.) On his return to Australia, newly married, he and his brother established a wool-buying company near Circular Quay.

In her introduction to the book, Jacqueline thanked not only her husband but also her children, describing them as 'slightly surprised' by her endeavours and 'behind me from the beginning'. 'They bullied me

into buying a computer,' she wrote, 'and helped me work its magic; kind neighbours gave me further tutoring.' It wasn't easy for Jacqueline to become computer literate, but she persevered. She learnt to use library resources online, which gave her great satisfaction; she would telephone her children to talk about every new discovery. For the first five years, everything she wrote was in a single Word document, amounting to tens of thousands of words. She dated every entry, which enabled her to locate what she needed, but it was almost unmanageably cumbersome. Most of us are so familiar with computers that it's hard to conceive of someone not knowing about separate Word documents, but why should Jacqueline have worked that out? She added this new information to her notebook of handwritten instructions, which began with how to turn on the computer and how to open a document. Nicholas recalls that she found great pleasure in overcoming technical hurdles and in the new knowledge revealed each time.

After the book was published, Jacqueline delayed her plans to continue her historical research to care loyally for her husband. Brian began to show signs of depression when Jacqueline was in her sixties. His children recognised it as a symptom of dementia, but Jacqueline saw only the sadness and devoted herself to keeping him engaged with life and as happy as possible. She redirected her research skills to helping him write a book about the history of anaesthesia and pain management in Australia and the United Kingdom, a field in which Brian had been a notable innovator. *A Career in Anaesthesia* was privately published in 2002 and deposited in the National Library of Australia. Nicholas thinks the work on the book helped his father without changing the course of his illness. Jacqueline looked after Brian for six or seven years: an onerous responsibility. She applied to Brian's care the same doggedness and persistence that she brought to every other challenge in her life, until he died in 2006.

Brian's death, sad though it was, freed Jacqueline to devote more time to researching her family history. She was also determined to ensure that

her children knew the family stories, believing that the past has much to teach us about the present.

As she began to publish articles about her research, in both English and French, Anne came to be taken seriously as a historian. She began to be invited to write chapters in books and to speak at conferences, which, Nicholas said, meant a lot to her.

Postgraduate students discovered her book and some contacted Jacqueline to learn about her firsthand experience of French history in Australia. Among them was Margaret Barrett. Margaret joined Jacqueline's circle of scholarly friends in about 2009, when Professor Ken Inglis recommended Jacqueline's book to her. Inglis was an important Australian historian, especially of the First World War, and it was a mark of Jacqueline's skill that he accepted the work of this amateur historian as a significant contribution to knowledge. Margaret showed me her copy of the book, bristling with sticky notes and bookmarks, as an indication of how useful it had been in research for her master's degree on the Free French in Australia. The Playoust family was in Australia for the duration of the Second World War, where Jacqueline witnessed the bitter enmity within the small local French community between supporters of Philippe Pétain, the head of the collaborationist Vichy France, and of Charles de Gaulle, who led the Free France government-in-exile against Nazi Germany.

Margaret and Jacqueline exchanged emails about Margaret's research. Jacqueline enlivened hers with accounts of her childhood, including the suspicion surrounding 'foreigners' with obvious political interests. This story, apparently among Jacqueline's favourites, gives me particular delight: 'Did I tell you that our telephone was tapped and on one occasion when my mother was talking to a friend in French a voice broke in saying, "Would you please speak in English"?'

Jacqueline told Margaret that she had an unusual archive: a notebook in which her mother had detailed every dinner party, complete with menu and guests, saying that her 'excellent Australian cook' had made it easy for

her to entertain so well. Jacqueline wrote to Margaret that on 25 March 1939, for example, the French official who came to dinner was given 'Melon; Poisson Sauce Normande; Poulets Rotis; Salade; and Minnie's sublime Coffee Ice Cream made on a churn ... I would have had to spend a while turning it.' Jacqueline added, 'There would also have been Tuiles made with the leftover egg whites. This is one more course than usual so we can assume it was more formal than just dinner with friends.'

The nation of France also recognised Jacqueline's contributions to French history in 2014 when, at the age of eighty-five, she was made a Knight of the French National Order of Merit (Chevalier de l'Ordre du Mérite). In a charming and affectionate speech at her award ceremony, the French Consul-General proclaimed Jacqueline 'a living treasury of France in Australia'. 'There is no other personality in Sydney who represents as well as Jacqueline the depth and the strength of the bonds between Australia and France since the nineteenth century,' he said.[16]

Jacqueline's family had always been close to French Consuls-General. Nicholas joked that 'the poor old French consul had been supervised by the family since the 1890s'. Jacqueline continued that tradition. She became not only an important historian but also the oldest French person in Australia. She was introduced to Présidents Hollande and Macron on their visits here and gave Macron a copy of her book.

Inspired by the postgraduate students she had come to know, Jacqueline decided to enrol at the Australian National University to undertake the degree of Master of Philosophy. Her goal was to expand her research and revise her book with a more sophisticated historical analysis. She was initially dismissed by ANU staff as being too old, which she countered with 'Don't be silly'. The next hurdle was to provide evidence of her results from her first degree. Nicholas recounted her war of attrition with ANU: 'She described to me, in her usual matter-of-fact style, how she fought her battles in Canberra. Having packed her little blue pull-along suitcase (the one with the ribbons) she would drive up to the taxi rank at Mosman Junction, which she recognised as being about as far as she could safely

drive. She would park and then take a cab to Central Railway Station. There she would board the bus to Canberra, taking a seat immediately behind the driver. Arriving in Canberra three hours later, she would trundle her bag over to University House and set up her base. From there she skirmished with the ANU's bureaucrats, explaining why she couldn't provide an electronic, or even a hardcopy, transcript of her undergraduate degree ("Don't you know there was a war on?").'

Once she was accepted as a candidate, Jacqueline continued to travel to Canberra in this way two or three times each semester, delighting in meeting with academics and fellow students, all considerably younger than herself. She was eighty-five when she began and ninety when she graduated, the ANU's oldest successful higher degree student. The ANU website reports that Jacqueline loved the mental stimulation of university study, quoting her as saying, 'You need it in old age, otherwise you just shrink.'[17]

Giving no sign of intellectual shrinkage, Jacqueline continued to be invited to speak at conferences and to write scholarly articles. One of her presentations was in Melbourne, at a conference of the Australian Society for French Studies. The seminar was led by former French prime minister Lionel Jospin, who said that he was astonished not only to find a ninety-year-old in the group but that she often led the discussion.

Jacqueline was ninety-two when the second edition of her book was published in 2017. It is more than a hundred pages longer than the first edition, with a greatly expanded bibliography, reflecting the increased depth and sophistication of her research.

Jacqueline died at ninety-four. Her academic supervisor, Dr Peter Brown, published a laudatory essay about her scholarship: not something that happens often to postgraduate students. He wrote that among her publications was a contribution to a volume about a French–Australian newspaper, noting her august company: 'In late 2019, the *Courrier Australien Collector Edition* commemorated the history of the paper launched in 1892. Jacqueline Dwyer was one of the Preface writers, fellow

contributors being the Governor-General of Australia, David Hurley, and the French Secretary of State for Europe and Foreign Affairs, Jean-Baptiste Lemoyne.'[18]

Jacqueline's first grandchild, Nicholas's daughter Rosie, feels privileged to have known Jacqueline well and to have had a strong bond with her. She said that all the grandchildren were aware that Jacqueline demanded a high standard of them. I asked Rosie if Jacqueline was intimidating, because all that I'd heard about her intimidated me. 'I don't think I ever found her intimidating, but certainly, when I was younger, we felt that, if you're going to have a conversation, it needed to be a substantial one, not just about something that you might speak to another grandmother about. You wouldn't have a conversation with her about gossip or a celebrity; she would want to speak about some novel that she'd just read or want an in-depth review of the concert that you went to last night. She wasn't a frivolous woman. I think she was maternal and grand-maternal, but she wouldn't lie on a bed reading to you. She would show you a nice piece of art on the wall and discuss that with you. I think that was the difference in the way she showed her love. And yes, I can see that that could be a bit intimidating and a bit different to what others might do.'

In photographs, Jacqueline doesn't look intimidating. She was beautiful as a dark-haired young woman. In her nineties, with abundant white hair, she was still striking. But, as a slender person who was probably the shortest in the room, she seems approachable. Her posture is strong and her face open and intelligent; she looks at the camera with interest in her eyes. Jacqueline in photographs is someone you'd want to talk with at a party.

I'd heard so much about Jacqueline as cerebral and an aesthete, it came as a surprise when Rosie revealed that she swam every morning until well into her eighties. When Rosie and her siblings were children and went to stay with Jacqueline and Brian, their grandparents would wake them early and, before their parents were out of bed, take them to the beach club where they were members for a cold swim and a hot shower.

'My grandmother had a good sense of humour, so she'd always find it very amusing how you could hear the men talking in their showers as you walked down towards the women's change rooms, and that they'd always take twice as long to come out as we would. She and my grandfather swam every morning for most of their lives. She was a reasonably strong swimmer, and she'd walk lots of places, including up and down the hills around Mosman. Towards the end, when she was in her nineties, it was impossible to keep her still, even when she was a bit breathless.'

All of Jacqueline's children have achieved great success in their various fields. Rosie, too, is an extremely impressive young woman in the mould of her grandmother. She is an emergency medicine specialist with experience in helicopter rescue in Australia and the United Kingdom, she has a PhD in emergency care of older people, and she is the mother of two very young children. Rosie says she was inspired by Jacqueline. Her grandmother's tenacity and strength, especially in completing a master's degree at ninety and writing a book, encouraged Rosie to persevere with her PhD.

Jacqueline's family is grateful that she did not have to endure the worst of the pandemic and its restrictions. She had wanted to attend Rosie's wedding in Melbourne in 2020 but was too ill to travel. Jacqueline was shown the photographs a few days later and died that night.

The last words on Jacqueline belong to Rosie. 'She was a really remarkable woman. In another time, she would have been an astronomical success, probably in academia. But I think her passion and her interest is something that stayed with her, in art, music, literature and history. She maintained a strong interest and worldliness, and she continually added to her knowledge. She was always reading, always going to concerts. She never just sat back and was content with where she was. She was always looking for something else to learn or something else to experience. Her driving spirit was her desire to make the most out of her life.'

An Accidental Solicitor

Pauline Lorenzen

(b. 1943)

Pauline Lorenzen left school aged twelve. At seventy-five, she graduated as a Bachelor of Laws from the University of the Sunshine Coast in Queensland. It wasn't until she was halfway through her degree that Pauline realised it would qualify her to register as a solicitor.

How do you accidentally almost become a solicitor? In Pauline's case, because she never wants to stop learning and she just happened to be interested in the legal system. Pauline's most notable quality is rampant energy of the kind that makes you want to lie down with an ice pack on your forehead just thinking about it. So, of course, when she wanted to learn about the law, she did a law degree.

One would not have prophesied a law degree from Pauline's origins. She was the third of six children born to a non-Aboriginal mother and an Aboriginal father. Her family lived in Emerald, a small country town in central Queensland that had been established in 1879 as a base for

the railway line from Rockhampton. The population at the time of her birth was about 1500.

When she was aged only eight, a great tragedy occurred in Pauline's life: her mother died giving birth to a sixth child. The baby was premature, underweight and very unwell. In those days before humidicribs, Pauline recalls him being wrapped in cotton wool and placed in a shoebox. After spending about six months in hospital, the baby was taken to be raised by his maternal grandmother, who lived nearby and ensured that all the brothers and sisters met for birthdays, Christmases and many more ordinary days. He remained their brother.

Pauline has few memories of her mother. She remembers her dancing on the verandah and singing carols the Christmas before she died. She remembers all five children being told to climb into the back of the ambulance to kiss her before she was driven to Rockhampton. She remembers her aunt receiving a telephone call from her father and sitting her and her siblings down to deliver the news. She remembers saying, 'Auntie Glen, I want my daddy to come home and look after us.' And he did. Pauline's father had sole charge of the remaining five children, aged ten, nine, eight, five and three. He took a job shunting engines with the local railway that allowed him to be at home with the children at night. They lived in a railway house.

Rather than the loss of her mother, the defining theme of Pauline's childhood is how exceptional her father was. He took on the maternal and paternal roles. 'He taught us to sew, and to cook, and to be independent, and that there was nothing we couldn't do if we put our mind to it. He didn't allow us to dwell on the bad things. Our father always expected us to do our best. I was encouraged every day to do as much as I could, to fit as much as possible into my day. I'd go off to school in the morning and, when I came home in the afternoon, I'd either be cooking or I'd be sewing clothes for children up the street or making our own clothes. Life was very busy. There was no reason to think that what I was doing was unusual. I just kept doing what I

wanted to do, what I was encouraged to do. And that's how my life has been.'

Emerald's sub-tropical climate was kind to children too poor for shoes, with hot, wet summers and mild, dry winters. Refrigeration involved a meat safe hanging from a tree, covered in wet hessian. It held butter, milk and meat. Washing was done in a large copper boiler over a wood fire, the clothing stirred with a long stick. I asked Pauline if she also had a hand wringer of the type I remembered from my childhood in the late 1940s. It did a good job of removing water and crushing buttons while threatening hands and fingers. No; that was too luxurious for Pauline's family. She didn't acquire a hand wringer until she bought her first (second-hand) washing machine in 1964. Their lavatory was a pan in a shed in the backyard, emptied every few days by the nightman. Before there was toilet paper, bottoms were wiped with squares of newspaper, cut daily from the *Central Queensland News* and hung on a convenient wire. Pauline has no memory of gendered expectations: all the siblings, girls and boys alike, had to participate in every household task, such as chopping wood and washing the dishes. This is in marked contrast to accepted practice at the time, as other women's memories confirm.

The family slept on homemade mattresses. The mattress cover was ticking, a heavy, striped cotton fabric that used to be common as the underlayer in upholstered furniture. Each mattress was stuffed with fibre torn from coconut shells. Leather buttons were stitched with heavy thread through the top and bottom layers every 30 centimetres or so to keep the stuffing in place. Over the course of a year the fibre would become compressed, so an annual ritual, until Pauline was an adult, was restuffing the mattresses. 'You'd choose a lovely, hot, sunny day and take your mattress out into the garden. You'd open it up and pull all the fibre out, then you'd wash it and shake it and put it out in the sun to dry. At the end of the day, you'd stuff it back into the mattress and sew the buttons back on so you had a mattress to sleep on that night.'

Pauline proudly describes her family's commitment to recycling. Sugar came in heavy cloth bags that were later cut up and used for, among other things, mats, protection from wind and rain (whether around the house or on one's head) and to cover the meat safe. Pauline even made her own bloomers from washed, sunbleached flour bags. She wore those bloomers, with elastic at the top and around each leg, until she was about sixteen.

When he was a teenager Pauline's father had built a wireless set, a popular activity for enterprising children in the early part of the twentieth century. He later became an amateur radio enthusiast. Pauline even remembers his call sign: VK4LP. In the 1940s, he began to repair radios as a side business and trained Pauline to do the same. When she finished primary school, Pauline repaired radios as well as working in the local bakery. She thinks fondly of climbing into the old Fords to install radios, long before they came thus equipped from the factory.

Pauline met Doug when he came to work in the Emerald post office. They married in 1962 and moved to Clermont, a small agricultural and coal-mining town on Gangula Country. It was there that she gave birth to her first child, at nineteen. Pauline's paid employment ceased when she married, not by choice but because of regulations banning married women from the workforce. Pauline didn't consider this unfair at the time and continued doing what she wanted to do: writing letters and diary entries, sewing, painting and drawing, making money where she could. She thought of herself as an artist and had already won awards at local shows for her embroidery, floral art and painting.

'I had three beautiful children very quickly,' she says. 'I had one girl; thirteen months later I had a second girl; and thirteen months later I had a boy. I wanted to continue having a few more children but I didn't get any more. I was lucky that I got those three.'

This exemplifies Pauline. Social convention set up barriers to employment; Pauline found a way around them. Biology reduced the size of the family she had planned; she reframed her disappointment as good fortune.

Pauline finds it hard to identify any impossible barriers she's confronted because her father taught her that there is always a solution. She doesn't sound Pollyanna-ish when she says this. It seems genuinely to represent her view of the world.

Doug's salary was 32 pounds a fortnight, about the basic wage. Pauline earned extra money by making and selling children's clothing: shorts, shirts and dresses were two shillings and sixpence (25 cents) each. She also volunteered in the church and, as her children grew older, at their school, and took courses in art and floral art. The family moved for Doug's work, first to Pomona on the Sunshine Coast, then Yungaburra on the Atherton Tablelands in North Queensland. There, when their income increased, Pauline became an entrepreneur, buying a drapery shop and a menswear shop.

Not long after, Pauline heard that a restaurant on Lake Barrine, near Yungaburra, had burnt down. She decided to lease the business, rebuild and run the place. After all, she'd always loved cooking. Others might decide to be a cook in someone else's business, but Pauline seems so often to skip the intermediate steps to her goals.

Lake Barrine is in the crater of an extinct volcano, fed solely by rainwater. It is a major tourist destination. From 1980 to 1991, Pauline oversaw the restaurant and its eleven staff, did most of the cooking and acted as a tour guide for the many coaches arriving daily from Melbourne, Sydney and Brisbane, 365 days a year. She would cook thousands of scones for Devonshire teas and make about a hundred daily lunches: salads and cold meat. The visitors had to be out of the restaurant within the hour for a cruise on the lake, giving Pauline time to prepare afternoon tea.

Perhaps unsurprisingly, Pauline's unstinting commitment to her work and Doug's commitments elsewhere put pressure on their marriage, and they divorced in 1988. Pauline remained with the Lake Barrine business and lived at the house they had built in Yungaburra. After eleven years at Lake Barrine, Pauline says she 'took a break'. Her idea of a break was somewhat idiosyncratic: she opened several coffee shops.

In 1993, Doug began to woo his way back into Pauline's affections. Their children were, as they'd hoped, happily surprised. Doug accepted a posting to the Aboriginal community of Pormpuraaw, to manage the bank and the post office. Pormpuraaw used to be known as the Edward River Mission, established by the Anglican Church in 1939. In 1987, the name was changed to reflect a Dreamtime story of a burnt hut, or Pormpur, in the Kuuk Thaayorre language of the Traditional Owners. The population listed in the 1990s consisted of 850 Indigenous and twenty-nine non-Indigenous people. Pauline assumes that she was counted among the twenty-nine because Doug wasn't Indigenous.

Pauline's time in Pormpuraaw changed her understanding of herself and her Aboriginal history. Pauline's father had brought her up to be proud of her Aboriginal identity. He died at only fifty-four, when she was twenty and her first child was eight months old. She describes it as a far greater loss than her mother's death because her father was the wise parent upon whom she depended and who had shaped her life. She already knew that her mother was of English and Scottish stock and that her father had Aboriginal and Danish forbears. Her Danish grandfather was a seafarer who landed in Australia and stayed. His Aboriginal wife, who was born in Queensland at a little town on Barambah Creek, near Gayndah, had a Chinese father. The family thus embodies much of the history of colonial Australia.

In Pormpuraaw, Pauline learnt more about the disruptions caused by colonialist, racist policies and about the rich and complex history of Australia's First Nations peoples. 'My grandmother came from the Wakka Wakka tribe in South Queensland, where a lot of the Stolen Generations were taken from and placed on places like Palm Island in North Queensland. Some of these Bowen people that were relatives from the Wakka Wakka tribe went up to Palm Island and then they intermarried. One of the ladies at Pormpuraaw had married somebody and she'd moved to Pormpuraaw with her husband. They came down from the northern tribes, which were the Wik-Mungkans, and the

southern tribe in Pormpuraaw, with the Thaayorres. So we had a divided community of two tribes: the Wik-Mungkans, the northern tribe, and the southern tribe, the Thaayorres. We also had, I think, six dialects within that northern tribe, and then we had something like twelve dialects within the Thaayorres.'

Pauline and Doug felt welcomed and respected by the community. Pauline was honoured when they were asked to be godparents to some of the babies born during their time in Pormpuraaw. They had originally signed a contract for a year but loved the community so much that they stayed for nearly eight. It is geographically isolated, located right on the Gulf of Carpentaria, beautiful and abundantly lush. The residents lived from the sea, catching fish, prawns and crabs. The simple life reminded Pauline fondly of her childhood.

The Aboriginal Community Council of Pormpuraaw owns and operates a large crocodile farm and a cattle station and runs tourist activities. Entry to the community is regulated by the council. From about 1994 it employed Pauline to be head of their catering and accommodation services. She was in her element, running a guest house and overseeing the feeding and housing of all visitors. Small private planes arrived daily, usually carrying government workers, but sometimes luminaries like the premier of Queensland, the Governor-General of Australia or Steve Irwin, who invited her to watch his adventures with crocodiles. She found him full of infectious energy on and off camera.

When Pauline said that she also had a part-time job on top of her work for the council, I thought she was joking. She was not. Pauline doesn't like to have idle time. Education Queensland employed her as the school's librarian, tuckshop manager and teacher of art and English. Hearing her talk about all her responsibilities and activities left me feeling completely inadequate. She worked long days and slept for four hours a night. 'I'd get up in the morning and tend the guesthouse and make sure everybody was fed for breakfast. Then I might go off to the school and do an hour or two in the library or teach an art class. Then I'd have

to come back and do lunches or catering for the meeting at the council. Then I might have to go to the airport to pick up somebody to bring back to bed them down for the night. My life was very full, but that's how I live my life.'

It's not possible to list all of Pauline's business ventures or her voluntary work. She was involved in the Junior Chamber of Commerce, Rotary, Quota International (a service organisation supporting women, children and hearing-impaired communities) and the Royal Flying Doctor Service (RFDS). The RFDS received $52,000 from Pauline in 1989 after she ran a bake sale and crocodile race in Pormpuraaw. That's a lot of money to come from a small Aboriginal community. In the same year, Pauline was shortlisted for Businesswoman of the Year.

In 2000, Pauline left Pormpuraaw and returned to Yungaburra with the money she had saved over the previous eight years. She topped it up with a substantial loan from the Aboriginal and Torres Strait Islander Commission and built a restaurant and gallery specialising in Aboriginal art. By this time, Pauline had taken up sculpture and was exhibiting her own bronzes. She had won awards from the Cairns Art Society and at the Yungaburra Arts Festival.

In about 2010, Pauline and a friend developed a park in Yungaburra on 12 hectares of land that had been given to the council for that purpose but left languishing for twenty years. The two of them started planting cordyline and bromeliad cuttings from Pauline's garden, doggedly creating a lush landscape. These improvements were funded by raffles and donations. With support from the council, tables, seats and a watering system were eventually added. The project took ten years to complete. Pauline maintained her commitment to it even after she had moved out of the area. She would fly up to the Tablelands via Cairns to do the work.

Pauline sold her last business in 2012 and decided to retire. Predictably, retirement didn't suit her. She couldn't bear spending the whole day in the house. Buying and selling all those businesses, and observing many of the inequities in the legal system through her time in rural and regional

communities, led her to think that she would find knowledge of the law interesting. She rang James Cook University in Cairns and told them she had 'no education at all' but wanted to enrol in a law degree. She went for an interview but heard nothing further.

After a few months of silence from the university, Pauline and Doug decided that they would take a trip around the world. As always, Pauline planned every detail. On the very day that she made the final payment for their accommodation, she received a letter telling her that she had been accepted into the Tertiary Access Course. This is a six-month bridge to university for people who lack the usual academic prerequisites. Pauline was relieved to discover that she could defer enrolling in the course until she returned from her holiday.

In 2013, Pauline began studying the required subjects: Introduction to Academic Skills, Learning Through Technology, Critical Literacy and Text Analysis, and Mathematics A1. Learning Through Technology was about computers, which Pauline confessed she 'didn't know anything about'. Pauline had bought, managed and sold businesses for about thirty-five years, until 2012, without the aid of a computer. I find that astonishing.

On the first day of Learning Through Technology, each student sat in front of a computer. To Pauline, all the instructions seemed to be in a foreign language. 'Push hash?' she whispered to a fellow student, aged about twenty. Then, 'Which one do I push next?'

Pauline was the oldest of a diverse group of students. She thought she found a friend that day, a woman who lived not far from her and was not too much younger. After having lunch together and confiding that neither knew much about computers, they returned to the classroom. When this woman sat back down in front of her computer, she burst into tears, stood up and left. Pauline couldn't understand why she didn't persevere. After a few weeks, computers began to make sense to her.

Pauline's marks were good enough for her to be accepted into Law. Despite her age and lack of formal education, she didn't feel out of place

at university. When Pauline drove onto the campus on her first day as a student, she felt immediately that she belonged there. 'It was just the loveliest feeling.' Partway through her degree, when she moved house, she transferred to the University of the Sunshine Coast, but that feeling remained with her to the end of her studies.

Because Pauline knew nothing about studying a Law degree (or any degree, for that matter), she wasn't strategic in choosing her subjects. In addition to the core subjects, there were electives, and Pauline chose subjects she would enjoy, such as drawing and creative writing. No one advised her to look broadly at the course catalogue or to think about how she might develop a plan for her degree. She now believes that she should have undertaken a double degree in Arts and Law and chosen subjects focused on Aboriginal law and culture. She advises her grandchildren to explore all the options and ask questions before committing to a course of study. At almost eighty, Pauline can use her recent experience as a university student to counsel younger generations. In fact, she was invited back to the Tertiary Access Course twice a year to talk to students and help them overcome their anxiety and fear about undertaking further studies. Her success was an example of what could be achieved.

During her degree, Pauline secured a six-month placement in the community law office in Maroochydore. She worked with a solicitor, assisting with civil law disputes between neighbours and with wage disputes. This position led to further work. The time she enjoyed most was the six months she spent at the Aboriginal and Torres Strait Islander Legal Service in Ipswich, south of Brisbane, with a team of eight solicitors. It took her a three-hour train trip to get there; Pauline left home at 5.00am. She would then go with her instructing solicitor to interview Aboriginal children aged eight to eighteen – predominantly fourteen or younger – who had been in the lock-up overnight. They were charged with offences such as shoplifting, breaking and entering, and stealing cars. They were usually a long way from home.

Pauline has been offered several positions and would love to accept one defending Aboriginal children. She doesn't think her age would be a barrier. However, it would entail being a long way from home and she now feels that she can't leave Doug, who is in very poor health. Pauline has therefore held off from formally registering to practise as a solicitor in Queensland. Her life and the demands on her time have changed dramatically since she first contacted James Cook University.

Pauline's home these days is the town of Beerwah in the Glasshouse Mountains, where she moved to be near her daughters. She is still filling every minute of her days. She grows orchids as an active member of the Orchid Society and uses her industrial sewing machine to make bags for an animal charity to protect injured koalas and kangaroos. Art remains important in Pauline's life, as it has always been. She collects found objects, such as seeds for jewellery-making, and finds beauty in the presentation of a meal, the arrangement of textiles in dressmaking and the creation of sculptures. Pauline is also involved in the lives of her fifteen grandchildren and seventeen great-grandchildren, all of whom are hard workers and high achievers. She regrets that she has had to slow down. Now that she has osteoporosis, she fears falling and breaking a leg or a hip.

It was startling to learn of Pauline's physical insecurity because she seems to have been indomitable all her life. I asked her how old she felt and her answer neatly summarised the way she has lived her life. 'Sometimes when my knees hurt and I can't get up, I feel like a hundred! I have arthritis in my knees. But I walk the dog every morning and I always feel better. I've never thought about age. It's strange; it's only when I have to do something like renewing my licence every year because I'm over seventy-five that I'm aware of it. The other day I was talking about going on a cruise and somebody said, "But you'll be eighty years old!" I can't relate to that. I don't have any fear of dying or falling off my perch. It's just that there's so much more to do. So, when I wake up in the morning, I plan my day so that I can fit so much into it.'

Pauline might have accidentally almost become a solicitor, but she has arrived at a fulfilling old age not by accident but through a lifetime of full days animated by curiosity and enthusiasm.

Fun, Faith and Fervour

Ann Druett

(b. 1936)

In *The Importance of Being Earnest*, Oscar Wilde has Gwendolen Fairfax say, 'I never travel without my diary. One should always have something sensational to read in the train.'

Having kept a diary since she was ten years old, Ann Druett would not have lacked entertainment on public transport. She wrote about a happy childhood, recording plenty of lively discussion and disagreement over ideas with her parents, but no anger. She was an exuberant teenager, naming in her diary all the boys she went out with and the fun they had. The pages are full of passion: of intimate secrets shared with friends, of going to school dances, of deciding which boy's invitation to accept, of whether the boy she fancied also fancied her. Her accounts took me back vividly to my own teenage years. I couldn't possibly remember them with the degree of detail Ann has recorded, but the excitement, the moods high and low, the hopes and their sudden dashing: all these evoked flashes of familiarity

Ann drew on her diaries to write a memoir for her children. She was impelled to do so when one of her sons asked his grandmother what Ann was like as a child and was told she didn't know; Ann was away at boarding school. There was another reason: Ann's husband, John, had died when she was forty-five and their five children were aged between twenty-three and thirteen. The children had known their father only as an invalid who sometimes had good days. Ann wanted them to have a repository of stories about him from when he was healthy and active. She wrote in longhand and employed someone to type the manuscript. The project took seven years of intermittent attention. When it was finished, she gave each child a copy for Christmas in 2002.

When I asked if I could read her memoir, Ann said that she had lent her copy to someone but would post it to me when it was returned. I suggested that she could email to me the original document that she'd had typed on her computer. I was touched to learn that, once each chapter had been printed six times (one for each child and one for herself), Ann had tidied up by deleting the documents. It can be difficult to adapt some habits to the digital world.

The diaries appear to have helped Ann to keep her memory active. During our conversation she described events in her life with vivid animation. Perhaps her greatest accomplishment, now she is in her late eighties, is her continued capacity to live life with gusto, despite its attendant sorrows and setbacks.

When she was born, Ann's parents were living in Rosebery, a mining town on the west coast of Tasmania. Her mother had been a secretary and her father was a mining engineer. A sister, Kath, was born two years later. Ann remembers the mine's whistle blowing when there was a mine accident or a fire in the town, the latter started by sparks from the steam trains. There was once a mine cave-in and her neighbours were trapped underground. She can still feel the fear emanating from the adults in the community.

Ann's mother was ambitious for her daughters and wanted them to be well educated. Until Ann was ten she went to the local school. Then her

parents sent her to boarding school for a better education and to make friends outside their small community. As Ann's mother sadly told Ann's son many years later, Ann never really returned home.

Ann, meanwhile, was excited to embark on the adventure. This was when she began to keep a diary, marking her awareness of this momentous transition in her life. Although she knew that her parents would miss her while she was away, Ann was eager for new experiences.

Her first boarding school, where she stayed from 1947 to 1951, was at Deloraine, a rural town in the central north of Tasmania. Our Lady of Mercy College was a strict, spartan school run by Roman Catholic nuns who were not stern enough to stop Ann from having fun. She lived in a world in which she felt secure and valued. Ann credits them (as well as her parents) for instilling in her the values and religious faith that have formed her. She told me that her faith is fundamental to her capacity to overcome adversity.

At the end of each term, Ann and Kath (when Kath joined her two years later) packed their cases and were taken by horse and cart to the station, where they caught the steam train to Burnie. They stayed the night there – with friends in the early years, and later at the Emu Bay Hotel – and took the rail motor to Rosebery the next morning. The rail motor was a small, light, one-carriage train that looked very much like an old-fashioned tram. The driver, the conductor and the ticket officer at the station knew them well and greeted them as friends. The conductor made sure the motor stopped at Barker's Crossing, where their mother would be waiting.

Ann's parents decided that, after four years of boarding in Deloraine, she needed experience in a city. They had family in Melbourne, so in 1952 Ann was enrolled at Genazzano, in the Melbourne suburb of Kew. Genazzano was established in 1889 by nuns from the order the Faithful Companions of Jesus as a boarding school for country girls. When I was at school in Melbourne in the 1950s and early 1960s, Genazzano was considered prestigious. Kath felt it was elitist. When both girls were at

Our Lady of Mercy College, their homecoming had been exuberant: they would leap off the train and fling themselves into their parents' arms, accompanied by tears and prolonged embraces. Kath said that, when Ann came home from Genazzano for the first time, she stepped sedately off the train and offered her cheek to be kissed. Kath didn't want to turn into a snob like her sister and chose to remain at Deloraine, where she became head prefect.

The sisters still had fun together, as Ann's diaries demonstrate. She celebrated a party at home for Kath's fifteenth birthday with the high-spirited comment, 'Beaut! Kissed every boy in the room.'

Ann was meant to be at Genazzano for two years but during her first year she secured an interview with the Victorian Education Department, which she attended without telling her parents, and was awarded a teaching studentship. Her parents were disappointed that she was finishing school a year early but they knew that she had always wanted to be a teacher and supported her decision. Ann moved to Caulfield South, to live with an aunt whose children had left home and who quickly became her second mother. She enjoyed her two years at Toorak Teachers' College, making friends with whom she shared a lively social life. She loved Melbourne and went to as many concerts, plays and operas as she could.

But that wasn't enough. When she graduated, at the end of 1954, Ann wanted adventure. Unlike most of her friends, who were eager to stay in metropolitan Melbourne, Ann applied for positions in the country. She was offered one in a little farming town called Nayook, in West Gippsland. Her studentship required her to stay two years; she stayed for almost three, becoming active in the community and making friends with the parents of her pupils. Ann taught in a two-room school with one other teacher. Her thirty pupils were in prep and grades one and two.

Ann boarded with a farming family and, inconveniently, shared a room with their nine-year-old daughter. After she'd been there a few months, the husband made a forceful grab for her, declaring passionate love. Ann picked up the chair she'd been sitting on and hit him with it.

Like so many women before and since, Ann didn't feel that she could tell anyone about the assault. His wife would not have believed her and her parents would have insisted that she move out of the house, but there was no other accommodation available. Ann developed a nervous tic and for months couldn't be alone with a man, including her father, without having a panic attack.

Despite this awful experience, Ann went out with young men in the company of groups of friends. She was very attracted to Tas, a farmer whose immigrant parents loved Ann and who bought Tas a dairy farm that he hoped she would share. She also developed a relationship with John, whom she'd met on trips home to Rosebery, where he was working as a geologist. Somehow, Ann agreed to marry them both. Tas was the more exciting, but she had more in common with John. This proto-bigamy was manageable when the men were satisfactorily located in different parts of the country, but the inevitable day came when they met.

John's parents lived in Goulburn, New South Wales, and Ann was invited to meet them. She thinks she shocked his very straitlaced mother by wearing a strapless dress to a ball at St Patrick's College, John's old school. At the end of the trip, John accompanied her back to Melbourne and waited with her at Spencer Street Station until her train was due to depart. 'I was sitting on the train, which used to go to Bairnsdale every Sunday at six o'clock. John was with me, ready to go back to Rosebery the next day. We were saying goodbye – and I saw Tas walking past the window! I didn't know what to do. He walked back and saw me, otherwise I think I'd have ignored him. So we got off the train and stood on the platform. There was no shouting, there was no yelling, but the two men were standing there, saying, "Well, Ann, what are you going to do?" I thought, *I've got to go back to my job! School starts tomorrow.* Tas had come down to drive me back, as a surprise. So I said, "I'm going to go with Tas."'

Ann saw John the following weekend in Melbourne. She continued to be torn between the two men and applied for a teaching position in Mornington, away from them both, to contemplate her future without

distraction. Mornington is now an outer suburb of metropolitan Melbourne but in 1957 it was a beach holiday destination. It took her eighteen months by the sea to decide between them. Ann realised that she was not cut out to be a farmer and married John in 1959, when she was twenty-two. Her diary records every detail of the marriage preparations, wedding and reception, her dress and going-away outfit, the bouquet, the cake, the guests, and much more. Ann was delighted with it all.

She was not delighted with the unwelcome drama of their wedding night in a hotel. To their great shock and mortification, Ann haemorrhaged and had to be taken to Burnie hospital, where she spent the rest of the night. At the hotel, there was blood on the sheets and the carpet, on the towels they had used to staunch the flow, and all over the bathroom. John was embarrassed to have to explain the apparent crime scene to the hotelier and offered to pay to have it cleaned. Ann said it was a good thing that they didn't believe in sex before marriage because they would never have been able to keep it a secret. 'The nurse at the hospital said, "I don't think it's a miscarriage," and I leapt off the bed and said, "I'm absolutely sure it's not a miscarriage! And if I'd known this was going to happen, I would never have got married!" Later, the doctor said, "You probably will never have children; you're very small." But I thought, they're not going to tell *me* that!'

Two months later, they discovered that their first child had been conceived on that memorable night. Ann read Dr Grantly Dick-Read's *Childbirth Without Fear* (1942) and believes his advice helped her to have a very brief labour. Despite being considered 'too small' to have children, Ann gave birth to five of them, two girls and three boys, between 1959 and 1968. She was twenty-three at the time of her first and thirty-two when the last was born. Four was the planned number but, as the old joke goes, the Billings or rhythm method of contraception occasionally fails if you're syncopated. Her births were so easy that, with number five, she felt a contraction, sprang out of bed and the baby fell on the floor. He made a soft and safe landing. She loves telling this story.

Ann and John returned to live in Rosebery, where John had a job in the mines. Their marriage was traditional: he was in charge of the family finances; she did all the household work, childcare and shopping. Ann wasn't happy about John's after-work trips to the pub with his workmates but accepted that it was a feature of mining towns in those years, as it was throughout Australia. Although they had known each other for five years before they married, Ann had not witnessed the sudden and frightening temper that he later revealed. With difficulty, she learnt to ignore it; trying to find a reason for his anger only irritated him. Despite his temper, Ann was always confident that John loved her.

Ann taught occasionally at the state school and the convent school in Rosebery, both casual and part-time, until her youngest child, Anthony, was in preschool. She had also completed a course in special education, drawn to teaching children with special needs. After Anthony had been in preschool for a term, Ann heard that the convent school was having trouble finding staff, so she put him in the prep class and went there to teach, usually in their special education classes. Ann still feels guilty that because of this, Anthony was always a year younger than the other children, although she concedes that he turned out all right.

Only three years into their marriage, when John was twenty-nine, he consulted the local doctor about sharp pains in his shoulder. Tests in Hobart revealed rheumatoid arthritis, a painful, incurable autoimmune disease that particularly affects the joints. John deteriorated rapidly from an active sportsman to a man who often couldn't move. Once the mine's senior geologist who frequently went underground, John was confined to office work as his condition worsened. He had been so involved in the local community that he'd been awarded an Order of Australia for community service, one of the youngest people in Tasmania to be so honoured. He did his best to stay engaged with the community, but it was difficult. 'He had plaster casts on his hands. Some days he could walk. Other days, he couldn't get out of bed. It was very unsettling for the children. The pain was intense, but he never complained; he would

just go very quiet. He was a terrific father, always very involved with the kids, very considerate, kind, thoughtful, fun-loving. A great husband. But in lots of ways we all suffered. There were times when the children just had to get out or be quiet. They didn't understand.'

Ann remembers John's death in 1982 in almost cinematic detail. Their oldest son was working interstate, their oldest daughter was away from home at nursing training and the youngest three were at boarding school. These three had just been home for the holidays and John had wept as he said goodbye when they boarded the train back to school. On the way home, he had stopped to look at the view. Ann thought John believed he was seeing it for the last time.

A few days later, he managed to attend an evening community meeting. When John came home, Ann had the television on. 'He said, "What are you watching?" I said, "Nothing, really. I'm reading my book." He said, "Would you mind if I turned the TV over to another channel?" He turned the TV over, sat down in the chair beside me and dropped dead.'

Ann ran next door, screaming. Her neighbours rang the doctor and ran back to the house with Ann to try to resuscitate John. The doctor arrived and continued working on him until Ann begged him to stop; she could see it was futile. Friends, the priest and the local policeman came to the house. Ann contacted the children and arranged for them to come home.

My father was a GP in the days when doctors made house calls. Sometimes he came home after being with a patient who had died and said that they and their families had had 'an experience of a religious nature'. As an agnostic, he envied this spiritual comfort. I think he would have recognised it in Ann's account of what happened to her. 'It was a very, very strange thing. I'm not an airy-fairy person at all. But there was an atmosphere in that room of peace, of calm, almost as though I knew it was going to happen, and almost as though I knew I was going to be looked after. I can't explain it, except I felt it.'

Lying in bed on the night of John's death, Ann wondered what to do next. She was alone in the house. Her children were away. John's mining

company provided their accommodation but wouldn't do so forever. Where should she go?

Ann's mother was in Devonport and her sister was in Hobart. She saw in the paper that there were vacancies for boys at a Catholic school in Hobart. That pointed to Hobart as a possible new home for her and her children. Ann needed an income as well as an occupation in which she could find meaning for the rest of her life. She decided that becoming a full-time teacher was the answer.

A school trip to Hobart had been planned for two weeks after John's death. Ann went on the trip and, while she was there, discovered fortuitously that Hobart's St Mary's College needed staff. She went to an interview, and within a month of John's death she had a job.

What Ann needed next was a house. The mining company, which had been supportive through all the years of John's illness, offered Ann the house for another year. Ann was grateful but wanted to set up all the details of her new life as soon as she could.

Not long before his death, Ann had brought John the newspaper to read in bed. He had pointed out a house in Hobart in the real estate section and said that he'd like a place like that when he retired. It had four bedrooms and a swimming pool. Ann had cut out the advertisement, little knowing that she would come to rely on it six months later. John died in September. Every weekend thereafter, Ann looked at many, many houses in Hobart, clutching that advertisement as a guide to her ideal home. One day in December, she and her two daughters were shown a house and immediately agreed, 'This is it.' Ann bought it and the younger children spent their teenage years there. It didn't have the pool that John had envisaged but Ann eventually added one.

Rather than let her life shrink after John's death, Ann expanded it, seeking new personal and professional connections. She taught at St Mary's, especially enjoying classes of seven-year-olds because they were 'at the age to be helpful and interesting'. She was pleased to include in her classes children with special needs. Ann made new friends and revivified

her social life. She travelled frequently as a member of Friendship Force International, a non-profit organisation founded by former US President Jimmy Carter in which members from one country are introduced to those in other countries through homestays. Friendship Force has a presence in more than sixty countries on six continents and claims 15,000 active members worldwide. The goal is to learn about the diversity of human lives and ways of living.

Ann continued to teach at St Mary's for seventeen years. However, when she retired at sixty-two, she worried about having enough money to live on. Her superannuation was modest, as it is for many women with an intermittent employment history. Her large house had become too much for her to manage. She knew she'd need to sell it but was reluctant to go into a retirement village. At a family meeting, one son offered to buy a unit that his mother could rent while living on the proceeds of the sale of her home. This suited Ann very well. The unit wasn't far from her previous house, right on the waterfront. Her youngest son, who had joined the Navy at seventeen, returned to live with her. Life seemed close to idyllic.

Then, one Sunday afternoon in 2018, the police knocked on her door. When she opened it and saw them there, Ann was overcome with fear, dreading what they might be about to tell her. The news was devastating: her eldest son, Peter, had died of a heart attack in Queensland. He'd been doing that most prosaic of activities, mowing the lawn.

Ann had been able to re-establish her life after John's death, but this was different. It wasn't just that she was desolate; Peter's death shattered the whole family. The unpredictable effects of grief can isolate people in their own sorrowful bubbles. Grief over Peter's death, it seems to Ann, led some of her children to float away, if not from her then from each other.

Ann, however, learnt to live with her loss, sustained by her faith, her children and her friends. She worked hard to keep busy, filling every day with socialising and volunteering. For a time she was president of National Seniors Australia, a non-profit organisation begun in 1976 that advocates

for the welfare of older Australians. The organisation's campaigns included arguing for an adequate age pension, improving residential aged-care services and ensuring that government policies benefit (or at least don't harm) older Australians.

Ann travelled annually, until the Covid-19 pandemic struck, through Friendship Force. She was on the committee for years and, while the pandemic curtailed her travel plans, she remains interested in the world and its people. Ann exchanges letters and emails with friends she has made over the years and learns all she can about their home countries from television documentaries.

Ann is now almost eighty-seven. She plays croquet, bridge and Mahjong regularly and does water aerobics. She goes on long drives with a friend and has other friends over for lunches and dinners. Well into her eighties, she played competitive tennis, golf and table tennis, until a snapped Achilles tendon forced her to give them up. She is still active in National Seniors Australia. She has overcome breast cancer and two hip replacements but mentions these disruptions to her health only as an afterthought. Ann remains optimistic and expects to emulate her mother, who lived to be 'one hundred and three and a half'.

There are also the inevitable losses that accumulate with age. Ann has an accompaniment to her diary, a book she has kept since 2000 in which she records the names of those in her life who have died. Towards the end of 2021 Ann had entered thirty-eight names. Other friends have suffered memory loss or become incapacitated. It's harder now to make new friends.

The pandemic has dealt her optimism some blows. Lockdowns prevented her from visiting her children, grandchildren and great-grandchild, and meant that she missed birthdays and other important events. She knows that these are sorrows she shares with the rest of the community.

Nevertheless, Ann, just like her teenage self, is fun to be with: both interested and interesting. This might be why she has had offers of marriage

from three men – not all at once this time around. She is happy to spend time with close male friends but doesn't want to marry again.

Summing up her life, Ann says, 'I've been very lucky.' Her sense of fun, the security of her faith, and support from her children and the community have combined to lead her to a happy and fulfilling older age. It can't be denied that luck has also had a hand in the opportunities that have come her way, but Ann has been ready to take advantage of them and to seek and accept help when she needs it. That's not a bad example to follow.

A Tripartite Life
Sharron Pfueller
(b. 1943)

It's often said that things come in threes: bad luck, trams, blind mice, good luck, little pigs, sneezes. It seems to be in harmony with the universe that Dr Sharron Pfueller segments her professional life into three phases. She can identify the year each career began and the years the first two ended. Evident in all phases of her life from childhood are the three demands of self, relationships and occupation. Sometimes these demands have complemented each other; at other times they have necessitated difficult decisions. These decisions have been influenced by Sharron's values, her desire to contribute to the world and serendipity.

Sharron's father immigrated to Australia from Germany in 1933, living first in Melbourne and then in Sydney, where he managed the Holeproof factory before setting up his own business. Sharron's mother was the daughter of a spirited divorcée who ran a boarding house in Sydney. Her parents met when her mother opened the door of the boarding house to

her father. Sharron's grandmother set an example that Sharron was proud to follow. 'As a teenager, my grandmother had never learnt about how babies were formed because her mother had died, leaving her to look after her younger brother. This ignorance led to her getting pregnant. And then divorced because her husband liked other women. She wasn't daunted and set up her boarding house. Later, she joined the Feminist Club in Sydney; she took my mother along to meetings and once I went too. My relatives provided examples of independent, strong women who tried to make the world a better place. This sat in my unconscious throughout life so that, when circumstances out of my control came along, I had the mindset to take up the challenges, take a different direction and create something new.'

Sharron's father somehow escaped internment during the Second World War. The fate of most so-called enemy aliens was to be locked up in jails or purpose-built camps for the duration. But he couldn't escape the hostility and suspicion of the populace. Despite doing everything he could to overcome his Germanness, he was abused by his parochial neighbours for naming his house 'Bon', his wife's nickname, because they thought it referred to the German city of Bonn.

Persistent pneumonia and other respiratory problems meant that Sharron rarely attended school. As an only child she had the full attention of her very protective parents, who feared the outcome of every bout of illness. Sharron loved learning at home by correspondence during her early high-school years. Her parents' support and encouragement were unremitting. They wanted her always to do her best but had no overt expectations of the kind of life she should lead. When she was well enough to leave home isolation, she attended the nearest school, to limit travel. It was a domestic science school, not at all to Sharron's taste. She felt completely out of place. It wasn't only her history of cerebral home schooling: her schoolmates knew her to be sickly, she topped her classes and she was tall. The experience made Sharron rebellious and motivated to escape.

A major influence on her life, as on the lives of many young Australians at the time, was *The Argonauts Club* on ABC Radio, which was broadcast every weekday from 1933 to 1972 (with a few interruptions). It's hard now to appreciate the effect of this club on intelligent, creative children. If you look it up on Wikipedia you'll find a long list of important Australians, now in their seventies, eighties and nineties, who were members, along with their Argonauts name. Sharron's was Eurysthenes 42. The show interviewed artists and scientists about their specialties, and children aged between seven and seventeen could send in their poetry and art. Sharron's accumulated prize points gained her the club's highest honour: the Golden Fleece and Bar, reserved for particularly talented and industrious children. It was a finer education for her than the domestic science school.

When the education system in New South Wales was modified – transforming domestic science schools into high schools – it was just in time for Sharron to complete her education by studying the most intellectually challenging subjects that her school then offered: biology and economics. She was passionate about science and her parents encouraged her to pursue it at university. Despite coming first in the state in high-school biology, Sharron lacked the necessary physics and chemistry scores for admission to a Science degree. Bridging courses gave her entry.

In 1959, when she was sixteen, Sharron had taken part in a Billy Graham crusade. This is another phenomenon of the time. Crowds of more than 140,000 people (from a national population of 10 million) gathered in each of several states to hear the American evangelist and his massed choirs, after which they came forward in their hundreds to pledge themselves as Christians. Their names were given to their local churches, to be followed up by the priest, minister or pastor. Sharron and her parents joined the crowds at the Sydney Cricket Ground, went forward and joined their local church, where Sharron met a young medical student. By the time she graduated from the University of Sydney in 1964 with a first-class honours degree in science, they were engaged. This was when she discovered that her romantic doctor had visions of her as

135

a housewife and a mother. She had visions of herself as a scientist. She broke off the engagement.

A broken engagement was frowned upon in her church and so, to escape the inevitable judgement, Sharron moved to Adelaide to undertake postgraduate work at the university. Her parents were upset at the move but didn't stand in her way. Career number one thus began in 1965. By then Sharron's health was excellent, and her years of association with the medical profession encouraged her interest in becoming a medical researcher.

At first Sharron enrolled in a Master of Science degree in biochemistry. Her supervisor suggested that she experiment with a microorganism that had been described in a major biochemical journal as secreting a rare protein. They contacted the scientist who had written the paper about his research and were sent a sample of the microorganism. Instead of endorsing the scientist's work, Sharron demonstrated that the protein secreted was not at all unusual. The same journal published her paper, and Sharron converted to the degree of Doctor of Philosophy to conduct further research in the area. Her PhD was conferred in 1967.

Australia's cultural cringe at the time meant that scholars needed to be recognised overseas before they could be considered valuable at home. Sharron was determined to seek work outside Australia but, to her parents' relief, returned to Sydney for a year while she prepared her applications for a post-doctoral position. She spent 1968 as a research assistant in haematology at the University of Sydney before accepting an offer to work in a Swiss laboratory. 'My parents were glad to have me back for that year and very sad to see me go. I really must praise them for allowing – not allowing, being comfortable and not trying to make me feel too uncomfortable about following my goals. That's a real tribute to them. Parents can be absolutely overwhelming, overbearing, and thwart a young person's career. At that time, it was not necessarily assumed that women would go to university. If they did, they had to study Arts. Perhaps Medicine or Nursing, but not Science. There was this public perception

that the sort of thing I was doing was not the norm, but somehow I didn't take any notice. I have no idea how I managed that, or how my parents managed to not condemn my chosen path.'

At the age of twenty-seven, Sharron set off for Switzerland. From 1969 to 1976, she was a research fellow in haematology at the Theodor Kocher Institute, funded by the Swiss National Research Foundation, in Berne. Sharron loved her work and loved living in Switzerland, surrounded by postcard views of the Alps. She was working with a scientist who had a strong international profile and encouraged her to present the results of her research on the immunology of blood-clotting cells at conferences around Europe and in the United States.

Although most scientists spoke English, other people in Berne spoke a dialect, *Berndeutsch*, which Sharron hadn't learnt at the language classes she attended before leaving Australia. She therefore chose to socialise at a club at the British Embassy. This led to what she describes as a big mistake in the form of a very attractive man, whom she married. He was a teacher, a playwright and a poet ('of not particularly high standing') who also wrote for the local newspaper. Marriage meant that she extended her stay in Switzerland for another six years and was able to indulge her enchantment with Europe as well as advance her career.

Sharron eventually discovered that her apparently romantic husband was not only a reprobate but fundamentally not husband material. After a few years, she told him that she was eager to have children, which aroused his angry opposition. The end of her marriage coincided with the end of her time in Europe because Switzerland made it extremely difficult for foreigners to become citizens. It was not, however, the end of Sharron's first career.

Sharron reflects now that her life has been influenced by a series of responses to circumstances over which she's had no control. As she prepared to leave Europe, someone in her network of scientists in haematology communicated with a professor Sharron knew in Melbourne. He rang her long-distance (a drama in those days) and offered her a job – one of

three such offers she received. Someone had dropped out of a funded position because of pregnancy, and Sharron eagerly stepped into her place at Monash University. Here Sharron continued her research on immunology, the language of which has become unexpectedly familiar to us in the Covid-19 pandemic. Her work, in general terms, was to investigate how human bodies react against themselves and damage their own blood cells.

In 1978, Sharron married again and, in 1979 and 1981, gave birth to the children she'd hoped for: a boy and a girl. It would have been professional suicide to stop working. To retain credibility as a scientist you have to keep up with developments and continue to publish your research in prestigious academic journals. Sharron continued to work so that she didn't drop out of the scholarly race and to service a demanding mortgage. To be able to care for her children, she reduced her hours to part-time.

Sharron's second husband was a secondary-school teacher who supported her work – 'or at least went along with it' – and was able to arrange his life around the children. Sharron was as involved in her children's activities as work would allow, even becoming the founding secretary of the after-school program at their school. Then, once again, circumstances sent her in a new direction. The professor who had appointed her retired and an ambitious young medical doctor took his place. The new head implemented major changes, including setting up his own department in a suburb many kilometres from Sharron's home. This would have meant not only a long commute but also unworkable disruption to her childcare arrangements. She resigned in 1989, and this led her, ultimately, to career number two.

Sharron's husband suggested that they take advantage of the upheaval to become self-sufficient. Sharron had already begun thinking this way, having read a book called *The One Straw Revolution* (1975) by Masanobu Fukuoka that introduced her to the philosophy of ecological sustainability. They bought twenty-three acres in Gippsland, built a mud-brick passive solar house and started growing fruit and vegetables. Sharron's desire to

save the world moved from medical research, where she suspected she wasn't saving much, to the environment. She set up a permaculture system.

Sharron loved the physical work and, for the first eighteen months, life was sublime. She was making and laying mud bricks, doing carpentry and working in the garden. Her husband then continued teaching, but his salary didn't fully cover daily expenses or the mortgage. Interest rates had hit 18 per cent. Financial pressure meant that Sharron had to find an income. She delivered census forms in 1991, which was hard work and included being pulled out of bogs by tractors while tracking down people who were living in tents in out-of-the-way places, doing their best not to be found.

Sharron then successfully applied for a position at Monash University's Gippsland campus, where she developed a distance-learning course about climate change and the environment. Her PhD gave her the edge, even though she lacked qualifications in the discipline; the interviewers correctly assumed that she had the experience and the necessary commitment to overcome any gaps in her knowledge. Alongside the course development, in 1993 Sharron ran a major conference on greenhouse gases and global warming, with important speakers from science, politics and the energy industry. Despite the persistent disappointment of a lack of political will, Sharron has continued to fight for action on climate.

While Sharron was active in her paid work and on their property in Gippsland, she was also studying part-time for a Graduate Diploma of Environmental Science at Monash University in Clayton, more than 150 kilometres away. This would give her the formal qualifications to consolidate her reputation in the field. She rented a flat near the university and slept on an air mattress there a couple of nights a week. Sharron did so well in the course and so impressed the staff with her experience that, as soon as she graduated, she was employed as a lecturer in Monash's School of Geography and Environmental Science, beginning in 1994. She relished the work, especially because the students, all postgraduates, shared her enthusiasm for the natural world and the need to save the planet.

This happy time was disrupted by political shenanigans within the university, with disputes between departments. Sharron held on to her job on the condition that she worked part-time. She made the best of it, redirecting her research to ecotourism – which held the potential to encourage greater respect for the natural world by enabling people to visit it without doing harm – while at the same time contributing to the funding required to maintain and promote conservation.

Throughout her second career, Sharron continued her commitment to voluntary work, including at her children's school and the local community health centre. Her unpaid environmental work could fill a chapter on its own. Highlights include working with the Australian Conservation Foundation, Landcare, the Halls Gap ecotourism project, the Victorian Greens Party, the Australian Complementary Health Association and the conservation group Greenlink. Until 2020, Sharron organised a monthly Harvest Share Swap, enabling locals to exchange produce from their gardens.

Sharron's living arrangements during her second career reflected rather than caused the erosion of her marriage. The children divided their time between her flat in Clayton and the house in Gippsland. When her son became a Monash University student, he spent his weekdays with her, and her daughter visited on many weekends. The end of her marriage occurred round about the time of her career transition in 2009.

As her employment at Monash was coming to an end, Sharron had begun to ponder what she would do next. She was unhappy with the increasingly onerous demands of teaching. Retirement seemed inevitable. She took to the internet and discovered an organisation called Sustainable Gardening Australia. She read that their mission was to encourage sustainable practice in public and private gardens. They also had an accreditation scheme for professional gardeners and for retail stores designed to reduce the pollution in commercially available chemical products. Sharron contacted them and was delighted that they were thrilled to have a scientist with a PhD volunteer to work with them.

At sixty-nine, Sharron entered career number three: she became a champion of sustainable gardening.

Sharron began working with Sustainable Gardening Australia to evaluate the impact of pesticides, herbicides and fertilisers on human health and on the environment more broadly: 'birds, bees, fish, frogs, soil, earthworms; everything like that'. With her obvious expertise and commitment, she was soon invited onto the board, coincidentally just before the organisation ran into financial difficulties. It was no longer possible to pay their few staff. Either the organisation had to dissolve or it must continue exclusively with volunteers. Sharron and the president of Sustainable Gardening Australia worked together to keep it active and to raise funds to expand once again. The president took charge of human relations and Sharron managed communications, which meant sending out newsletters and engaging with social media to advise gardeners on how to protect and nurture the natural environment and grow healthy food. First she had to learn how to use social media and how to run a website. After an enormous amount of work, they succeeded in reinvigorating the organisation. Sharron even raised funds to create an app that gives information on the risks of using commercially available pesticides and herbicides in Australia.

Sharron, who has written more than fifty articles for Sustainable Gardening Australia, is buoyed by the impact she is making. This work is read by thousands of people and, she thinks, probably has more influence than her academic teaching and more than sixty published papers, which have a narrow readership of other academics and students.

In 2018, Sharron became president and CEO of Sustainable Gardening Australia, two almost full-time, unpaid roles that unite all of her lifetime interests and goals: 'Health, biochemistry, protecting all aspects of the natural world – soil, plants, waterways, animals, biodiversity in general – growing local healthy food, and trying to make a difference.' She has gradually reduced her hours and has secured funding for an employee, whom she has trained to take over part of

her work. Her passion is sustaining but it's also exhausting, especially with the impact of Covid-19 restrictions and lockdowns, which have diminished her psychological reserves. At seventy-nine, Sharron would like to spend more time in her garden, which refreshes her for creative online work in the organisation.

In 2010 Sharron's mother died, bequeathing her enough money to move out of her unit. (The mud-brick house had been sold when Sharron's ex-husband had remarried a couple of years after their divorce.) She searched for a block of land with a dwelling destined for demolition and built a new house designed to have a low environmental impact. It has solar panels, solar hot water, passive solar heating and good insulation. The house is small but the garden is large, allowing her to grow most of her own food. Sharron's children and their families don't stay with her as often as she would like because their own determination to contribute to the world has led them to move far away, including overseas. Channelling her own parents, she encourages them to pursue their goals.

Even though expectations and possibilities for women are much less restrictive now than when Sharron was young, her experience has led her to assert that women are still subject to social constraints, which start early in life. Sharron thinks it takes a particular personality to persist despite sexist discrimination. She concedes that following your own path and considering your own needs, as she has done, has its disadvantages: 'You can be very selfish and ignore other people's feelings and needs.' It is the dilemma that confronts women, especially those with a partner and children. The social expectation that women will put their family members' needs before their own might be challenged today as it rarely was when members of the Silent Generation were young, but prioritising a career remains a conscious decision and source of guilt for many women. It's still not uncommon to hear young mothers describing their male partners as 'helping' with childcare rather than fulfilling their responsibilities as a parent. The implication is that women are the primary parents who must decide how selfish they are prepared to be.

Sharron can now look back on a life in which she has pursued her personal and professional goals, stayed true to her values and done her best to contribute to the good of the planet. Her children have thrived even if her domestic relationships did not last as long as she might have hoped. She stresses the need for every person at any age to be enabled to live a meaningful life. 'It is really important that retirees can still be enlivened by making a significant contribution to society in older age and don't feel that they are no longer relevant. It gives us a sense of purpose. When you're associating with other people who have similar passions, or you can see that you're actually making some changes in the world, or even trying to make changes, it really does make life worthwhile.'

Gently Down
the Stream
Robina Rogan
(b. 1940)

One night in 2016, during a break in her amateur choir rehearsal in Melbourne, Robina was startled when the woman standing next to her said, 'You don't want to build a boat, do you?'

'I said, "Huh?" Between our times to sing, I said, "Look, I've got arthritis in my hands. I wouldn't know what to do with a drill. It doesn't make sense. And I'm seventy-six." Then I said, "Okay. Why not?"'

Boatbuilding is a fitting occupation for someone born by the River Clyde in Glasgow, famous for its shipwrights. The *Cutty Sark* and the *QE2* are among many vessels that began their maiden voyages on the Clyde. Robina's rowboat, albeit much smaller, similarly represents enterprise and adventure.

Robina's birth coincided with bombs being dropped on the Clyde, early in the Second World War. Her mother was fortunate to give birth in a maternity hospital rather than a bomb shelter. Robina was her parents' first child; a brother and two sisters followed. Her father didn't serve in the armed forces because of ill health but was active in what came to be known as Dad's Army: the Home Guard. His responsibilities often took him away from the house, especially during and after emergencies. Robina's mother would rush her to the bomb shelter with other residents of the tenement in which they lived.

This way of life continued for two and a half years until Robina's father, who was a pharmacist, moved his family and his business to a small village on the west coast of Scotland. Its population was about a thousand people – at least, Robina said, when everyone was home from college. Her paternal grandfather was in the wholesale pharmaceutical business, which gave his son access to scarce items. Despite the very different time, there are some parallels with the beginning of the Covid-19 pandemic. 'Grandpa was able to get goods for Dad that people hadn't seen all the way through the war, like toilet paper. There were queues for his toilet paper! And sanitary towels. That was the most impressive thing. And he helped the village. As a result, there would be a salmon on the porch when you opened the door in the morning, in recompense, and there would be eggs and things like that. Even venison would appear. Venison! And you knew that somebody had poached them from the Duke's place.'

There were advantages to living in a small community, far away from where the bombs were dropping, but education wasn't among them. Robina doesn't recall any discussion about her future. In the post-war years she and her siblings all attended the local school, until one of Robina's sisters demonstrated talent in ballet and gymnastics. Her parents decided to send her to England to board at a prestigious school that catered for the children of film stars. The youngest sister was also enrolled, for company. Their mother went with them from the village to school on the first occasion. Thereafter, the eleven-year-old and the eight-year-old were put on the

bus to Glasgow on their own. They would then walk across Glasgow to the railway station and catch the train to London, where they walked to the bus station for the bus to Surrey. No helicopter parenting for them.

When Robina was fifteen, her brother began to attend boarding school in Wales. Robina had reached the limit of local education. She asked her mother where she would be going and was told that she'd be joining her friends at the public school in Oban. Rather than being disappointed, Robina was pleased not to be heading off to private school. That didn't mean, however, that she would stay at home. Oban is a small seaside town on the west coast of Scotland, a popular holiday destination then and now. It was only about fifty kilometres from Robina's village, but the roads were rough and the journey took at least an hour and a half. Robina was therefore sent to a boarding house, to come home only in the term holidays. The landlady, Mrs Ferguson, had two other girls as boarders. 'I was a bit of a mummy's girl, a homebody. I had all my friends in the village and we knew what everybody was doing and where we'd go. The first day, I arrived before the other boarders and I was in tears. I didn't want to stay. "Well," Mrs Ferguson said, "you can sit there and cry as much as you like, or you can come with me. I've got a job to do down in the caravan park. I do the dishes at night. You can come and help me with the dishes." She found a bicycle for me and off I went. From then on, I learned that you don't sit and feel sorry for yourself. You say, "What can I do?" And that's what I did. I wasn't homesick again.'

Refusing to sit and feel sorry for herself has marked Robina's life ever since.

Mrs Ferguson also taught Robina to fit in, to make do and to adapt to circumstances. The landlady's four children would come home for university vacations while the three girls were still in residence. In the summertime, the house served as bed-and-breakfast accommodation for tourists, so the seven young people had to relinquish their rooms and sleep on the floor in the loft. They didn't complain, just accepted that this was what you did in summer.

At the end of her schooling, Robina had no idea of a career or field of study. Her mother sent her to Edinburgh to train as a beauty therapist, which turned out to be an excellent choice. When she finished, her father invited her to open a salon in his pharmacy. Robina worked there until she was twenty-one.

Robina's time in Oban also transformed her from a homebody to a traveller. She would get on a bus in her holidays to visit new places. She spent a lot of time staying with her paternal grandmother in Glasgow and told her all about a book she was reading, which was set in Australia, and how the thought of Australia captivated her. She couldn't believe that a place could be so hot, or that you could lie outside in the sun. The book was Nevil Shute's *A Town Like Alice*. To her astonishment, her grandmother said that she had family in Australia and fossicked about in her old sideboard until she found their address at the back of a drawer chaotically filled with letters. She suggested writing to a cousin in Carnegie in Melbourne, and the two became pen pals.

Robina's Australian family was so delighted by the contact that in 1960 they decided to visit. They booked passage on a ship and arrived in Glasgow six months later.

Of course, the Australians asked Robina when she was coming to Australia. Robina said she would love to but first she had to reimburse her parents for her education. 'And my father, he looked at me, and I'll cry, even now. Because he said to me, in his broad accent, "If that's all that's keeping ye, ye can just go." And I said, "Right! I will."'

Robina learned that her father had planned to emigrate to Australia when he was a young man. Then he met her mother, there was the war and she was born; it was no longer possible to leave. Remarkably, she discovered that her grandmother had also wanted to emigrate, following her brother, whose family was now visiting them in Scotland. He had sent for her to be his housekeeper but their mother, Robina's great-grandmother, had refused to let her daughter go because it was improper for a single woman to travel on her own. So Robina fulfilled the dreams of

her grandmother and her father, getting on a boat at the age of twenty-one, a Scottish ten-pound Pom.

It was a long journey, six weeks, and Robina soon became bored. She read all the books in the library and attended more than enough parties. She channelled Mrs Ferguson and asked the purser what she could do to help. He gladly sent her to work in the crèche. She volunteered there until the end of the journey, when the purser presented her with a beautiful handbag in appreciation.

I did wonder whether arriving in suburban Melbourne, so far from Alice Springs, was a disappointment, but it wasn't. When Robina looked along the Esplanade as the boat docked, she immediately felt at home. Australia has been home to Robina ever since.

At first, she stayed with her cousins in Carnegie. They soon invited Robina's brother to come to Australia to help with their company. Robina's brother was delighted, and the siblings set up house together. Their parents followed, so Robina's father achieved his wish and was content.

In 1961, Robina couldn't find the beauty salons in Melbourne where she'd hoped to work; facials seemed to be unheard of. Ever resourceful, she found a job as a make-up artist in television, beginning at Channel Seven. Robina worked on all the shows and made up actors, prime ministers, sporting legends and anyone else who went in front of the camera. Being new to the country, she had the advantage of not knowing who was famous and who wasn't, so she wasn't intimidated by anyone. This otherwise helpful ignorance did cause occasional embarrassment. A man came in to be made up and, while they were chatting, Robina asked him what he'd been doing that day. He'd been playing cricket, he said. She asked him what team he was on. It was only later that she discovered he was Neil Harvey, vice-captain of the Australian side and well beyond famous.

The make-up artists had other, unexpected, tasks. On Saturdays, undercover police came into the studio to be made up as though they'd been in fights in order to pass as the criminals they were pursuing. At the

time, Robina didn't feel a particular sense of responsibility to the men in her chair, although she realises now that the standard of her work had a direct impact on their safety. Later the same day she would put make-up on footballers to disguise their bruised faces. So she spent Saturdays giving black eyes to the cops and taking them away from the footballers.

It was at Channel Seven that Robina met her husband, Len, a lighting technician. Staff all worked very long hours. If they finished before midnight, they had to get themselves home. If it was after midnight, when there was no public transport, they were given a taxi voucher. Therefore, they were rostered on until 11.30pm on the dot. Robina didn't have a car and was often given a ride home with one or other of the men, all of whom knew her strict rule of no nonsense. One night, Len gave her a ride home. They stopped for coffee on the way, chatted all night, and that was that.

They were married when Robina was twenty-three and Len was twenty-one. His mother was less than pleased. She had led a hard life in country Victoria in primitive conditions: getting supplies in a horse and cart, keeping meat in a Coolgardie safe, having to manage a hole in the ground instead of a toilet. Robina visited the house where she had grown up. It was just a shack with hessian curtains instead of internal walls. More recently, his mother had been living with her sons in Melbourne and relied on them personally and financially. Adult wages were paid from the age of twenty-one, and she had been looking forward to greater comforts as this birthday approached. But, as Robina said, 'I waltzed in and took her boy.' The two did their best for her, including taking her on overseas holidays, but Robina doesn't think her mother-in-law ever forgave her.

It could be irritating to be married to a mummy's boy whose sympathies lay with his mother and whose expectations of his wife were high. In defiance of custom and propriety, Len expected Robina to keep working after they were married. When his mother briefly took a part-time job, he would meet her when she left work and carry her bag home, saying

afterwards to Robina, 'Poor Mum!' She replied, 'What about poor me?' Nevertheless, Robina was sympathetic to her mother-in-law because of her difficult life. The stark difference between growing up outside Ballarat and growing up in her part of rural Scotland a few decades later was manifest in Len's mother, who was sent to Melbourne not to expand her horizons but with the solitary goal of finding a husband. Robina remained grateful that her parents wanted her to sail away for adventure and new experiences.

Unfortunately, Len had absorbed the patriarchal attitudes of his time, fostered by his mother and his aunt, who had cossetted him because he was not only the eldest child but also a sickly asthmatic. This had led him to expect similar treatment from his wife. Robina and Len lived in a tiny flat in Inkerman Street, St Kilda, with a mattress on the floor, a second-hand fridge and two old-fashioned banana chairs. The first time she cooked dinner Robina assumed that Len would at least help with the dishes, but he insisted that it was her job. Robina left the dishes in the sink. It took years to solve the problem of a fair division of labour.

Robina's stubbornness also paid off at work. There was a rule at Channel Seven (and elsewhere) that when two employees married, the wife had to resign. When management tried to enforce this rule, Robina refused. 'Why should I leave? He can leave if he wants, but I'm not.' She stayed. When her first pregnancy became obvious, Robina was moved to reception, which had a high desk, sparing visitors the sight of her bulge. Then Channel Nine invited her to work for them as a casual make-up artist, which she did almost to the day of her daughter's birth.

While she was in the maternity hospital, Len accepted a job in Wollongong. In those days mothers weren't sent home as soon after the birth as they are now. When she left hospital after about ten days, the car was already packed. Her daughter was put in a cardboard box next to Robina, on the back seat with the dog. Her mother, who had offered to stay with the family and help with the baby, sat up front. The company provided a flat for them on the second level of a building with no lift,

which led to adventures with their large English pram. It was the first of many moves for Len's work. Over time he left television, worked in Robina's uncle's business and achieved promotion in several fields; Robina admired his cleverness. Her career wasn't considered, but Robina found compensations in the adventure of new places.

Robina did find a job in television in Wollongong. She also found friendships and learnt their value in making a complicated life possible. Their landlady, who lived next door, looked after Robina's daughter while she worked. Other neighbours became friends, sharing childcare and acting as guides to the unfamiliar. Moves to Sydney and then Melbourne followed. Robina built businesses with private clients each time. Finally there came an opportunity to experience Nevil Shute's climate. Len took a job in Brisbane, where Robina discovered that warmth is not necessarily all that it's cracked up to be. When the plane landed, she stepped out of the door and got straight back in again. It was too hot to breathe. Len had to push her off the plane.

Robina took a while to adapt, learning about cooking in hot weather, how to manage invading beetles and (the last straw) how to avoid bold blue-tongue lizards. Again, a neighbour made life bearable by welcoming Robina and her family and resolutely folding them into their lives. The two families are still friends.

Steadfast friends are essential to our wellbeing. Clearly, Robina has a gift for making and keeping friends that continues to enrich her life.

She needed that quality when Len moved the family again, back to Melbourne this time, for a job that entailed a lot of travelling for him and a lot of solo parenting of three children for Robina, who also continued in paid employment. At first, Robina struggled with Len's frequent and unpredictable absences. Then her mother gave her some valuable advice: 'Just pretend he's never there. Run your life as if you're the only person in it. He just becomes a bonus.' And that's what she did.

In Melbourne, Robina worked happily in television until, after doing make-up on the news shift one night, she was told she had to stay on

because the person who was to relieve her was delayed. Robina declined; she had young children waiting for her at home. This time she was unable to defy her manager. It was a turning point. She resigned.

After a few weeks at home, Robina applied for and was accepted to participate in a program for women who were out of the workforce and looking to retrain, another Whitlam government initiative. It was 1975; her youngest child had been born only the year before. Robina chose a computing course at Caulfield Technical College, having foreseen the increasing importance of computers. She would drive to college in her little Mini Minor, once again entrusting her children to her next-door neighbour. A few weeks into the course, her car was stolen and she couldn't afford to replace it. Robina found another training course that was closer to home; she could walk the two kilometres each way. That car thief turned Robina's career from computers to secretarial and then managerial work. She was frequently promoted, eventually becoming the national sales administrator for a major pharmaceutical company. Along the way she learned to work with computers despite not having completed the course.

Robina retired at fifty-five, rapidly regretted it, and embarked on a series of different jobs until finally retiring ten years later. That's when she began volunteering. Her first volunteer job was at a local citizens' advice bureau. She and five other women had to be trained before they could begin, providing a fine example of bureaucratic inflexibility and lack of imagination. These women, all experienced professionals, including a doctor, a headmistress and other senior managers like Robina, had to complete a six-week course on how to answer the phone.

Then Len got a job that would take them to India. The prospect was thrilling and the financial rewards greater than they could have imagined. They would be comfortably off for the rest of their lives. Len and Robina bought land in a new suburb and planned to build a house in which they could live on their return. An architect designed exactly what they wanted.

Before they broke ground on the house and before they left for India, in 2008 Robina and Len went on a holiday to Bhutan, a place they'd always wanted to visit. Bhutan was everything they'd hoped for. The landscape was spectacular, as far from both Australia and Scotland as they could imagine. They were entranced by the ancient Buddhist monasteries. Robina thought that this trip would be a highlight of their lives, but what happened next swamped those joyful memories. On their way back, on a stopover in Sydney, Len became ill. He had a chest X-ray and was reassured to be told that it showed healthy lungs. Nevertheless, back in Melbourne, his coughing and general malaise increased. A second X-ray showed lung cancer. Robina found out that the Sydney doctor had mistakenly examined another patient's X-ray. Len had surgery and appeared to be doing well, but he deteriorated rapidly on Christmas Day and was readmitted to hospital. It was found that the cancer had spread to his brain. Len died in January 2009.

As well as her grief at losing Len, Robina was left with a mortgage on the house in which she was living, a second mortgage on the planned house and no income. Furthermore, because of the global financial crisis and the rapid diminution of investments, Len had cashed in his superannuation. During Robina's working life, of course, the money that a woman could accumulate in superannuation was negligible.

Once again, Robina didn't stop to feel sorry for herself. She assessed what she had to do. She learnt how to be a project manager, how to read plans, how to remedy builders' errors (such as finding light switches that had been plastered over) and how to prepare the finished house for sale. She sold it, and then she sold the house she'd been living in. She bought a small unit because everybody said that was all she would need. They were wrong; she needed more space. So Robina bought a larger house down the road, and on she went for a while, buying and selling houses and making money on the deals. In her seventies, she found that she had a talent for reading the housing market. Robina has now lived in more than forty houses.

Robina's most recent move was to Ballarat, to be near her daughters. This came about because of two events in her late seventies that led to her daughters driving from central Victoria to help her: diagnostic surgery and a fall from a ladder while changing a light globe. Robina still lives near her daughters, although she has twice bought and sold her homes.

In the midst of these adventures in real estate, Robina was volunteering. She was involved with the local council's Women's Advisory Group and joined a consumer panel for Western Health, where she served in various capacities for twelve years. She made friends and learnt new skills by joining a choir and taking ukulele and Mandarin classes at the University of the Third Age.

And, of course, she built that boat. It was with an all-female team that met near Seaworks, the maritime history centre in Williamstown. At the first meeting, the other women, who were mostly in their fifties, looked startled when Robina rolled up. But Robina found them to be a superb group of women, all of whom had professional commitments during the day, and she fitted right in.

The group began with about fifteen members, gradually whittled down to ten stalwarts over the four or five years it took to fund the project and to build the boat. The first step was to buy the kit, which cost several thousand dollars. The team devoted each Thursday night to the task of fundraising. They discovered that, as a group of women without wealthy and generous corporate contacts, it was difficult to find sponsors. It took a long time to sell enough washing powder and hold the necessary number of sausage sizzles.

Eventually, they raised the money and by late 2019 the St Ayles skiff was complete. It was modelled on a type of fishing boat common in St Ayles, on the east coast of Scotland: a large rowboat that takes four single-oar rowers, with room for a coxswain as well. It looks magnificent; it would do professional boatbuilders proud.

In recognition of their weekly commitment to friendship and achievement, the women named their boat *Thursday*. They rowed the vessel

around Port Phillip Bay from Williamstown – on Thursday nights, of course. When Robina told her son excitedly that they were rowing in the dark, he exclaimed, 'But Mum, you can't swim!' Learning to swim is on Robina's list, which she'll do in the old folks' home when she no longer cares about her hair. She'll also learn to play the piano.

Robina hadn't rowed in her youth but recalled a time when she was, one could say, rowing-adjacent. She was going through a box of keepsakes when she found a picture of herself as a Sea Ranger in Oban. The photo, which was published in the *Oban Times*, shows Robina and two friends in their uniforms. The caption states that the girls were there to make the afternoon tea for the launch of the boys' boat. Given the challenges with sponsorship and raising funds, maybe times haven't changed as much as some of us would like.

While building the boat, Robina not only learnt to use a drill but bought one of her own, and she can now operate circular saws and other previously alien equipment. She feels stronger and more competent, ready to tackle household repairs and small construction jobs on her own. She hadn't envisaged any of these accomplishments before Len died. 'I didn't go sit in the corner. All my friends are pretty much the same way, including the ones who sat through the citizens' advice bureau telephone course with me. There's so many of us who have lost husbands, but we just get on with it.' Now in her early eighties, Robina continues to get on with it; to row her boat gently but resolutely down the stream.

Social Warrior
Jo Rodger
(b. 1943)

Jo Rodger is glad that her grandchildren have many more opportunities than she had as a child. She would have liked to become a kindergarten teacher, but her parents couldn't afford the training. In her forties, Jo was lucky to have been encouraged by a mentor to study social work and advance her career. She could not have foreseen that her qualifications and experience would become intrinsic to the great tragedy of her life.

When Jo was born in Woking, south-west London, the bombs of the Second World War were still laying waste to England. Her parents were in their late thirties; they had waited a long time for this much-wanted baby. Jo's father was a sheet-metal worker and her mother had been a servant in the north of England. To Jo's regret, her mother was too ashamed of her lowly social status in the large house to reveal much about her time there. Those of us steeped in *Upstairs, Downstairs* and its

successors would find the life of a servant fascinating. Jo's mother didn't see it that way. 'What would the neighbours think?'

Her parents had endured the Great Depression and grown up in poverty. They still had little money by the time of Jo's birth but made a secure and loving home for their only child. Her father was a union man who identified strongly with the working class. Jo shared her parents' passion for social justice from an early age and has voted Labor all her life.

Jo was twelve when the family decided to emigrate to Australia in 1956, in search of a warmer climate to manage her father's emphysema. The voyage exposed her to social inequality for the first time, and this had a powerful impact. The ship's route took them to Cape Town. It was during the Suez Crisis, in which the United Kingdom, France and Israel invaded Egypt, so the Suez Canal was closed to shipping. Before passengers disembarked in South Africa, they were told not to speak to any black person and to use toilets designated for white people only. That puzzled Jo and sensitised her to signs of racism, reinforcing the nascent social conscience that her father had imbued in her.

The family lived in a migrant hostel for eighteen months and then in a housing commission flat in what had been Melbourne's Olympic Village before eventually buying a home in the suburb of Heidelberg Heights. At first Jo hated Australia, where everything was strange and she knew no one. Starting school regrettably brought religious discrimination to her attention, reminding her of the experience of racism on the voyage. After three months in a state school with inconsiderate, rough male teachers, Jo moved to a convent school. Her family wasn't Catholic but she'd had a benign experience in a convent school in England and expected the same in Australia. Instead, she was bullied by the daughters of Irish Catholics because she was English and a non-Catholic.

Jo left school at sixteen, despite longing to continue studying. Her parents didn't have the money to support her and she had to earn an income. She consoled herself by saying that she was only filling in time

until marriage, in line with the prevailing attitude to women's futures. Jo had done shorthand and typing at school and so, after a brief stint at a secretarial college, got a job in a typing pool that led to work in a legal office.

At eighteen, Jo found a job closer to home and became engaged to a colleague. They married when she was twenty. Because couples were not allowed to work together, she had to leave her job. Jo had dreams of being an air hostess, but marriage also barred her from that career, so she returned to secretarial work elsewhere. Prioritising a husband's career was such an entrenched social pattern for women in the sixties that Jo didn't consider rebelling. She was pregnant at twenty-two with the first of her three children and felt obliged to leave work. Jo says, 'I don't think these were the good old days, whatever people tell you. I've got a couple of friends who say, "Oh, everything was so good!" It wasn't. It was awful. Awful for women.'

In the meantime, her husband's career was advancing, as was his political ambition. He became mayor of their local area. Jo enjoyed being the Lady Mayoress for a year and was glad not to have to worry about money. But after her third child was born, Jo began to look about her.

The Women's Electoral Lobby (WEL), an important second-wave feminist group, was founded in Melbourne in 1972. Their mission was initially to survey political candidates' views on matters of importance to women and encourage women to lobby politicians about what mattered to them. WEL made a lot of noise and Jo heard them. It inspired her to redirect her life. In the late seventies, Jo returned to school and completed her secondary education.

Jo's husband didn't support her new endeavour and showed his dissatisfaction by coming home late whenever Jo had an evening class and needed him to be with the children. It was a trying time. She could see no way to change her circumstances, unhappily mired in the family home. Her enthusiasm for voluntary work, such as serving on committees at her children's schools, was not enough to overcome her dissatisfaction.

In about 1980, Jo went on a trip with a friend and met a man who seemed to share her views and support her interests. Her husband, as a member of the Liberal Party, disapproved of Jo's participation in demonstrations, including against the Vietnam War and extending the Eastern Freeway. He was also unfaithful. She decided she didn't want to live in service to his needs anymore. Jo left the marriage and moved to a small suburban flat with her children, aged fourteen, twelve and eleven. To her great distress, her older daughter returned to her father. It was a long time before this daughter would speak to her mother, let alone forgive her.

In 1982, Jo and the two youngest children moved to Sydney to be close to Ron, the man she'd met on holiday. Not long after her arrival, her daughter rang to say that Jo's mother was dying. She had been admitted to hospital for what was thought to be a minor ailment but turned out to be an aggressive cancer. She was expected to die within three months. Jo and the children went straight back to Melbourne.

Jo hadn't been in paid employment since her first pregnancy, but she had enough money from the property settlement after the divorce to stay in Melbourne until her mother died. She then returned to Sydney with the two children, moved in with Ron and found a job as an office manager. Her manager was an American woman who invited Jo and Ron to dinner. The woman's husband (also American) asked Jo if she'd ever been overseas and, when he heard that she'd visited a friend in Washington, he replied dismissively, 'Washington's full of blacks.' Jo recalls, 'My husband and I looked at one another. And for the first time in my life, I realised, "I can't say anything here. Because I'll lose my job, and I need my job."' At home, however, she and Ron discussed the abhorrent racism and Jo decided to take a stand: she resigned from that job within a month.

Apart from missing her daughter, Jo describes the next fifteen years as 'the happiest time in my life'. It wasn't only her new relationship and marriage that sparked such joy, but the beginning of her new career.

Jo interviewed for an office manager's job with a group known as CRC: the Civil Rehabilitation Committee of New South Wales. Jo thought its work was to rehabilitate people who had been injured. 'I walked into their office. Sitting on a chair was this old, dirty man, Fred. I'm thinking, *What do I have here? What sort of a place is it?* Then out comes this Irish lady screaming and shouting at a boy. Fred said, "That's our mad Sheila, and that's some guy they've been helping." So they called me in, and there were four people interviewing. One of them said, "What do you feel about people who've been in jail?" And I said, "I don't know. I've never met one." I got the job! And that changed my whole working life. Sheila was the executive officer. She was eleven years older than I was and the most marvellous mentor I've ever met.'

CRC was a support service for recently released prisoners, helping them to adjust to life outside. It had about 300 volunteers and seven or eight paid staff. Sheila mentored Jo, taking her on prison visits and teaching her about prisoners, incarceration and reintegration into society. She urged Jo to seek tertiary qualifications, both to improve her expertise at CRC and to equip her for anything else she might want to do in future.

Jo took Sheila's advice. She completed a Welfare Certificate and a Diploma in Community Management, the latter at Macquarie University. The course at Macquarie had been designed to suit women of Jo's vintage who were in senior positions at community organisations that had started off as voluntary agencies. All the women were very experienced but lacked formal qualifications. Jo had never expected to attend university and felt unimaginably privileged to be there.

Jo worked her way up at CRC and became the executive coordinator, just as Shelia had foreseen. By then, she knew how to set goals and achieve them. She wanted to work directly with people in need, rather than in administration. Jo became a social worker, assisting people with HIV/AIDS, people with mild intellectual disabilities and communities grappling with inter-ethnic disagreements. There were periods in Sydney and Melbourne, but Jo and Ron finally returned to Melbourne for good

In December 2005, Jo's fifteen years of happiness came to an end. Her 36-year-old son, Simon, became severely depressed. His marriage had ended and his wife and daughter had gone interstate. Simon moved in with Jo and Ron and was supported by a Crisis Assessment and Treatment (CAT) team. Jo was impressed with their care of Simon and of the whole family. Then, at the end of 2012, Simon had another severe episode and Jo took leave to care for him. He was unable to return to his job but eventually found work in aged care. His mental health appeared to improve for a time, but in 2015 he went interstate briefly and returned extremely unwell. Jo felt that she couldn't do her job effectively while caring for him. So, at the age of seventy-three, Jo retired to focus on Simon.

For the next few years, Simon lived sometimes with Jo and sometimes with his ex-fiancée. His sisters did their best to support him. He was drinking heavily and gambling. Jo, who knew the value of support services, joined Mind Australia, one of the largest organisations that support and advocate for those with mental health problems. She was very active in Mind throughout 2016 in particular, including as a member of their carers' advisory committee.

Simon's daughter came to visit him for Christmas in 2016. The whole family was troubled that he seemed to take little pleasure in her visit, although she was the most important person in his life. A few days after Christmas, Jo was on her way to the airport for a holiday with Ron when their granddaughter telephoned to say that Simon had been saying he wouldn't be around the following year. Jo called the CAT team and was told that they would contact Simon and support his daughter. Reassured, Jo boarded her flight.

On her return two weeks later, she found that Simon had deteriorated. The CAT team had left him as soon as he gave his usual response to serious offers of help: 'Nothing wrong with me. All good.' Thus began many frustrating attempts to find help for Simon. He needed to consent to hospitalisation and he would not. After his ex-fiancée found a text message threatening suicide, the police were called, but they said they

couldn't do anything because the message had been sent more than twenty-four hours earlier. His sisters were able to persuade Simon to be admitted to a psychiatric hospital but he discharged himself after less than two weeks. The family's efforts to find help for him intensified over the next two months. Despite having professional experience in dealing with mental illness, Jo was dismissed as merely an overanxious mother.

On 5 March 2017, Simon hanged himself.

The months after Simon's death were the worst Jo had ever experienced. She fell apart. Her grief was exacerbated by guilt over what she believed she should have done. As a former social worker, she had known better than most how to find the appropriate resources. Although the system had worked as it should during Simon's first episode and Jo had had confidence in it, she concluded that the care wasn't sustained and teams across three mental health areas failed Simon completely in his last five years.

Jo eventually dealt with her grief by acting on her anger about everyone she felt had let him down. In the months after Simon's death, she documented every detail of the inadequate care he had received in a passionate letter of almost 2500 words, which she sent to all the area mental health professionals in Victoria responsible for Simon's care:

> During those last six months we lived our own hell. Simon had come back to our house so many times and every time it would not work. I received so much advice from all the professionals stating I needed to let go as he was the only person who could control his life and I was worn out with the anxiety and worry. They assured me constantly that he would not kill himself. I foolishly believed that letting him go would save him. How wrong I was. I knew in my heart that the situation would end badly. I now know that people with mental ill-health need help – some whether they want it or not. Simon was incapable of helping himself and nobody would listen to me. As long as he said 'Nothing wrong with me. All good,' no one could help.

Jo became determined to do her best to change the system that had failed Simon. She met with the heads of the three psychiatric departments and related her experience. She complained to the National Mental Health Commission, and eventually received an assurance that her complaints would be investigated. She met with policymakers, politicians and advocacy groups. She joined a support group called Roses in the Ocean, helping and being helped by others who had lost someone they loved to suicide. She became active in suicide prevention. She was involved in her local Primary Health Network and spoke at conferences, trying to improve understanding, policy and action.

Jo now volunteers with LifeConnect, where she supports people whose experiences mirror her own, and with the Banyule Support and Information Centre (BANSIC), which provides emergency relief in West Heidelberg, where she began as a social worker. In June 2022, Jo wrote to me, 'As Simon has been gone five and a half years, I do not feel the anger I felt in the beginning. The pain of losing a child, regardless of their age, never leaves, but I can deal with it now. I look back and think of all the pleasure we had together and I miss the "well person" so much.'

At BANSIC, Jo volunteers alongside young social workers who keep her up to date with research and practice in her field. Helping others is how she wants to spend her retirement years. While she values the University of the Third Age, she'd rather not hear about any more joint replacements.

At seventy-eight, Jo is also beginning to find enjoyment in the quotidian activities of life. After being impelled to rush everywhere, she appreciates walking the dog for an hour each morning and sitting over a cup of coffee. She can envisage feeling content. As friends become ill or die or lose their husbands, Jo is aware that the future looks less expansive. She thinks she is reaping the benefits of a husband who is ten years younger; Ron remains healthy and active.

Jo has lived a parent's greatest fear, yet she has emerged not as a victim but determined to help others avoid the same tragedy. Jo couldn't

save her son but she is doing her best to save other sons and daughters and to care for families damaged by suicide, as well as for others in the community who need her assistance. She has met parents whose children were very young when they died and is grateful to have had her son for forty-seven years. She has a rose tattooed on her ankle and, each time she looks at it, she thinks of Simon.

Service and Adventure
Kath Clune
(b. 1938)

When I was a student at the Kindergarten Teachers' College in Kew, Victoria, from 1966 to 1968, I was fascinated and horrified by the Carmelite convent next door. Young women who were inconveniently pregnant lived there to save embarrassing their families and their communities, while simultaneously protecting the men responsible. They occasionally sat outside in the sun at the convent's entrance, and a few responded furtively to our attempts at conversation. They were supervised by nuns who could be seen only as shadows behind iron grilles. As far as I can tell, this is still the image that many people have of nuns: shrouded wardens.

Kath Clune is not that kind of nun.

She belongs to a Roman Catholic order called the Missionary Sisters of Service, formed in Australia in 1944 with an initial six members. The order is dedicated to pastoral care, especially in country areas. Their website states, 'We stand with all Aboriginal and Torres Strait Islander

peoples in their struggles to achieve a First Nations Voice to Parliament enshrined in the Constitution and a Makarrata Commission to supervise treaty processes and truth-telling.' They don't avoid controversial subjects. They welcome and support people who have been marginalised.

A recent photograph of twenty-four members of the order shows a group of smiling women in ordinary dress whose median age is probably well over sixty-five. These women don't live in a convent, let alone behind closed doors; they are scattered throughout Australian communities, working where they feel they can best contribute. Kath, at eighty-two, looks at once forthright, gentle and fearless, with soft grey hair.

Kath was born the second of five children to Rose and Jack, teachers who relocated to Sydney from country New South Wales. Kath describes the family's circumstances as 'reasonably well off, but careful'. As Australian historian Joan Beaumont demonstrates in her book *Australia's Great Depression* (2022), the late 1920s and most of the 1930s were difficult years for Australia. By 1932, only six years before Kath was born, more than a third of the workforce was unemployed. The Clune family was lucky to have an income, but care was imperative.

Jack was the deputy principal of the local state school and Rose taught there between pregnancies. The school was close enough to her house that Kath could hear all the announcements over the loudspeaker. Her mother would rush home during the morning break and at lunchtime to do domestic chores, such as hanging out the washing. Kath thinks that Rose enjoyed her paid work and didn't question her additional obligation to manage the household.

As the older girl, Kath was given responsibility for her younger siblings, especially the youngest, Ken. Her mother returned to teaching when Ken was about three years old. Kath took him to school with her during her final year, the Intermediate Certificate (Year 10). He occupied the bench seat next to her and she fed him lollies to discourage him from complaining about having to sit still. The teachers accepted the necessity of her brother's presence.

Some girls grow up to resent being expected to devote their lives to others. In contrast, Kath shaped her life to continue what her family and the church had initiated, and she did so without rancour.

When Kath left school in 1952, she was fourteen. That wasn't unusual for the time. From 1939 to 1990, the state of New South Wales legally mandated that children should attend school only between the ages of six and fourteen.[19] In the 1950s, it was common to spend no more than the compulsory time in education. Kath did win a bursary to complete her Leaving Certificate but managed to have it transferred to a friend whose father had died and whose family was experiencing financial difficulties. The friend, she thought, needed it more than she did. Her parents, in common with most parents of the time, had different expectations for their sons and their daughters, accepting that girls would marry and be supported by their husbands. Kath's brothers were encouraged to finish school and attend university, but she and her sister were not. Despite this gender discrimination, Kath is at pains to emphasise that she was happy and felt loved. Although her older brother was her mother's favourite, Kath thought of herself as her father's pet.

Rose and Jack's marriage was complicated and, although Kath doesn't say so, it appears not to have been wholly beneficial for either spouse. It might be supposed that a mother who worked was a role model for her daughters, but Kath thought her 'distinguished, outgoing' father was the parent to emulate. Kath describes Jack as the leader and decision-maker and Rose as subservient. Her mother seemed content with that role. She could be lively when teaching, but at home was withdrawn. Eventually she became agoraphobic, making excuses not to attend events such as Kath's deb ball or the social activities associated with her husband's active public life. Kath thinks their parents' preoccupations made the children very independent.

Kath began a business course in 1953, but soon postponed it for a year because her mother asked her to stay home and mind the children while she returned to teaching. Looking back now, Kath thinks it wasn't good

for her to spend so much time on her own as a teenager. Nevertheless, during her year at home, Kath found paid work that she enjoyed when her mother was on term break. The responsibility given to someone we would now consider a child is remarkable. 'I had a job at an American bag store on the corner of Pitt Street and Market Street. I was selling handbags in the days before we had plastic bags. I had to wrap them up in brown paper, and that was all a challenge. I did that two Christmas holidays, at the ages of thirteen and fourteen. Then I worked for an architects' firm in Kings Cross. I used to say to people, in my ignorance, that I worked at the Cross. They'd look at me askance and I'd say, "Only during the day!" One of my jobs was for an agent who imported Swiss watches and Tobler chocolates. As a fifteen-year-old, I'd be delivering these watches to the jewellers around Sydney. I'd be getting on and off trams with this open cane basket full of watches that were just wrapped up in tissue paper, probably thousands of pounds' worth of watches. No talk about safety or insurance! Another time, I worked down at the Pyrmont fish markets. Every Friday the boats would come in and they'd parcel out all these fish to people and I'd take it home in the tram. I had a special bag that, if the fish leaked, the water would seep out the bottom of the bag. Smelled like fury!'

In 1954, Kath resumed her studies at business college. At the end of the year she was employed as a secretary with the Public Service Professional Officers Association, thrilled to be earning an adult wage at only sixteen. As well as working, Kath played sport – tennis and basketball – and was active in the Catholic Youth Organisation. She recalls with pleasure one of their St Patrick's Day concerts at Sydney Town Hall in 1956, when she sang and danced on stage with two other girls. Until Kath joined the order, she was a Sunday-school teacher and raised money as a member of what she recalls as the Blind Society Younger Set. At weekends, she ran the 'Little Shop' at St Vincent's Hospital Sydney, a retail store that raised money for patient care. She was always engaged with the Church and always volunteering.

However, Kath wanted to try life in the country. She was imaginative, with a yearning for adventure and independence. On a whim, it seems, she decided to become a governess. Kath left her 'fantastic' secretarial job in Sydney for a small town called Garah, about fifty kilometres north of Moree in New South Wales. It was a very different life. She had thirteen pupils in a tiny schoolroom, reached on horseback or in an ancient Dodge. Kath's role was to assist the children with their correspondence lessons. She loved it.

In fact, Kath loved working in the bush so much that she felt called to join a religious order dedicated to working in rural Australia: the Missionary Sisters of Service. They trained their novitiate nuns in Tasmania for work in communities all around the country. Nuns of the order travelled the Outback, visiting people who rarely saw anyone outside their immediate family for years at a time. Often the women wouldn't see another woman between one visit from the nuns and the next. And, of course, it was in the days before television or most other means of making contact with the outside world. Apart from infrequent mail, communication with remote stations was almost non-existent.

When twenty-year-old Kath told her parents that she wanted to join the order, they didn't welcome her vocation. Rose couldn't bear to lose her and begged her to wait until she was twenty-one, which she did. Kath joined the order in August 1959 and her parents visited her at the convent in Tasmania over Christmas. They seemed reconciled to her decision. As it happened, nun Kath was far more available for her parents than married Kath would have been. She went home every Christmas to spend time with them. She assisted Jack when he had a stroke and moved to Sydney to care for Rose after he died. Rose was determined to die at home, and Kath's devotion ensured that she did.

I am intrigued by the apparent contradictions in Kath's life: the independence and the service; the separation from home and the return of the dutiful daughter. The way I understand it is that she chose to care for her mother as a filial and religious duty that gave her great satisfaction.

The order expanded, rather than limited, Kath's life. Since becoming a nun, she has travelled extensively and had adventures not always associated with members of a religious order. She has worked, usually alone, in isolated areas of New South Wales and Queensland and across the Simpson Desert. She went station-hopping, often in the mail truck, from Birdsville to the Gulf of Carpentaria, staying to talk around the kitchen table well into the night and driving to the next property in the morning.

Since 1962, Kath has taught many Aboriginal children. Her time in Indigenous communities has given her great respect for Australia's First Nations peoples and prompts many anecdotes. 'One memorable week I spent in a small town near Brewarrina with a population of 100, mostly First Nations people,' Kath tells me. 'I stayed in the CWA room and visited families, sharing their meals, teaching their children, but spending most of the day sitting with the women in the red sandy soil under a shady tree, playing bingo. They didn't need buttons to cover the numbers on their well-worn bingo cards. The women would deftly pick up a pinch of red dust between finger and thumb and position it over the number called. One wise comment I remember was from an Aboriginal woman in Normanton in the Gulf of Carpentaria, who said: "The difference between us is that you put things before people, whereas we put people before things."'

In joining the Missionary Sisters, it seems to me, Kath found a way to choose her own form of service; to avoid the typical subservience of a 1950s wife and mother and to maintain her independence while being part of a close, if dispersed, community. 'As a Missionary Sister of Service, I have shared community with many strong, good and beautiful women. As a result I've become a better person. The work I did was one big adventure. Rather *avant garde*! Exciting and full of variety. Challenging. Which strengthened me.'

Kath has now been a member of the order for more than sixty years. The very opposite of those forbidding, cloistered nuns of my youth, she has always sought to enjoy life and speaks of all her contributions and responsibilities as rewarding experiences. She often urges others to take

risks, whether it's climbing ladders to trim vines (as she still does) or going to places overlooked by most other people.

After remote and rural Australia, Kath worked in some very different urban settings. She was appointed chaplain to Mont Park Asylum in Victoria and worked at several other psychiatric hospitals. Kath tried to understand the world of those with mental illness. Why did some do and say 'such unconventional things'? She listened with compassion.

She then moved to Sydney in 1989 for what became a career highlight: being part of the inaugural pastoral care team at the new 100-bed hospice at St Vincent's Hospital in Darlinghurst. It was built in response to the AIDS epidemic and housed patients, mostly men, who were desperately ill. She found the staff, many from the LGBTQI+ community, to be dedicated and inspirational. It was a privilege to become close to young men dying from AIDS and to witness the love and commitment of their partners. Because she had no dependents, Kath was rostered on at weekends. She usually saw about five deaths a day.

In 1994, like so many Australians, Kath was overcome by the news of the genocidal war in Rwanda. Our television screens were dominated by images of unimaginable cruelty and appalling suffering. Kath wanted to do something. She thought she'd never make a competent nurse; she couldn't even mitre a bed. Then she discovered a one-year TAFE course to qualify as an enrolled nurse and completed it in 1996, when she was fifty-eight. All her fellow students were straight out of school and Kath felt like Grandma. However, she topped the state and received the Outstanding Nursing Competence Award for Advanced Enrolled Nursing, a result she attributes to her maturity and experience.

Kath considers this award her key achievement in older age. However, I think topping the state, impressive though it is, has been eclipsed by her undiminished desire to help other people to live and die well. Along the way, she has faced disappointments that she manages to reframe as serendipitous. One disappointment was not getting to Rwanda. In those pre-internet days, it was for the most mundane of reasons. The Jesuits of

Kings Cross wanted to send her to work with the Daughters of Charity in Ethiopia, but they couldn't complete any of the paperwork because the nuns couldn't afford paper for the photocopier. At about the same time, Kath's mother fell and broke her pelvis. Kath thinks it was 'providential' that she wasn't out of the country and was able to look after her.

While caring for her mother, Kath continued to work full-time. She was hired by a nursing agency in Sydney and worked at various hospitals in New South Wales. Then she went back to the AIDS hospice for two years, followed by three years in psychiatric hospitals. She loved it all. Kath also worked as an enrolled nurse for seven years with about twenty very old Marist Brothers, sometimes staying overnight to care for them, relieving the registered nurse. For ten years she worked with the Good Shepherd sisters at Ashfield as their aged care coordinator, looking after women going through the court system. Kath is glad to have stayed in touch with many of the women.

It's not possible to do justice to such a long and extraordinarily diverse career that encompasses paid and voluntary work, not always clearly defined and often overlapping. I got lost trying to write a chronological list. Sometimes Kath had a different job every day of the week, with others at weekends. 'I worked with the Olympic Games, the Paralympics, in 2000. That was marvellous. I was chaplain in the Olympic Village and also a driver. I've worked at the Masters' Games. I did parish work in my local parish. I was a catechist – went into state schools and taught children. I mentored a student for the priesthood, led discussions for Lent and things like that. I was secretary of the local Garden Club. I delivered the local weekly paper because I enjoyed the exercise. I've become an expert on letterboxes! I was a regular at the folk dancing club and active in a book discussion group. I've also been a blood donor since I was a teenager, so goodness knows how many litres of blood I've given. I don't do it anymore. I think when you turn seventy-five, that's the cut-off.'

Then, in 2013, at the age of seventy-five, Kath was diagnosed with cancer of the tongue. All cancer is distressing, of course, but when it

interferes with eating and speaking it can be an exceptional torment. Kath had six operations in Sydney, carrying on with life as usual in between each one, before moving to Melbourne to be near her religious sisters in case she needed continuing care. At the time there were about twenty sisters in Melbourne; now there are about ten. Kath made a good recovery and didn't need to call on her community.

In fact, instead of needing care, Kath has continued to provide it. She doesn't advertise her services; one person tells another, and word spreads. Kath says she has tried to retire several times but always finds something else to do. When she went to Melbourne, she had firm plans to slow down but life followed its usual pattern. She wanted to do 'something nice and humble'. She does housework for older people and checks in on women living alone whose families worry about them, staying overnight if they need extra care. Some are bedridden and live with their children who work during the day, so Kath calls in to feed them lunch. She has worked with qualified gardeners from the local council to maintain the gardens of people no longer able to do it for themselves. She likes the gardening but especially enjoys listening to people talk about their plants and what they mean to them. Even in her eighties, Kath finds real joy in caring for others.

When I ask about her weekly schedule, she thinks for a moment and says, 'On Fridays I help at a nearby Neighbourhood House, cooking and serving free meals for about seventy students. On Wednesdays after school I help at the local Anglican Church with children who can't do their homework at home; English isn't their first language. And on some Sunday afternoons I volunteer at the St Kilda Repair Café, where competent people offer their expertise free of charge to repair items brought in by locals, mostly electrical items. I like the idea of reducing consumerism and fewer goods going to landfill.' This digest comes nowhere near encompassing the breadth of her current voluntary work.

Kath is also a student at the University of the Third Age. She loves learning from her fellow students, who might be physically limited but are mentally alert, with decades of professional experience. She is an iPad

Zoom enthusiast, although she claims it's making her lazy. She combines her volunteering with exercise, such as walking dogs for people who are frail or ill.

Although Kath's order supports independent service, with members dispersed across the country, Kath says they form a compassionate community with a profound bond. They keep in touch online and meet for birthdays and funerals. Despite their valuable work, the Missionary Sisters of Service are not exempt from the broader decline in religious vocation. They are therefore transforming the order to a secular organisation called Highways and Byways to ensure that their work continues. Kath describes its goal as 'supporting people and projects that benefit the environment, especially in rural and needy areas of Australia'. The group is small but growing.

Kath gets irritated when people can't see past her age. She hates being patronised. She is going deaf, which encourages some to assume she's also gaga. 'I'm a little bit overweight, but otherwise I'm quite healthy and still mentally alert.'

Kath is the kind of woman who might go unnoticed except by those who benefit from her ministrations. Nevertheless, she isn't reticent or humble in a Mr Micawber fashion; she knows that what she does is of genuine worth. She is proud of her achievements.

At the same time, she doesn't expect more of life or feel that she is owed anything more than she has. 'I've got a very nice little place that I rent. I've got a cat named Bobby. I love my garden. I'm really enjoying Melbourne; there's so much to see and do, mostly on the weekend when you get free travel.' These days, Kath's world may be smaller than the Outback, but it is no less full of wonder. 'I see everything as a marvel. You go for a walk and you just wonder at the beauty of nature. I want to stop and look at everything.' She is not troubled by what lies ahead. 'I think I'll end up in an aged care facility somewhere. But that's okay. I'm content with that.'

One Foot in Front of the Other

Val Leiper

(b. 1943)

When Val Leiper was seventy-five, she walked 110 kilometres of the Camino de Santiago in Spain. That in itself was an achievement, but Val did it with undiagnosed lung cancer. Her journey epitomises the strength, courage and capacity to seize opportunities that she has demonstrated throughout her life.

Val was brought up in Geelong, then a manufacturing city about seventy-five kilometres from Melbourne. She was the middle of five children raised in a housing commission house. Although money was limited, the children never felt underprivileged. Their father had the thrilling occupation of engine driver, which made them proud. They used to ride their bikes to the railway line and wave as the train whooshed past.

It was assumed by everyone they knew that children would stay at school only for the mandated time (the conclusion of Year Eight) and then earn an income. Val left school at fourteen and found a job at the telephone exchange. It's hard to imagine now, but many calls in the 1950s had to be made by asking an operator to connect you to the number you wanted, even in metropolitan areas. The telephonist would plug a cable into the wall to link the two ends of the line. Val spent all day saying, 'Number, please. Hold the line, please.'

A couple of years into the job, Val had a sleepover at the house of a friend who also worked at the exchange. The friend had a cousin who was a student nurse at St Vincent's Hospital; she entertained Val with stories of patients, doctors, matrons and friendship. By morning, Val had decided that she, too, would become a nurse.

So, at the age of eighteen, Val took a deep breath and went to see the matron at the local hospital in Geelong. Strictly speaking, Val should have completed at least one more year of school, but the matron took her on. The training then was a kind of apprenticeship, where she learnt on the job and carried out most of the manual tasks. Students constituted the bulk of the workforce in public hospitals, working long hours. Val loved it, taking to it, she says, 'like a duck to water'.

But Val knew that marriage was a woman's destiny and she found 'a lovely husband', Neville, brought home by her brother. (How I used to envy friends who had brothers!) She was able to continue nursing, even after her three children were born, with her generation feeling themselves to be pioneers in work after marriage. Single women preferred not to work on weekends, so there were jobs for married women who could maintain their skills on Saturdays and Sundays until they were able to return full-time. There was no such thing as penalty rates.

Neville took responsibility for the children while Val worked. It was seen by men at the time (and too often today) as doing their spouse a favour. 'I had to thank him. I did thank him, because other people were having a harder time and I knew that I was pretty lucky to have a helpful

husband. Even though, once I finished a couple of shifts, I had to catch up with all the housework and washing and cooking and everything else.'

In the late 1970s, Neville found a job with the Forestry Commission and the family moved from Geelong to the Macedon Ranges. It's a beautiful part of the country and they lived at its pinnacle, right on top of Mount Macedon. Val managed the kiosk on the summit, making and serving scones in the tearoom every weekend for all the tourists. Only the oldest child was at school – Mount Macedon Primary – and Val found it to be 'a lovely little life' for a while. However, she came to feel isolated 'stuck up on that mountain' and looked around for something better.

A solution came from among the local community. Someone discovered that Val was a nurse and asked her to work at the nearby town of Trentham, where there was a bush nursing hospital with too few staff. In 1976, Val and Neville bought a house there with a beautiful garden, and she began working a few nights a week, gradually increasing her hours. Val came to feel, however, that she needed to extend her general nursing training. She had never done midwifery but found herself delivering babies because the midwife frequently didn't arrive in time. Val asked the matron at the Ballarat hospital if she could train there but met with disapproval for having children and living too far away.

Nevertheless, when the Ballarat hospital was granted money for a few extra students in 1983, Val was telephoned and told that she had a place if she could start the following Monday. She accepted enthusiastically and then went home to discuss it with Neville, who was happy for her. It was the first occasion since she'd had children that Val had worked full-time, but that's what midwifery training required: fifty-two weeks without a break. She was thrilled to complete the course.

During her midwifery year, the year she turned forty, the catastrophe of the Ash Wednesday bushfires burnt more than 2000 square kilometres in South Australia and Victoria in a single day, 16 February 1983. The man who was to become my second husband was one of many volunteers with the Country Fire Authority battling the blaze on Mount Macedon.

His team was on the golf course, near the centre of the Mount Macedon township, with only a makeshift fire truck. After hours of struggle, they were notified that three fire fronts were about to converge on them. It was obvious that they were not equal to the flames and they managed to retreat at the very last minute over the mountain. Although most of them lost their homes, those firefighters survived.

Across East Trentham and Mount Macedon, seven people didn't escape the flames. Among those who died were Val's aunt and uncle in Mount Macedon. They would have been only a few hundred metres from where the volunteers, including my husband, were doing their best to avoid such a tragedy. Early in the day, Val's aunt had thought that Trentham was more at risk than Mount Macedon and invited Val's family to their house to keep them safe. 'They were down near the Trading Post. She rang me and said, "I think you should come over and have dinner with us. I've got a big piece of silverside."

'And I said, "No, it's alright, because the fire's down near Greendale. It's going south. You're alright and we're alright."

'Later, I went outside and it was hot and the whole sky was red. I wondered if they might have been involved in it and I ran around to the fire station, but they said, "No, everybody's out." But they weren't. They died there. That was hard to take.'

Among the 628 buildings destroyed in the local area were the Mount Macedon kiosk and Mount Macedon Primary School. In Trentham, Val's house was saved. This good fortune was little compensation.

Despite this terrible interruption to the year, Val enjoyed being a midwife. A small community in which everyone was doing their best to rebuild and to recover from grief and loss was a therapeutic place in which to live and work. In the little bush nursing hospital they were careful to select only safe births and to avoid predictable emergencies. The hospital also managed the needs of everyone in the community. 'We had some lovely times with the old people and the new babies. As things progressed, I became the only midwife in the town and I'd go to

bed with a tracksuit beside the bed because I'd be up and down during the night.'

Val was so highly regarded by the community that she was appointed matron without having to apply for the position. She was active in management committees and became intimately familiar with all aspects of running the local health services. This alerted her to the fact that something was wrong, although she wasn't sure what it was or how to make it better. Searching for a way to change management practices, she enrolled in an Applied Science degree, during the years of free university education. Val's attitude of seeing a problem and seeking a solution was to take her far.

Val spent four years dividing her time between working at the hospital and attending lectures at the Phillip Institute of Technology (now part of RMIT University) in northern Melbourne. Val enjoyed university and was surprised that she could do the work comfortably. Her experience and maturity gave her an advantage over younger students.

Resistance to Val's commitment to advancing her career came from her parents and her in-laws, especially her father-in-law and sister-in-law, even her much-loved mother-in-law. They saw it as signalling her husband's failure to support her. Christmas, when the families celebrated together, was always difficult because of the frequent caustic references to latchkey kids. Despite this, Val felt loved by her extended family and understood that they were reflecting the values of their generation.

After graduation, Val saw an advertisement for a job in Sunbury, then a small satellite city, about forty kilometres from Melbourne. Their private hospital was looking for a Director of Nursing. Val applied and was appointed because of her impressive qualifications; somewhere along the way she had also completed a Graduate Diploma in Business Administration. Although she has held several positions since, this was the last for which she had to apply.

She became Director of Nursing under very difficult circumstances. Nurses all over Victoria went on strike in 1986, led by the redoubtable

Irene Bolger, demanding changes to their increasingly inadequate pay and conditions. Nurses and midwives picketed hospitals and went without pay for months; many of them suffered not only distress over their patients but huge financial loss. The strike ended in January 1987, not long before Val arrived in Sunbury. 'The hospital was in absolute turmoil, because that was the only hospital in the state that closed completely during the nurses' strike. I didn't know anyone there. But I soon also became CEO of the hospital, and I ended up working for the organisation that owns groups of hospitals.'

Val drops in that she was in charge of a hospital as though it was nothing.

Before long, she became a troubleshooter for the organisation, frequently travelling around Victoria and interstate to assist with management of other hospitals, flying in and out and home again for a few days. Val enjoyed the work and thinks that her nursing training made it possible because good nursing revolves around solving problems.

In 1992, at the age of forty-nine, Val suffered a second terrible loss. She woke at 5.00 one morning to find Neville dead in the bed beside her. He was only fifty-three. Their children were young adults. It was found that he'd had a major brainstem haemorrhage. Val says, 'That's pretty tragic. That's pretty bad. So, bad things; I try not to think about them.' She kept working hard, grateful to have a demanding job.

After losing her 'lovely husband', Val wasn't looking for anyone else, but Fred was just there. Not only had she gone to the same school as Fred, but he had married her best friend, Maureen. Every school holiday, they and their three sons had visited Val's family on Mount Macedon and then in Trentham. The six children were good friends. Not long after Neville's death, Maureen went to have a post-operative check-up with her GP after a hysterectomy and died suddenly in the medical centre. Fred and Maureen had stayed in Geelong, where Val's parents still lived. As 'the single female in the family, with no husband to look after', it was Val's role to visit her parents. Each time she did so after Maureen's death, she would call in to see how Fred and his sons were coping.

Six years after Neville's death, Fred and Val were married. It breaks one's heart to learn that, after only two years together, he was diagnosed with a brain tumour. Val stopped work to care for him, which she did until he died in 2001. Val is in the unenviable position of being able to speak from personal experience on the relative merits of having someone you love die unexpectedly or slowly. People have said to her that a sudden death is preferable – over quickly – or that you can prepare with a slow death. She wouldn't choose either; both are devastating.

Val's way of coping with Fred's death was to travel. She spent a month in India, visited Scotland several times because that's where Fred's family had come from and where some family still lived, and took trips to other interesting places. She stayed retired for three years, until she was fifty-nine, when a past colleague rang to ask her to fill in for six months – 'just six months' – in hospital administration. Val worked at that position for fourteen years, until she was seventy-three, when her confidence began to wane. She told herself, 'I'm too old to be doing this. People out there probably think I'm an old twit.'

Val was at a loose end – in excellent health, but not sure what to do next – when a niece asked her if she was planning to travel again. Her first thought was that she couldn't be bothered. Her second thought was regret that she had never walked the Spanish pilgrim path, the Camino de Santiago. She had pondered doing it for years, but said to her niece, 'I feel I'm a bit too bloody old now. I don't think I can do it.' Her lovely sixty-year-old niece rang her later that day and said, 'I'll come with you. Let's go!' Then her sister Carleen said, 'You're not going without me.' Val's daughter also decided to join the party, as did one of Carleen's daughters and a daughter-in-law. Val's other sister, Pat, had died only six months earlier, and her two daughters said they wanted to come too. Val was swept up in the excitement and planning.

Despite her good health, about eighteen months before the trip, a medical check found a spot on her lung. She had it assessed frequently with no alarming change detected. Then, about two weeks before they

were due to leave for Spain, Val was told that she should have a biopsy. She refused to consider it until after the trip – a delay of three months – in case the events set in train by the biopsy prevented her from travelling.

So, in May 2018, the full complement of women arrived in Monforte de Lemos in north-western Spain to walk to Santiago de Compostela. The group set off together each morning, with the faster walkers waiting for the others at refreshment stops. Val and Carleen were notable for always enjoying a piece of cake that fuelled them for the next few kilometres.

Sometimes Val walked with her family, sometimes she walked with other pilgrims. I don't think Val has a counterpart in Geoffrey Chaucer's fourteenth-century *Canterbury Tales*, although one of his pilgrims, the Wife of Bath, had also been to Santiago de Compostela before heading off to the shrine of St Thomas á Becket in Canterbury. The main things I remember about the Wife of Bath are that she'd had five husbands, displayed a gap in her front teeth and wore a hat as big as a shield. Nevertheless, Val shared with Chaucer's pilgrims a delight in the stories told by her companions.

The best stories came from her loyal team of women. 'It was the most amazing experience. Even though we saw them at Christmas and we talked to them on the phone, and you think you're reasonably close to your family, you're not, until you actually spend that time on the trail and sleeping in very basic places. We did treat ourselves a couple of times to very flash five-star accommodation, to have a good bath and a sleep. But there was great rapport. It was a wonderful experience. It was the best thing! I was sorry I was so old because, if I was young, I would have gone back.'

Val also loved hearing about the lives of strangers from all over the world. There was a sense of camaraderie, of a communal quest, evidenced in the generous sharing of food and water, as well as stories, along the way.

When she was in trouble, strangers came to her aid. One day Val tripped and fell flat on her face. First aid kits appeared from nowhere and were used to clean away the blood and dirt. A pilgrim doctor assessed

the damage and reassured her. Thereafter, people would recognise the Australian walker who had hurt her face and would greet her, chat and farewell her with a cheery, 'Buen Camino!' The warmth and kindness she encountered filled Val's heart with joy.

Sometimes Val chose to walk on her own, enjoy the scenery and reflect on her life. She'd had two wonderful husbands who would have been thrilled to take this journey with her. Neville would have been absorbed in the history of everything along the way: the tiny churches, the pilgrim shrines, the houses and farms, and the people whose ancestors had seen millions of pilgrims over hundreds of years walk past their doors. Fred would have found the spiritual and religious aspects of the pilgrimage most engaging.

Val finished her walk at the pilgrims' destination: Santiago de Compostela, where she attended the daily pilgrims' mass in the great cathedral. She was overcome with emotion thinking of Neville and Fred and other people she had loved who had died. She thought also of those who had walked with her, both family and strangers, who had enriched the journey with their kindness.

These memories and the continuing love and support from her family gave Val strength to deal with what awaited her on her return: the diagnosis of lung cancer, removal of half a lung, and the rigours of chemotherapy. Once the cancer was in remission, she was frustrated by the onset of Parkinsonian tremors in her hands. However, despite her deteriorating health, Val's pilgrimage had gathered up the strands of her life and knitted them into a fabric that continues to give her warmth and pleasure.

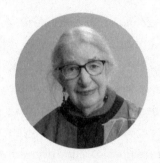

Country Values
Lester Jones
(b. 1931)

At ninety-one, Lester Jones runs her own tutoring business. She has travelled internationally and held senior positions in education. Although she has come a long way since her childhood in rural New South Wales, Lester still thinks of herself as a country kid.

'I was born in Merriwa, which was a town of about 400 people in the Upper Hunter Valley of New South Wales, where the world ended where the sky hit the ground,' she says. 'Most families were interrelated. Any newcomer was regarded with suspicion. My father's family migrated from Cassilis, a town about fifty kilometres away, in around 1900. My father heads the Honour Role for First World War veterans located in the local public school. Our family was seen, however, as not belonging, since we were related to no one in the town.'

This tension between being part of a small community and feeling excluded from its heart seems to me to have accompanied Lester most of

her life. However, Lester has worked hard to build her own community and construct a sense of belonging.

Lester was born into a loving family. Her parents were devoted to each other but their lives were darkened by mourning. Their first child, a girl named Terry, had died from diphtheria as an infant, three years before Lester was born. Local Presbyterian tradition had it that women didn't go to funerals, so that ritual wasn't available to Lester's mother, who never recovered from her grief. Terry remained a presence in the family, forever shadowing Lester and her younger sister, Rosemary.

In Lester's view, it was her parents' deep love that enabled them to carry on. Lester's father was a master builder who caught sight of her mother at a Masonic Lodge ball and determined then and there that he would marry her. She took a lot of persuading, but eventually perceived him as 'the only person in the world who knew everything'. Lester came to regret that her own expectations of marriage and children were shaped by this rare example.

The family left Merriwa in 1943 because there was no suitable secondary school for Lester and Rosemary. At the age of twelve, Lester began at St George Girls' High in Sydney, a school with more pupils than the entire population of Merriwa. She was utterly discombobulated.

Once she had settled in, Lester excelled at school. She especially loved art classes, enjoying biology and botany not only because of the science but also because she had to draw the specimens. However, Lester's options for post-secondary study were limited. Medicine and architecture were men's careers, although some women fought successfully to be admitted. Women's careers were librarianship, teaching, sales and domestic work, all mere precursors to having babies. In lieu of other options, teaching seemed the most palatable choice. In the late 1940s, the Baby Boom brought about an urgent need for teachers in the infants' classes and, upon graduation from teachers' college, Lester spent three very difficult months with sixty kindergarten children squashed into the corner of a school assembly hall with seating accommodation for forty.

It turned out that teaching suited Lester. In subsequent years, she taught at primary schools all over New South Wales and in classes for children with a mild intellectual disability. She loves remembering cheeky students such as the five-year-old boy who tried to teach her to whistle. Frustrated that Lester could produce only the occasional squeak, he pondered her failure and said, 'I know what the problem is. You've got front teeth.' That pronouncement has amused her for decades.

She also recalls overseeing crowds of children at the Hay showgrounds in 1954 for Queen Elizabeth II's first visit to Australia. The Queen stood as she was driven slowly around the showground in an open Land Rover. Lester thought she was beautiful but was 'childishly disappointed' that she wasn't wearing her crown.

Lester sought a relationship that was as happy as her parents' and thought she had found just the man for her. They were married in 1957, not long before she turned twenty-six. At first they were indeed happy. Her father built them a house that Lester compares to the properties on the television show *Grand Designs*. Life seemed to be going in the right direction. Then, without warning, her husband told her that another woman needed him more than Lester did. He had proposed to this woman before he met Lester and she had refused him. Now she was divorced with a four-year-old child, and Lester's husband felt compelled to look after her. He told Lester that she would deal with it because she was 'so strong'. Lester didn't feel at all strong but pulled herself together.

Their divorce left her not only with feelings of failure and grief but also the pain that came from the social opprobrium attendant on divorce at the time. Others taught her that there is dignity in the death of a partner but never in divorce. It was not until 1975 that the *Family Law Act* introduced no-fault divorce to Australia. In 1966, when Lester divorced her husband, it was still necessary for one party to prove that the other was to blame for the breakdown of the marriage. This added unnecessary distress to the process. The stigma only contributed to her sense of isolation. Ultimately, Lester was not fulfilled but saddened by her marriage.

In the divorce settlement, Lester kept the house and accepted $20 a week maintenance for ten years. Although she had been contributing financially throughout her marriage, Lester sought nothing more. She knew that maintaining her integrity and her independence were essential to her survival. She refused to speak ill of her former husband or to allow her family to do so. They found her restraint difficult to emulate.

After living in her beautiful house for a few years, Lester sold it. She felt guilty for disposing of her father's gift, but it enabled her to move on from the divorce. She bought a unit with a river view instead.

Lester has never remarried. She did have suitors, but they wanted to cohabit before committing to marriage and that wasn't consistent with Lester's principles. She was sad to have no children but grateful to be childless when her marriage ended. She didn't think she could tell a child, 'Of course Daddy loves you, dear. He just loved another lady and her little girl better.' These days, Lester does admit to feeling a twinge of sadness when she sees how lovingly her friends' children look after their parents. However, she is a devoted aunt and great-aunt to Rosemary's children and grandchildren. They are equally devoted to her. Lester became an aunt in 1964 and a great-aunt in 1994.

In her determination to lead a fulfilling life, Lester has pursued education, art and voluntary work. She has been so busy that dates and even the sequence of events are difficult to marshal. Lester briefly returned to teaching but decided that she didn't want to do playground duty for the rest of her life. 'There's not much joy in that; the wind blows and the rain falls.' Her previous experience in voluntary social work through her church prompted Lester, in 1967, to enrol in a social work degree at the University of New South Wales. All her education was supported by scholarships; it would not have been possible otherwise. She soon became engrossed in sociology – the study of societies – rather than the practicalities of social work, discovering that it shaped how she looked at the world and her place in it. Given that she was a country kid, she was especially proud to top her year and be awarded first-class honours for her degree.

After graduating, Lester lectured at a teachers' college in sociology and early childhood education, then returned to university for postgraduate study. She tutored undergraduates during this time and, failing to find the textbook she needed on research methods, wrote and published her own in 1978. She felt excited about the ideas she was communicating and loved to see her students grow in understanding.

Lester's students at university volunteered something less innocent than teaching her how to whistle. 'The students offered to get me the very best drugs, and why wouldn't I take them? I said, "Well, to be honest, I've watched you when you're no longer in control of what you're thinking, and I'm not prepared to lose control of my thinking. Thank you very much. I'm sure it would be the best. But no." That was after this student had said, "Lester, what are we doing this for?" I explained that it was research methods. Five minutes later, he said, "Lester, what are we doing this for?" So I said, "John, don't ever come to my class high again. But don't you dare miss the class." So he came, not high. This sort of thing stays vividly in one's memory. Hopefully I had a lasting effect, but what he did, that was his business, when all is said and done.'

Soon after, Lester was appointed principal of a school for children with learning difficulties. She thought that the students would benefit from having a market garden, so she sought an innovation grant to support the work to be done by the children and volunteers. The name 'Lester' has significance in her family despite being uncommon for a girl. It has caused confusion from time to time, occasionally to her advantage. When the Minister for Social Services visited the school, he sat talking with Lester in her office until, somewhat imperiously, he announced that he had come to speak with Mr Lester Jones. He was so embarrassed by his gaffe that Lester received all she'd requested.

Lester's rewarding time at the school came to an unhappy end when, in 1988, she disagreed with the men in authority on an organisational matter. She refused to resign and was dismissed without a reference.

That punitive action immediately rendered Lester unemployable as an educator. It was heartbreaking for her.

Lester applied to Centrelink but was told she was ineligible for financial assistance and was too highly qualified to be found a job or a place in a skills program. She was shocked by the unsympathetic advice to cash in her assets, spend her capital and apply again. Lester instead found work selling blank visiting cards at shopping centres – in the 1980s people sometimes put their name and home address on small cards. That was followed by work in a call centre, where Lester had the unpleasant task of persuading people to buy children's books, whether they had a use for them or not. She hated that job, but it had the very great benefit of allowing her to resign with a reference.

Eventually Lester was once again employed by the Education Department. She worked with the early grades, then as a special needs teacher. When she resigned from paid employment in 1998 at the age of sixty-seven, it marked the end of a bumpier journey than she would have liked. Lester says – implausibly – 'I've been a lady ever since.'

Art has been a significant source of joy throughout Lester's life. To hear Lester describe her artistic influences is to take a guided tour of important early twentieth-century Australian artists. It was when she saw Walter Bennett's work in Sydney galleries that she considered taking her art more seriously. In about 1960 she began attending a class taught by Bennett himself, who had been associated with the Heidelberg School. Bennett was a master of figure drawing. She remembers him saying of the life models, 'Look at the lovely curves through there! Look how this balances that, and how the light goes there and the shadows there.' Lester now has on her walls the nudes she has painted over the years.

Later, when Lester had finished her degree, she took up sculpture. She was taught by Thomas Bass, among others. Lester describes Bass as an Australian icon. He taught her several techniques but it was only later, when she toured ancient sculptures throughout Egypt, that she realised, *This is what Thomas was trying to tell me.* Lester even studied

with Joshua Smith (1905–1995), who is known less for his own Archibald Prize–winning work than for being the subject of William Dobell's 1943 prize-winning portrait that was challenged in court as a caricature. Lester has warm memories of Smith and his approach to teaching. It was on his advice that Lester later joined Graeme Inson's (1923–2000) painting school. Although Lester participated in group exhibitions and occasionally sold her work, she painted and sculpted solely for pleasure.

By 1984, Lester had saved enough money to begin the travel she had long desired. She went all over the world, to more than twenty countries, often with guides who could take her to places not usually visited by tourists. She wanted to see the famous sites but also to experience the cultures of the places she visited, appreciating people's lives from the perspective of a sociologist. 'My chief interest was in observing the ways of the people living in the countries I visited: the role of women, the power structure, the division between the haves and the have-nots.' Travel in Australia was also rewarding. 'I have a drawing on my wall done for me by an Aboriginal Elder. He first drew it for me in the sand and later gave me a replica of that drawing. This gentleman helped me walk up a very steep incline at the tip of Australia as I placed my hand on his arm. This experience was so memorable!'

Voluntary work has also played a large part in Lester's life. Towards the end of her marriage, she began interviewing people applying to the Churches of Christ Social Services Department. Lester was untrained and had to use common sense; she hopes that, in her well-meaning ignorance, she did no harm. It was this experience that led her to study social work. She also volunteered on the Salvation Army Care Line, a telephone counselling service, for twenty-two years, until the service ended. She found it very humbling to hear the diverse difficulties and tragedies suffered by the callers.

A voluntary activity in which Lester has a very personal stake followed her first cochlear implant in 2010. She realised in 1995 that she was going deaf because she had to keep asking her students to speak more

clearly. Her determination not to concede defeat was prompted by the example of her mother, whose deafness and blindness had isolated her from the world. After receiving the magnificent gift of cochlear implants, Lester felt compelled to reciprocate. Since 2010 she has volunteered with the cochlear implant service. She offers herself as a guinea pig to test developments in the device, gives staff a consumer perspective through lectures and discussions, and speaks at seminars for people considering having an implant.

A cochlear implant is not like a hearing aid; it doesn't make sounds louder. People who need the device have lost (or never had) the nerves that carry sound. The implant sends electrical signals to the inner ear, which the person then must learn to interpret. When the device is switched on, there is no magic flood of words and sentences. It takes effort and a great deal of practice to make sense of what is being experienced. The work Lester does as a volunteer, helping people to prepare for surgery, letting them know what to expect afterwards and talking to those having difficulty adjusting to the implant, is invaluable.

Lester moved to a retirement village in Sydney in 1998, when she was sixty-seven. The relocation was motivated by her desire not to be a burden on her family. Extra support is available in the village should she need it.

On her move to a retirement village, Lester didn't relinquish art; instead, she joined the Ryde Art Society. Several members had worked with Max Meldrum (1875–1955) and followed his artistic principles. From 1999 until 2020 she taught art at the local leisure learning centre. When Lester branched out into jewellery making, it was initially to adorn an outfit. She taught herself, drawing on her experience as a sculptor. She has since had a few exhibitions of her jewellery and sold some pieces. Lester regrets that her failing eyesight and an arthritic shoulder prevent her from pursuing this artistic practice as much as she would like.

Lester remains active in the retirement village. She has served on the residents' committee as president and secretary. For years she held an

open house on Boxing Day for residents who didn't have family to visit. It became so popular that it eventually had to be halted after a complaint that Lester had too few chairs. She started a birthday group that held parties in various houses on each person's birthday; Lester provided the cake. She runs a monthly current affairs group and is involved with local churches. Covid-19 lockdowns prompted Lester to initiate and coordinate links between residents needing help and those willing to provide it.

Lester is grateful to be healthier than most people her age; depending on the day, she feels somewhere between thirty and sixty. Her health isn't perfect: she was diagnosed with macular degeneration in 2009 and has lost the central vision in her right eye. She also has considerable back pain from severe scoliosis, which is helped by physiotherapy. But 'otherwise, I'm amazingly healthy'. Nevertheless, Lester has experienced the adverse effects of age stereotyping. In 2021, she was attending a ninetieth birthday party when she fell over. 'I broke the bone above my thumb and a bone in my wrist, but I only knew about one of them. I went for my final treatment at the local fracture clinic and said to the doctor, "I'd be glad if you were to go through the X-rays with me, because I expected pain here which I don't have, but I do have pain here that I don't think can be referred pain."

'He said, "Oh, yes, you've got a fracture there, but we didn't bother to tell you about that because you're eighty-nine."

'I said, "You mean, on the basis of your stereotyping of an eighty-nine-year-old, you made a medical decision for me?"

'He said, "Well, yes."

'I said, "What is the outcome of this going to be?"

'He said, demonstrating some wrist movements, "Well, you won't ever be able to do this, and you won't ever be able to do that." It was too late for me to repair it.'

Lester tells this story in her formal, precise English. One can only hope that her incisive conversation was a salutary lesson for the doctor who had treated her like a poor old dear.

Lester is realistic about the changes that may happen as her health worsens. 'Not being able to see and not being able to be mobile is going to mean a complete change. What I can do in the future will be variable. Perhaps it'll only be as an example to other people, so they can say, in years to come, "Oh, she was wonderful!" Perhaps I'll end up in a nursing home, being nice to people.' She roars with laughter at the thought. But she is also preparing for that time. Lester runs a business she registered in 2000, JD Lester Enterprises. She tutors in primary-school subjects, Maths to Year Ten and essay writing for secondary and tertiary students, with a focus on those with learning difficulties. She can do this work remotely, by telephone or online, so future blindness won't be a barrier. Lester has no need to advertise because satisfied clients refer others to her. She is accredited with the not-for-profit organisation SPELD (Support for Specific Learning Difficulties) but she has no website and employs no staff. It is work that she loves. She needs only a few students to keep her happy.

Above all, Lester believes that what has kept her going is that she has always felt loved by people who are important to her. The other great pillar supporting her life is her faith. Lester says that her first statement when asked to describe herself would be, 'I'm Christian.' She has an astonishingly ecumenical approach to Christianity, having grown up participating in the Methodist, Presbyterian and Anglican churches, as well as the Church of Christ and the Salvation Army. She attended a Catholic school and lives in a Catholic retirement village while being a parishioner of the local Church of Christ. She feels comfortable almost anywhere. Underneath the folderol, she thinks they are all sending the same message. This is telling because, for all her achievements, what strikes me as most remarkable about Lester, a cultured, sophisticated, well-travelled woman, is that she has maintained her down-to-earth Merriwa attitude. She enjoys talking to people of all ages and has dear friends in their sixties, one of whom she nursed as a baby. 'At heart, I'm still a country kid. My friends are appalled that I will speak to anyone, at

any time, anywhere. I am amazed myself, sometimes, at the people who tell me the most intimate details of their lives as I travel on buses and so on. They unburden themselves and I empathise with them.'

It seems to me that Lester, once an outsider, has built around herself a community network as strong as that of a country town. She has created a world in which she feels completely at home.

Carpe Diem
Rosemary Salvaris
(b. 1945)

When Rosemary Salvaris was in the first year of an Arts degree at the University of Melbourne, majoring in Latin with sub-majors in English and History, her mother commented that she was disappointed Rosemary wasn't bringing home any of her paintings. That was when Rosemary realised that her mother had no idea of what she was studying. The great gulf between her parents' understanding of university and her own was telling.

Rosemary describes her family as working-class, although her parents were relatively well educated for the times. Her father had completed Year Ten and worked for a few years before fighting in the Second World War. He was demobbed in Queensland, where Rosemary was born. Three more children, a girl and two boys, followed with barely a break. Until she married, Rosemary's mother had been a nurse.

When Rosemary was five the family moved to Gippsland in Victoria, where they managed a small dairy farm. Rosemary later wrote vividly about her childhood for her granddaughter:

> I loved the cow breath smells in the milking shed and the fun of hunting for eggs in the hay, but it was a challenge for me, as the eldest, to go out into the frosty paddocks and bring in the cows and then get the wood stove going for breakfast because Mum and Dad were busy milking. I speared pieces of bread on a long toasting fork and made breakfast for the other kids.

Rosemary was puzzled and angry when she and her sister were sent to board at a convent school only about eight kilometres away. They were told it was because there was no other Catholic school nearby, but Rosemary has since come to understand that her mother would have been overwhelmed by dealing with four very young children, a house and a dairy farm, with no running water or electricity and no extra help. While life seemed like a daily adventure to young Rosemary, each day was a Herculean labour for her mother.

After a few years of struggle on the farm, the family moved to the suburbs of Melbourne when Rosemary was nine, finally settling in Strathmore, about ten kilometres north of the CBD. Her father worked as a builder and eventually went to night school before starting his own business. The children were enrolled in local Catholic schools. When they weren't at school they played games in the street, roamed the suburb, had adventures and got up to mischief, as did most children in those days. Rosemary was aware that some neighbourhood children were in her clan and some were not. At the time she thought it was because her friends came from large families and were more adventurous than the others, but she now attributes the separation to religion: Rosemary was with the Catholics. Denominational Christianity in the 1950s was strictly tribal.

Rosemary's parents took it for granted that girls grew up to get married, have children and run homes. When Rosemary was in Grade Seven, they told her that she had to leave school after completing her Merit Certificate, undertaken in Year Eight. That was the mandated end of formal schooling and the time when most children went out to work.[20] However, Rosemary had been doing well at school and was awarded a diocesan scholarship by the Catholic Church. These scholarships were transformative in the lives of working-class children, paying for them to focus on preparing for a junior government scholarship that would allow them to remain in school for Years Nine to Twelve. Rosemary spent Year Eight at St Philomena's, which has since closed, with thirty-nine other children, hot-housed in a single classroom. Every pupil won a government scholarship that year, so the effort was worth it, although Rosemary was thoroughly miserable. Those lucky scholarship girls were terrorised by a nun, their sole teacher, whose vocation evidently didn't include nurturing children.

With the government scholarship, Rosemary went to St Columba's College. She found her time there rewarding and intellectually stimulating. She made friends, played sport and joined clubs. She also remembers with delight the tidbits of advice given by a nun (who seemed to be very old) in the sex education class: 'If you are driving with a boy, always check that there are handles on the inside of the car door', 'Never wear red because it inflames passion', 'Never wear patent leather shoes because they can reflect your underwear.'

Rosemary's parents were happy that scholarships gave her the opportunity to finish secondary school, but they made no allowance for her homework or examinations. All the children were expected to complete their chores and share family mealtimes. Rosemary's sister was also a scholarship student and the same rules applied to her, but things changed when it was time for her brothers to be educated. They didn't win scholarships but were sent to St Kevin's, a more prestigious school than St Columba's. Rosemary believes that the distinction was not about

gender but arose because her father had started to make money and her parents could afford it.

University had not been on the horizon for Rosemary – it was certainly not part of her family's plan – but when two friends applied, she did too. One friend applied for Physical Education, aiming to teach, and the other for Medicine. Rosemary put her name down for both, imagining that she could combine the two rather than confining herself to one course. Among her subjects in the final year of school was Latin, essential in those days for Medicine. Although Rosemary was not accepted into Medicine, her love of the classics persisted and she remains a member of the Classics Association.

When her father learnt that Rosemary had been accepted into Physical Education, he insisted that she wasn't going to university 'to grow muscles'. Furthermore, she had to support herself and the only way was to become a teacher. In the fifties, sixties and seventies, the Baby Boom made huge demands on schools, so governments funded potential teachers, not only covering their university fees but also paying them an allowance. Students were bonded to teach in government schools for three years after graduation. (A woman who married had to teach for only one year; this acted as an incentive for some reluctant teachers to marry.) If you failed to fulfil your bond, you (or more usually your parents) had to repay the full cost. The scheme ended only in 1978 when the Whitlam government removed fees for tertiary education.

Rosemary was thrilled to get into university and loved the sudden rush of freedom she experienced. She enjoyed her subjects and made friends. At university she met Mike, the man who became her husband, and through him discovered that other families did things differently. His parents were medical doctors and one of his grandmothers had an Education degree, so they knew about university. During examination periods, his study and revision time was the family's priority and his meals were brought to him at his desk on a tray. Rosemary was astonished at the extreme contrast in parental attitudes. Exams or no exams, she was

told to hurry up and do the dishes. From her studentship, she paid board to her mother. Nothing like that was expected of Mike, who was always supported to do well. Rosemary didn't feel hard done by, though; that was just the way things were.

Inevitably, once she had finished her Arts degree and a Diploma of Education, Rosemary was sent to the country to teach English and History, which delighted her. She decided to turn to her advantage what some young teachers saw as a penance. If she were too far away from home to commute, she would really be independent, and therefore she requested Horsham, a regional city more than 300 kilometres from Melbourne. The city was surrounded by wheat and sheep.

Rosemary set off to Horsham feeling unsure about teaching, but during her year there discovered that she loved being in a classroom. She also developed a lively social life, playing netball and basketball, walking with friends in the nearby Grampians and joining the local amateur dramatic society, with a role in the musical *Annie Get Your Gun*. When she could, she took the train to Melbourne to see Mike, whose prolonged period of study encompassed a Law degree, an Arts degree and articles to become a solicitor. He still had a year to go when Rosemary had worked off her bond – the second two years in Melbourne – so she decided to spend 1970 in England.

Rosemary went on her own but made friends on the boat. She also had friends to connect with when she arrived, and shared houses with various groups in inner-city London. To fund weekend trips to Europe and all over Britain she worked two jobs, teaching during the day and having raucous fun being Maid Marian at the Blue Boar Inn at night. It was a marvellous year.

On her return, when Rosemary was twenty-five, she and Mike were married. Mike encouraged her to pursue a career in any field she chose. After briefly toying with the idea of being a radio presenter, Rosemary continued teaching. She stayed at her next school, Niddrie High, for twenty years.

Marriage didn't render Rosemary unemployed (the marriage bar had ended in 1966),[21] but it did terminate her access to full superannuation. Women teachers – and women in other professions – had to leave their super fund on marriage.[22] It was 1987 before she was allowed to become a member again. To put it in context, in 1972, the year following Rosemary's wedding, only 32 per cent of workers in Australia were covered by superannuation.[23] No wonder Silent Generation women have little, if any, super savings to fund their post-retirement years.

Rosemary reduced her teaching to part-time after the birth of their two children, the first in 1975 and the second two years later, combined with brief periods of family leave. Going part-time required teachers to resign and reapply, thus losing accumulated long service. She remained part-time until the early 1990s. Rosemary was active in important social causes all through her years of part-time work. The family lived in the inner-north suburb of North Fitzroy, an area that encouraged their political engagement. Rosemary had already fought for what was called control of entry – the now unremarkable expectation that teachers should be qualified to teach – and equal pay for equal work. She describes lack of parity with men as her most important battle. Alongside that, she agitated for high-quality, readily available childcare, which was almost impossible to find. With a group of parents, Rosemary established a community childcare centre, to which every parent committed time. This was the beginning of her passion for local community projects.

Rosemary's years of part-time teaching certainly didn't constitute stagnation. During this time she became, sequentially, a marker of English examinations, the chair of the committee for marking one section of the paper and the chair of the committee that set the questions for the Year Twelve English paper. Rosemary describes it as a period of academic growth. She joined the council of her children's school, formed and joined parents' groups and book clubs, and made new friends.

In 1992, when the Higher School Certificate (HSC) was replaced by the Victorian Certificate of Education (VCE), Rosemary stopped marking

exams and returned to full-time employment. However, she took on a different role, becoming a District Provision Officer, which required her to coordinate a whole district of schools to enable them to provide a full range of VCE subjects to their students. She worked with a team that gathered data on subjects being deleted from the local curricula and used the data to demonstrate that students were being disadvantaged by the lack of choice. Her task was then to guide the school communities to understand that amalgamating all these small schools into a multi-campus college would benefit everyone. She found herself absorbed by the work.

Alongside her enjoyment came increasing skills and expertise. Rosemary's principal noticed this and encouraged her to consider becoming a principal. She therefore completed a Diploma of Educational Administration, part-time, after work, to ensure that she was qualified for a principal's position. Mike continued to encourage her in her career, as she encouraged him in his. Their relationship sounds like the model for an equal partnership.

Rosemary applied for four or five positions as a school principal, learning how to be interviewed and how to deal with rejection. She was finally appointed to a new multi-campus college, first at the junior campus then at the senior campus. The area was more socioeconomically disadvantaged than she had previously encountered, with students of many nationalities and cultures, but she felt that she was learning and growing and making a difference.

Towards the end of her twelve years as campus principal, the school experienced a series of losses and grief that Rosemary felt ill-equipped to assuage. Inconceivably, in one year three students and two staff members died. She wondered what was required of her as a leader. How could she help the school community to manage their grief? She brought in counsellors, of course, but was concerned about whether she was saying the right thing in school assemblies, or at funerals, or when visiting the families of those who had died. She wanted to learn about how best to deal with other people's grief. Winging it wasn't enough.

Rosemary enrolled in what she thought was an unassessed work-shop. It was called 'Helping Families Deal with Grief and Dying'. She didn't want to be a counsellor, just to learn some techniques. It wasn't until she turned up for the first lecture and there were instructions about essays and exams that she realised it was one subject of a postgraduate qualification at Monash University that also trained her as a celebrant. It was a struggle to combine it with her responsibilities as a principal. 'I would chair the curriculum committee to get them out at five o'clock, which can be hard, and then I had to lock up the school. I had to be in the car, on the road to the Caulfield campus, park and be in the room at six o'clock. It was just such a stress, getting there! And then doing the essays and so on. I can remember my husband being terrific about the essays. He'd say, "You just get in there and do it and I'll cook dinner."'

The course covered everything from the music and poetry associated with ritual, through cultural and historical rites of passage, to managing a business. The students were mostly women, predominantly teachers and nurses. Rosemary loved being with her classmates and came to know them well. She was profoundly affected by the material and soon felt better equipped to give her staff, students and their families the support they needed.

However, after the first year of the course, she began to experience what is often called burnout: feeling overwhelmed by the pressures of work. She had gone on holiday to England and was hiking along Hadrian's Wall, relaxed, enjoying the sun and contemplating life, when it occurred to her that this was how she wanted to feel in future: not stressed.

Rosemary was sixty-one. She had intended to retire at sixty-five but recognised that the time had come. For almost twelve years she had arrived at school at 7.30 each morning and often didn't leave until 9.30 at night. Apart from the crises and the recent grief she was physically exhausted. Rosemary had been mentoring her deputy and knew that he was ready to take over. It was a huge relief to give her twelve months' notice.

Rosemary's graduation from the course coincided with her retirement from education and she became legally authorised as a civil celebrant. At first, she planned to conduct funerals and weddings. One of her first ceremonies was for a stillborn baby. 'Coming home, I had this terrible experience. I was completely overcome. I couldn't drive, and I realised all that grief that was sitting inside me was still there. I hadn't done anything about it; I didn't even know it was there. It was quite cathartic, but I decided I was not going to do funerals. That was not how I wanted to feel.'

Her son built her a website and word spread. She learnt to become active on social media. Rosemary has now officiated at more than 300 weddings. She finds it joyous to understand exactly what the bride and groom want, to design and write a ceremony that will please them, and to incorporate appropriate cultural elements. Because she doesn't rely on it financially, being a celebrant is a pleasure, not a source of stress.

At seventy-six, Rosemary began to see her wedding bookings growing again with the lifting of the pandemic's public health restrictions. She has even broken her no-funerals rule and conducted funerals for the parents of her friends. These were nothing like the heart-rending funeral for the baby because their deaths came after long and fulfilling lives; there was no violation of the accepted course of life and death.

Rosemary's practice of an extended annual hike was also interrupted by the pandemic. In previous years, she and Mike walked across England, hiked Mont Blanc and wore out boots all over the world. She loves the rhythm of walking: the chance to look around a changing landscape and the way it frees her thoughts. She said, 'I want to be able to keep doing that until I cark.'

To keep herself fit and entertained between trips, Rosemary has taken up orienteering. This competitive sport originated as a training exercise in land navigation for the military. Using a compass and a map, the goal is to navigate unfamiliar terrain as speedily as you can. The winner is the fastest around the course. Distances vary depending on whether it's

a sprint or a long course, but it's usually about five to seven kilometres and can be much longer. Devotees take it very seriously; it is far removed from a stroll around the park. Orienteering seems to me to be a bracing walk (or run) with a purpose, rather than golf, which is a good walk spoiled. Rosemary competes on her own, or with her dog, or with her husband or son.

Since the beginning of the pandemic, an app has taken over the role of the officials who used to staff checkpoints. Rosemary downloads a new map for each event, and the app makes a very satisfying 'ping' as she approaches a checkpoint. Managing the map and the dog can distract her from identifying tree roots and other obstacles in her path, so she prefers to take a companion as dog wrangler or to be completely on her own to avoid unnecessary falls. Her husband enjoys bushwalks and her son welcomes the opportunity to chat, but Rosemary's daughter is far too fit to walk even at Rosemary's cracking pace and would want to run all the way. When she's on her own, Rosemary can concentrate not on winning outright against those decades younger, but on beating people her own age. It's very satisfying when she does.

To acknowledge her seventieth birthday, Rosemary decided to stop dyeing her hair, thinking that the moment had come to cease fighting time. Although she is resigned to this new tonsorial display, she is adamant that it changes people's perceptions. She felt the need to warn family and friends that her hair would be grey before she did it. Rosemary certainly doesn't think of herself as 'elderly' and won't accept patronising or rude comments occasioned by her age. However, she does enjoy the perk of being given a seat on public transport, and doesn't usually mind when people call her 'dear'.

Rosemary has many friends, most around her own age, with whom she has robust conversations. They are, like her, physically active, dedicated readers, independent thinkers and eager volunteers for good causes. She participates in the University of the Third Age and enjoys volunteering, as do most of her friends. In particular, she is a member of Friends of

the Darebin Creek and spends days weeding and clearing up the banks and waterways in her community.

Among the topics she discusses with friends is her generation's lack of a sense of entitlement. 'We didn't have massive expectations. We enabled things by studying, or taking risks, or applying for jobs, or whatever. When they happened, we were happy and got on with them. I know my parents had harder lives than I did. I was born at the end of the war; they went through it. We weren't wealthy, but I never wanted for anything. We'd go camping every holiday. We had a good life. I don't feel that I've missed out. I know that there were other ways of being in the world, like my husband's family. They were much wealthier than we were and they had people to mow their lawns and do their housework. But I don't think, in looking back, it made them happier or me not so happy.'

As my Latin teacher, Miss Bazeley, might have said, had she known Rosemary: *Tempora mutantur et nos mutamur in illis*: the times are changing and we change with them.

A Resilient Rebel
Raylee George
(b. 1945)

We don't like to discuss class in Australia, but its existence is indisputable. Several chapters in this book are about women whose lives have taken them from their working-class origins to the educated middle class. This chapter is about a woman who was born into a professional middle-class family but rebelled against her parents' staid respectability and chose a less conventional path. I don't think this is a fall or a failure. The middle class didn't treat her well; a retreat from it was a life-saver.

Raylee George is the eldest of four children. Her father was a pharmacist in Quambatook, northern Victoria, and her mother became a podiatrist at about the age of forty. Raylee's mother sounds impressive. Raylee admires her strong work ethic and is glad to have inherited it, but they didn't get on well.

At home Raylee was subjected to the kind of physical discipline that was unpleasantly common at the time: smacking, a thump or two with a

wooden spoon or a piece of bamboo, a hearty beating with a belt. While acknowledging that she was naughty, Raylee describes her experience as emotional and physical abuse. Rather than pulling her into line, the reprimands, the yelling and the pain strengthened her resistance. It seemed to her that her younger siblings were not subject to the same restrictions and had much less turbulent lives. No child in a family has the same experience of parenting as their sisters and brothers: they bring to it a different psychological make-up and have parents who are at different ages and stages in life. They can give conflicting accounts of family life.

Raylee's parents hoped that she would, like them, have a professional career. She was sent to a well-established co-educational boarding school in central Victoria, both to ensure a good education and to make her parents' lives less stressful. Raylee stayed at school to complete Year Twelve and did her best. She passed French (in those days, a language other than English was essential for getting into university) and was dux in English. The end of the road, however, was signalled by a Theory of Art exam that asked questions about topics that had not been taught during the year. Failing Matriculation seemed like just another injustice.

As soon as school was over, Raylee ran away from home. She just didn't want to lead the life her parents had planned for her. 'I couldn't be bothered any more. I was not free to do what I wanted to do. I thought Mum was a bit Victorian-era and I was heading for the sexual sixties. I didn't want to rush out and be madly sexual; I just wanted the freedom to enjoy music and all that sort of thing.'

Raylee found lodgings with a doctor and his wife in Kerang, about forty kilometres from Quambatook. Her mother begged her to come home but she refused. Raylee took a job on a dairy farm nearby, doing chores in the house and in the dairy. It was far from the professional career of her parents' dreams.

She might have reconciled with her family were it not for one of those events that seem designed by fate or patriarchy to ruin women's lives. As she often did, Raylee went to a country dance in a packed hall that was

lively, noisy and smoky. The music was loud and rhythmic: lots of twist and stomp, a bit of rock. Raylee had a 'sort-of boyfriend', but he wasn't there that night. When the dance ended, Raylee, tired and exhilarated, was offered two lifts home: one by a local policeman and one by a group of rowdy boys. Raylee was nineteen; she knew where danger lay and got into the policeman's car.

He raped her on the way home.

Raylee didn't tell anyone. Who would believe her? She was not only female, she was a proven rebel. He was a man with a warrant card and a uniform.

When Raylee told her parents that she was pregnant, they were outraged: 'You can't live in this town. People will talk! We're professional people. We can't have this disgrace.' She recalls no concern for her welfare before they dispatched her to Melbourne. Her kind sort-of boyfriend let them think that the baby was his, although he didn't accompany her to the city. When, at the age of sixty, Raylee eventually told her mother what had happened with the policemen, her mother seemed unmoved. She offered no support even then; nor did she seem to understand the significance of that event in Raylee's life.

Raylee found a string of cheap rented rooms in Melbourne and supported herself throughout a difficult pregnancy in various short-term jobs: waitress, sales assistant, clerk. She was twenty and on her own when the baby was born in 1965, in a suburban hospital. Raylee was allowed to see the baby once before she was made to sign adoption papers. She suspects that her mother took steps to ensure that the baby was removed from Raylee and not brought into the family.

In the 1960s, adoptions were not arranged centrally but privately. Public policy ensured that neither the mother nor the adoptive parents knew the identity of the other. This was thought to be in the best interests of children who, it was assumed, would grow up in ignorance of their origins.

After the adoption, Raylee continued to work in temporary positions around the state: waitress, receptionist, sales assistant, factory hand.

In 1969, when she was twenty-three, she married the kind sort-of boyfriend because that seemed to be what was expected. People kept asking her when she was getting married and warning that she'd be 'left on the shelf' if she waited too long, which they said would be a terrible fate for a woman. She felt no deep passion for her husband but was pleased that he didn't object to her working. As long as Raylee didn't tell her employers she was married, she was free to work.

When she became pregnant for a second time, being married did not lead to a happy result. Raylee was working at the Phillips electrical factory, soldering keyboards, when her waters broke, before her due date. She rushed to hospital, where she was told that the baby was well. After a long labour, he was stillborn. Raylee wasn't allowed to hold him; they gave her only a quick look at a tightly swaddled bundle. She was told later that he was deformed, with only one leg and other problems. She was desolate, weeping inconsolably. The date her baby died, 15 October 1970, is permanently engraved in her mind as a day of tragedy, because it was also the day the West Gate Bridge collapsed, killing thirty-five people.

On Christmas Eve that year, in an act of bizarre cruelty, Raylee received an invoice for $15 from a company of funeral directors for the disposal of her baby's body. She rang the hospital, thinking that dealing with a stillborn baby was their responsibility, and was told that the body had somehow been forgotten and was discovered decomposing in a refrigerator or a drawer or a cupboard or somewhere else inappropriate and they'd had to call the undertaker. 'I've never really gotten over that. But there's an Aussie saying, "You just have to suck it up," and that's basically what I've done over the years and become resilient. Because you have to.'

Raylee's third pregnancy produced a healthy daughter in 1972 and she stopped work to care for her. Given all that she had suffered by the age of twenty-seven, it's not surprising that Raylee experienced severe postnatal depression, which happens after about one in seven births, including to those without a damaging history or mental health problems. Raylee did not realise at the time that her symptoms – a low mood, feelings of failure

and inadequacy, and a sense of hopelessness and emptiness – had a name, and she never sought help.

Raylee felt chronically unsupported and isolated. She didn't bond with her baby. One of the critical factors in recovery from postnatal depression is the support given by family and close friends. If Raylee was offered support, it was insufficient to overcome her existential feelings of rejection.

Her son was born two years later. This was a happier experience, although three years on, in 1977, her marriage ended. When they separated, Raylee says, her husband threatened to kill himself if she took the children. She castigates herself now for giving in to his emotional blackmail, but she believed him and didn't want to be responsible for his death. She began her peripatetic life around Australia. People have blamed her for walking away, but Raylee did what she thought was right at the time. She saw her children again only when her ex-husband brought them to Darwin for a brief visit before they all returned to Victoria during 1986, when her daughter was fourteen and her son was twelve.

Raylee became an itinerant worker, using her car as her base. There's a song called 'I've Been Everywhere, Man' that was a hit for Lucky Starr in 1962. It was a kind of pre-rap rap, a list of Australian towns and settlements. It could be Raylee's theme song. She worked in towns and cities in Victoria, New South Wales and Queensland, as a fruit picker, a barmaid and a factory hand, until she reached the Northern Territory in 1979 and settled in Darwin. She enjoyed most of the work and learned what she describes as useful life lessons from the array of people she encountered.

In Darwin, after a brief period as a barmaid and a sales assistant, Raylee discovered typesetting. She was recruited into the occupation by chance in 1980, when a neighbour who worked at a newspaper asked her if she could type. She could, and was employed to fill a vacancy at *The Darwin Star*. When that newspaper went out of business she moved to the *NT News*, today best known for its sensationalist headlines. Because she had acquired the habit of working only briefly at any job, she left to

become a court reporter, but missed typesetting and returned to the *NT News*, where she stayed for six and a half years. At the same time, she ran a cleaning business. Laziness was not one of Raylee's faults.

A modern typesetter arranges text and images on a computer to achieve a pleasing layout before printing or digital publication. Although it's not the typesetter's job to produce the content – to write the words or take the photographs – the typesetter has to care about the presentation and readability of the publication as a whole. The typesetter chooses the font and makes numerous design decisions. For example, how do you ensure that there aren't stacks of hyphens at the ends of lines? That words aren't too spread out or too close together? That there is the right amount of white space on a page? A good typesetter is a graphic designer. Raylee, in her mid-thirties, sought to secure an apprenticeship to learn all aspects of the trade but was judged to be too old. Instead she watched closely what more experienced people did and, impressively, taught herself. When she left Darwin for Victoria in 1986, Raylee continued to work as a typesetter.

It wasn't until she returned to Victoria that Raylee learnt of her parents' divorce. She hadn't seen her father for many years and heard that he was about to have coronary bypass surgery. She spoke to him briefly on the phone the night before the surgery. The next morning, she went to visit him in hospital, only to be told that he had died. Raylee found that to be very unsettling: she had been envisaging a reunion, perhaps even reconciliation, only to have death intervene.

In the aftermath of her father's death, Raylee began to visit her mother every month and she feels that they developed a close relationship, despite her mother's lack of insight into the difficulties of Raylee's early life.

Raylee had also been wondering about what had happened to her adopted daughter and whether she might look for her. Policy had changed and in 1978 an organisation called Jigsaw had been established to help the parties to adoption make contact. Raylee sent her details to Jigsaw, in case her daughter was seeking information about her birth mother. Against all principles of ethics and caution, someone in the organisation

(or perhaps the Department of Social Services – Raylee isn't sure) contacted the young woman and informed her that she was adopted. Raylee's biological daughter was about to have her first child and her mother was dying of cancer. It was not news that the daughter wanted to hear, especially not then. She did eventually contact Raylee and they had an awkward meeting and further occasional contact, but they had too little in common to build a relationship. Anyway, as Raylee says, she is not child-orientated. Despite society's powerful expectations of women's roles and feelings, not all women are. There are many reasons for the disinclination for motherhood or the realisation of one's unsuitability; Raylee's life experience contributed to hers.

I asked Raylee whether rebelling and running away had secured her the liberation she sought. She said that she felt so each time but, in hindsight, she could probably have made better decisions. However, running away is ultimately what led her to discover typesetting and she has loved every minute of that.

Raylee didn't return to Victoria as a single woman. She had met a Melbourne man in Darwin who came back with her. She married for the second time at forty-two and was happy in that relationship for nineteen years. But Raylee's husband was fourteen years her junior. What might not seem to be a problematic age gap at forty-two and twenty-eight can expand to an unbridgeable gulf at sixty-one and forty-seven. He left Raylee for a woman closer to his own age. She now considers a partner to be a liability and plans to stay single.

Raylee's mother retired from podiatry when she was eighty-three, when poor eyesight caused by age-related macular degeneration made it impossible to keep going. She moved into a retirement village in central Victoria. Raylee felt a filial responsibility and decided not to relocate to Tasmania as she had planned so that she could continue to visit her. Raylee maintained contact with her mother until her death in 2011.

Meanwhile, Raylee had continued to work as a typesetter, taking jobs throughout the inner and outer suburbs of Melbourne. Along the way she

completed a Certificate IV in Information Technology. Raylee had been at the *Pakenham Star News* for seven years, her longest commitment to one employer, when they decided to outsource their typesetting overseas. She was made redundant in 2012, at the age of sixty-seven. At first, Raylee was untroubled. She went on the old-age pension and planned to settle into a comfortable life of retirement, thinking, *This is great! I don't have to work anymore.* She began volunteering at an aged-care facility, taking recently hatched chickens around the rooms to brighten the days of patients with dementia, but found it too sad to see people who seemed to be just waiting to die.

After three years, Raylee realised that she was bored. At the age of seventy she applied for a job in a call centre, went for an interview and was astonished to be given the position. At first, she couldn't help feeling that a call centre was a drop in status. However, she soon realised that the work demanded knowledge of insurance law as well as company policy, and skill in dealing with difficult customers. Raylee is now a Major Claims Consultant, helping people make insurance claims and dealing with warranties on their cars. She works there still, three days a week, at seventy-seven.

Even those in their mid-fifties know that it's tough to find a job in a youth-oriented market, so an employer hiring someone in her seventies is a rare event. Raylee's manager told her that older people have a better work ethic than younger people and he hopes that, by employing older women, he can reduce the attrition rate occasioned by a demanding job. Raylee admires his insight and generosity. She works with three or four others aged over sixty and thinks that more women her age would be employed if they didn't believe (usually accurately) that employers wouldn't hire them. This flowering in her later years has been enabled by a thoughtful and generous employer. One can only wish for more like him.

After their difficult start to life and all the years of separation, it's perhaps to be expected that Raylee has not forged a close bond with her daughter and son. There was a brief time, following her second divorce,

that she stayed with her son after she had knee replacement surgery, but their relationship couldn't cope with the unaccustomed proximity. Her daughter lacked her brother's advantage of early attachment to their mother and, according to Raylee, has had a troubled life.

It is significant that Raylee gave up her brief study of psychology in an adult education class, despite being interested in what makes people tick, because she recognised herself as being too judgemental. She has had to become so tough and self-sufficient that she is at times unable to feel empathy for those who seek help to manage life's vicissitudes.

Raylee now lives in regional Victoria, not far from her work. She is pleased to be doing something constructive and being paid for it. 'I didn't want to go and just volunteer because I'm not all that into being old yet, even though I am. I feel about forty-five. The body doesn't feel that way, but my mind and my spirit are definitely forty-five. I know people who are my age and they're older. They have older thinking. I don't think I grew up till I was sixty. I've got friends who only watch reruns of movies and just sit at home all day. I don't want to do that; I want to be involved in everything.' She still finds computers and technology fascinating and helps friends and colleagues with their technology problems. Having worked all her life with Mac computers, she's now learning Microsoft programs and dabbling in Adobe Photoshop. Raylee does all this while managing the onset of age-related macular degeneration, just as her mother did.

Raylee has had to suck up more in her life than seems fair. It is painful to contemplate the cumulative effect of the rape, the adoption, the stillbirth and the postnatal depression on someone who was already feeling alienated from her family. I can't help reflecting on attachment theory, an influential psychological model of human relationships. It was initially formulated by psychiatrist John Bowlby in the 1950s and has been much ramified since. Its central tenet is that children require a satisfactory relationship with at least one responsive adult to be able to develop socially and emotionally. We don't know what led Raylee's mother

to be so out of tune with her as a child, but the lack of attachment can be seen to have flowed down the generations.

It must have taken enormous courage and determination for Raylee to continue moving to the next place and the one after that, always pursuing what she possibly didn't even know she was seeking. As Raylee approaches eighty, her attitude to life is driven by participation and learning. She does seem, at last, to have found her niche in the world.

Finding Meaning
May Wood
(b. 1943)

There was a time in May Wood's career when she had to assess a practical exam where students made mashed potato. This mundane dish was to be graded on three qualities: taste, texture and a third May has mercifully forgotten. There were seventy-five students and thus seventy-five mounds of potato: 225 separate marks. For mashed potato.

It was, she thought, time to reassess her life.

May was a home economics teacher. In her application to teachers' college she had put home economics ahead of her first love, art, because her home economics teacher looked so smart in her uniform and her art teacher looked a bit haphazard. May notes wryly that she now dresses very much like her art teacher.

May does indeed look more arty than domestic, with interesting clothes and bold, spiky grey hair. Her appearance speaks to the winding and adventurous road she's travelled, a long way from where she began.

She was born in Pascoe Vale, a then working-class suburb of Melbourne. Her father was a leather tanner who rode his bicycle to work many kilometres across the city every day. Her mother worked in a grocer's shop. May is impressed that her assertive mother achieved equal pay before teachers did. May was in high school at the time and was aware that her mother's employer respected and valued her. He put her in charge of one of his shops and, when she threatened to retire, raised her salary to entice her to stay. May's mother was then earning more than her husband. In May's youthful eyes, 'she wore the pants in the family. She bossed Dad around and organised us all.'

May loved her father, the gentle nurturer in the family, but wanted him to take more responsibility. He was completely dependent on his wife. When May was an adult and her mother spent a long time in hospital, May went to look after her father. While putting away his washing, she found bundles of cash in a drawer. 'I said, "Dad, what's this?" He said, "I haven't taken any! I've only taken my allowance." I said, "It should be in a bank, Dad. Too much money to be in your knickers drawer." He said, "I don't know how to do that." At that stage, he was supervising other people. He was going to all these shopping centres where there were banks everywhere. They were in a perfect symbiotic relationship. He just loved Mum and did everything she said.' May loved her mother too and thinks she is very like her, but she saw her parents' relationship as a model to be resisted. She wanted an equal partnership, not to be tied to a dependent child-adult, no matter how lovable.

May's mother planned a secure future for her, enrolling her in an evening comptometrist's course while May was still at school. This qualified May to work in a bank, adding up numbers on a machine. The prospect didn't fill May with joy. However, the principal at her school called May's mother to tell her that May should go on to further study. Her mother was overawed by the principal's interest and allowed May to do just that. May applied for and won a bursary to teachers' college that also gave her a small living allowance. Her parents couldn't afford

to support May but planned to pay for her younger brother, Wayne, to go to Dookie Agricultural College to remove him from an undesirable group of friends. To save for Wayne's college fees, May's mother found her husband a better-paid job and kept a book in which she noted all expenditure. May says that book changed her life. 'I had an argument with my mum. I said, "You don't treat us equally." "Yes, I do." "No, you don't. You've spent that much money on Wayne. It's in the book. You haven't spent that much on me. I'm paying my own way." Little upstart! But I was giving her two pounds a week rent. They were buying a new car and they gave me their old car, as compensation.'

That car was May's transport for two years. When she left college and went to teach in the country, she sold it and put a deposit on a block of land in an outer suburb. Her parents were cross, despite her foresight in purchasing land, because it would mean she was less likely to visit them if she had to come by train. May then saved and bought her own car.

May's mother extended her organising skills into every aspect of May's life, including sourcing boyfriends from among the families she knew. One of these young men was put to work, unbeknown to May, clearing her plot of land. He soon startled May by declaring, 'We will build our house here.' She reacted immediately: 'No, WE won't. It's mine.' That was the end of any prospects he might have had with May. She invited a friend to agist a horse on her land, which then no longer required annual clearing.

May didn't want to become a version of her mother: the organiser who helped a man to achieve things on foundations she had built. May was waiting for someone as strong and independent as herself.

After teaching for a few years in country high schools, May studied for a Diploma of Domestic Arts, adding to her earlier subjects needlecraft, needle technology fabrics, and food and technology. She was then employed as a lecturer in her old teachers' college, teaching home economics.

When I was at school in the 1950s and early 1960s, we took pride in the fact that our girls' school didn't teach what was then called domestic

science. In our arrogant ignorance, we dismissed it as 'housework'. However, the subject began in the nineteenth century as an attempt to elevate what was then solely women's work by identifying the science behind it and teaching women how to run homes efficiently and well. These days, subjects include food studies, health and human development, and textiles. Home economics graduates can find work in diverse fields including consumer advocacy.

Despite all the interesting possibilities, however, May's year as a home ec lecturer culminated in the mashed potato incident. It was 1969, the height of the counterculture. All her friends (and much of young Australia) were heading off to England. May went instead to Goroka Teachers' College in New Guinea. Alone. She lived in Goroka and trained New Guineans to be teachers. Teacher trainers must observe students in front of a class, so May drove her little car to the many remote schools hosting her students. It wasn't until she'd been doing that for about six months that she was told it was far too dangerous to go alone. Thereafter, she had a male driver who served as her bodyguard.

It was in New Guinea that May met Kathy, an academic researcher who turned out to be the equal that May had hoped to find. Kathy was a high achiever and as adventurous as May. They both worked in New Guinea for two years, then Kathy went to the United States for her PhD and May came home to Australia. When Kathy moved to Solomon Islands in the South Pacific for research, May joined her for six months. They had an exhilarating time walking around three islands, the first white women many of the inhabitants had seen. May and Kathy were experiencing something new every day and they were novelties to the people they were meeting. The world has shrunk so rapidly that opportunities for such discoveries are now rare.

May taught at a high school in Melbourne for a year before she and Kathy went to live in Canberra. It was a peripatetic life for a while, largely dictated by the needs of Kathy's research. May loved it. In Canberra she taught at a high school and began a part-time Arts degree, interrupted

by long periods in Solomon Islands. When Kathy found a university position in New Zealand in 1980, May went there with her and finished her degree full-time. She had been fascinated by culture in New Guinea and to learn more she had taken subjects in anthropology, pre-history and history. In New Zealand she added sociology.

Following her interests and learning about cultural diversity not only fulfilled May's curiosity about the world but also led to her next career move. Instead of doing an honours year, May enrolled in a postgraduate course in guidance and counselling. She became a school counsellor in New Zealand, able to draw on all her accumulated knowledge and experience to guide students as they made choices that would influence their futures. It was a time in New Zealand when they were initiating bicultural education: Māori and Pakeha. May was able to contribute to developing school programs to ensure that the Māori language, culture and worldview were given equal emphasis with Pakeha, both inside and outside the classroom.

It was devastating to May that, while she was in New Zealand, Kathy fell in love with someone else. With great resignation, May said, 'Shit happens.' That wasn't the end of their attachment, but it did mark the end of secure, equal coupledom. Kathy then found another girlfriend and brought her to visit May in Melbourne while she conducted research. It was cheap accommodation. May understood that researchers never have enough money and felt that the bond she shared with Kathy could withstand such onslaughts. When Kathy's new relationship ended, May supported her through her sadness. She remained loyal to Kathy from 1970 to 1987. She hasn't found another partner who embodies her dream of improving on her parents' marriage, but Kathy is now one of her closest friends.

In 1986, May returned to Australia when both her parents became ill. She had the sad privilege of holding her mother in her arms as she died. Thereafter, she did her best to care for her father without allowing him to take over her life. He had polyneuritis, an awful disease that caused

excruciating neural pain and made it hard to use his arms and legs. He had to be pushed to his wife's funeral in a wheelchair. He recovered from the condition but became so dependent on May that she felt more like a social worker than a daughter. He seemed incapable of learning any of the tasks for which his wife had been responsible. May had the bright idea of buying him a microwave oven and teaching him how to cook with it, something her mother had never done. That helped.

Her mother's death initiated May's permanent return to Victoria. She began a routine of self-reflection to help her manage her life, to live with purpose. She calls them annual check-ins. On a piece of paper she writes her goals for career, finances and personal life and assesses her progress towards each one. Even when goals aren't achieved, the process of reflecting on them has helped May to shape her life.

In 1987, May became a careers counsellor at a selective high school. The principal was introducing laptops and required his staff to become proficient in their use. To her astonishment, May was a natural. When she found computers she also discovered a whole new avenue of achievement. May didn't use them just for preparing lessons; she coded and wrote programs. She largely taught herself these skills after doing a basic course on computer literacy. She soon sold the programs she wrote (with her brother) to major organisations, including the Victorian Tertiary Admissions Centre, and set up what she describes as a hobby business developing websites for careers departments in schools. May maintained that business until she retired, which coincided with changes in the technology being used by schools. She found all of it good for her brain.

While she was at the selective school, May was diagnosed with breast cancer. A year of (successful) chemotherapy ended just before her fiftieth birthday. By then, May had established a relationship with a man who turned out to be married. She would be with him during the week and visit her father each weekend. When May came out of hospital, the man asked her, 'Do you think you got breast cancer because we sinned?' That was the end of him.

Unfortunately, the school didn't maintain the culture that May needed. When it introduced the International Baccalaureate, May was head of the careers department, with a substantial staff. Part of her role was to organise interviews with students for subject choices and potential careers. She understood the goal as helping people define what they wanted to be and offering them a few career pathways to get there. When she was directed to put all the best students into the International Baccalaureate stream instead of determining what was in each student's best interest, May told them 'to stuff it. Politely.'

So in 2001, at fifty-eight, May retired. In fact, she submitted her resignation on 11 September 2001, the day the Twin Towers came down in New York. In the midst of the shock and outrage over the attacks, it did cross May's mind that her superannuation was going to suffer as the value of investments declined under the threat of terrorism. She briefly contemplated humbly asking for her job back, but decided to take her chances.

May then had free time. She moved to an outer suburb by the sea, played golf and worked in the garden, but it wasn't enough. She needed an occupation with meaning. May began teaching computer skills at the University of the Third Age to complete novices. She also resumed travelling, overseas and around Australia: 'To China, a dig in Uzbekistan, Thailand, Cambodia, Vietnam, India, scuba diving off the Barrier Reef, tours in the Top End.' At the end of a trip to South America in 2007, she said to someone, 'If I had a partner I'd be a Grey Nomad.' Then she paused. 'Who needs a partner?'

At sixty-six May bought a campervan and set off, spending all of 2008 driving around Australia. She had a wise system for maintaining friendships and staving off loneliness: she'd have three friends join her, one at a time, for six weeks or so. In between friends, she had out-of-van experiences. One of these was crewing on a sailing ship, the *Leeuwin*, where she came to know the other crew members well. One told her that he had friends in Zambia who were looking for a tutor for their son; he thought May would be ideal. She emailed them and got the job.

Zambia was an enlightening experience. May lived in a safari camp while she tutored a seven-year-old child whose parents worked there. She went on safaris at least four days a week and sometimes daily. May began photographing the extraordinary range of wildlife that surrounded her and soon got into the habit of taking her camera everywhere. She found zebras, giraffe, wild dogs and wildebeest, as well as extraordinarily diverse scenery. This trip lasted six months and was another major turning point in May's life. 'In my Arts degree I'd studied race relations. God, the race relations in Zambia! You'd have really racist white managers who were alcoholics and would say to the guys, "You bloody black bastard." Then, because they were drunk, they wouldn't remember they'd said it. But, of course, the people they'd said it to would. And I joined the workers. I was a worker. I did have a choice to be at the top, but I didn't like a lot of what they were doing. I got into the culture and made a lot of really good friends there. It was brilliant.'

When she came home, May was struck by depression. Life seemed dull and pointless after the energy and magic of Africa. She took prescription medication ('six months of happy pills') and went to Vanuatu and nearby islands on research trips with Kathy. May photographed the interesting people Kathy was interviewing. On her return, determined to avoid depression, she began leading two-week tours to Zambia called 'Wildlife, Culture and Photography'. She led these tours annually for six years, keeping her life interesting. However, her friends had started to die and May felt that she was beginning to ruminate, a familiar sign that she needed to get up and do something else. She put her school counselling skills into practice and advised herself to return to study.

Photography had become so important to her that she thought she'd like to learn more about it. In 2012, at the age of sixty-eight, May enrolled in a new TAFE course. She wasn't confident in her abilities but thought that a TAFE trying to establish a course would accept anyone who applied. She enrolled part-time. She did all the required work and, without the distractions tempting younger students, extra work as well.

May undertook several specialist certificates in photography and in teaching and assessing photography. Her skills were acknowledged with an invitation to join the staff. So, at the age of seventy, she began yet another career: teaching photography at TAFE. Her life felt meaningful once more.

Five years later, May fell and broke her shoulder so badly that she had to resign. The damage required reconstruction, extensive physiotherapy, and spending her nights sleeping in a chair for six months. It made her realise that her bones weren't as tough as they once were and that she needed to arrange her surroundings to minimise the chance of falling again. Her house had a garden with grapevines and other plants that required her to climb ladders to maintain them, as well as uneven ground with many trip hazards. After a further fall, in which she wasn't injured, May decided to sell. She sold well and was able to buy a smaller, smoother, less challenging property in the same beachside suburb. May has made a beautiful private garden that she can see from every window. She can walk to everything she needs: medical care, food, the beach. She's in the process of transforming the long garage into a studio.

In her studio May will paint and draw as well as continue her photography. She has made things all her life and finds the process meditative. She becomes absorbed in the work. As she says, mundane tasks like housework don't do it for her, but her creative practice does.

May has had two photography exhibitions. She is an expert wildlife photographer and has also exhibited more creative, self-consciously artistic work. One exhibition grew out of projecting her photographs onto her plants and re-photographing them, producing images she likens to some of Salvador Dali's paintings. I think of his work *The Persistence of Memory* (1931), where clocks are draped over stray objects on a beach. I can envisage May's images draped over her plants, inviting viewers to make of them what they will.

May is also a qualified judge of photography competitions and trains new judges. To stave off boredom during Covid-19 lockdowns, she

developed a website for the Australian Association of Photographic Judges and taught them how to manage it. She teaches photographic subjects at the University of the Third Age, where she also studies drawing and painting. May takes action to keep her mind active and to avoid rumination, with its attendant risk of gloom.

May is sad that many people her age are afraid of technology and thinks that those who can't use it are lonelier than those who can. She recently taught a ninety-year-old to use Zoom so that she could communicate more easily with her family and friends. 'I've decided that age isn't really the leveller here. It's their mental age. I have friends who are waiting for God. I think I'm a bit more of a risk-taker, a bit more adventurous than a lot of my friends. And a lot of my friends see me as a bit of – I don't know. A bit strange, maybe, at times? In a nice way.'

May's life of learning, adventure, enterprise and creativity continues to serve her well. She sees the world, with or without her camera, as full of possibilities. She takes from it and contributes to it with sensitivity and imagination.

Living History, Writing History

Judith Deakin Harley

(b. 1929)

In January 2021, when she was ninety-one, Judith Harley received a phone call to say that her lifelong family friend, David, had died. She went straight to her studio and painted David meeting her late husband, Geoff, in heaven. The painting is bold, colourful and joyful. It shows two friends delighted to be together again. Judith said the painting released her from the weight of grief.

In 1942, when Judith was twelve and her school had been evacuated to the country, her art teacher began taking students to the bush to draw. Judith was enchanted; she loved charcoal and paint. This experience began a lifetime creative practice. When I spoke to Judith two days after her ninety-second birthday, she was painting every day. Her studio, a converted garage, is set up with paints, canvases and easels, with finished

paintings and works-in-progress in delightful disorder. She also has a computer with the monitor at eye level when she stands. During the pandemic lockdowns, Judith had to relinquish attending classes in person and instead participated in an art class every week on Zoom.

Painting is not only 'a form of expression and letting go' for Judith, but also a profound pleasure and a means of understanding the world. Her paintings are exuberant and confident. Some are abstract, but there are also portraits and landscapes, especially of the family's holiday house at Point Lonsdale, a coastal town on the Bellarine Peninsula in Victoria.

Although she loves attending weekly classes for the models and the company of other artists, Judith doesn't like anyone instructing her about painting. She paints, she says, what is in her mind. The most recent of Judith's eight solo exhibitions was for her ninetieth birthday. Expressing what painting means to her, she called the exhibition *Joie de Vivre*.

Judith has always found time to paint. Her parents encouraged her when she was a child. When she was married, her husband was happy for her to develop her talents and interests. She's delighted that her youngest son and his wife are both artists and finds inspiration in them.

It was a pleasure to visit Judith in person in June 2021 between lockdowns in inner-suburban Melbourne. As in her art, Judith chooses bright colours in her clothing, resisting Melbourne's commitment to black. She looks smart and comfortable, but tells me, 'I like my hair always being untidy because it expresses my thoughts.' Her attitude amuses me because, since I was a teenager, I have tried in vain to look artfully untidy. It's only since I took up running in my sixties that I've found, of necessity, how to relax my appearance. Lately, the texture of my hair has changed as grey patches appear, so it's much harder to control. Like Judith, I enjoy this new lived-in look.

Judith is disposed to like people and generally finds something to learn from them. She speaks about others with warmth, not sarcasm or unkindness. Although I don't know Judith well, I too have experienced

her thoughtfulness over the years. My late mother-in-law, Jessie Deakin Clarke, was her first cousin. However, Judith grew up in a world very different from mine. It's not just that she is from a different generation – born before the Second World War – but that she comes from a family of influence and fame.

Judith's maternal grandfather was Alfred Deakin, a central figure in Australian Federation, attorney-general in the first federal cabinet and our second prime minister. Pattie Deakin, his wife, was a noted philanthropist. Like Judith, she was also a painter, often choosing her subjects from the garden at Point Lonsdale. Judith speaks with affection about aspects of her grandfather's life that were not recorded in the history books. Although he died before she was born, her mother talked lovingly of him. Judith is particularly proud that he was passionate about social justice and was responsible for introducing the first parliamentary bill in the British Empire to regulate working conditions for women and girls in factories. Pattie used to buy his shirts a few sizes too big and reduce them to fit because piece workers were paid more for larger sizes. Judith notes with satisfaction that her grandfather declined the many honours he was offered during and after his political life.

Alfred and Pattie had three daughters: Ivy Brookes (born 1883), Stella Rivett (1886) and Vera White (1891). Vera was Judith's mother and Ivy was my mother-in-law's mother. All three sisters lived to eighty-six, which Judith says could be attributed not only to their parents' encouragement to exercise and keep fit but also to drinking boiled wildflowers with a particularly nasty taste. She did not impose this singular concoction on her own children.

Vera married Tom White, a hero from the First World War and a federal politician from Victoria. Judith was born the year he entered parliament, 1929. 'He teased me by saying I was Balaclava Jane, because I brought him luck and he got the seat of Balaclava.' He was a minister in the governments led by Joseph Lyons and Robert Menzies, and Australia's High Commissioner to the United Kingdom from 1951 to 1956. During

the Second World War he took leave from Parliament and served in Australia and in England.

When I was a child, long before I knew anyone associated with the Deakin family, I knew about Wing Commander White. As an RAAF fighter pilot in the Second World War, my father had escaped from a prisoner-of-war camp in Italy. He always admired White, his commanding officer, who had escaped from a Turkish prisoner-of-war camp in the First World War. We had copies of White's account of his time as a prisoner, *Guests of the Unspeakable*, and his narrative poem about the Second World War, *Sky Saga*. Even the idea of a narrative poem was impressive to me.

Judith speaks with great pride of her mother's philanthropy. A biography of Vera, emphasising her incomparable contribution to the Red Cross internationally and nationally, was published in 2020.[24] From 1915, at the age of only twenty-four, Vera was the inaugural Secretary of the Australian Red Cross Wounded and Missing Enquiry Bureau, based in Cairo. Judith considers the support she gave to Vera's biographer, Carole Wood, during her eight years of research to be one of her most satisfying and important achievements. Vera was also a prominent supporter of the Royal Children's Hospital and the Victorian Society for Crippled Children and Adults. When her husband took leave from parliament during the war, Judith's mother managed his electorate as well as her philanthropic work.

Judith followed in her mother's remarkable footsteps. Her voluntary work has included being a committee member, for decades, of the Queen's Fund, set up to provide financial assistance to single mothers in Victoria. Her grandmother Pattie was a member from its foundation in the 1880s. For many years Judith was also a member (at times president) of the Women's Committee of the National Trust of Victoria. She led busloads of people on trips to notable private houses and gardens all over Victoria and wrote historical notes for each event.

Judith enjoyed growing up in a political household. On 29 June 1950, while her father was Minister for Air and Civil Aviation, she overheard a

telephone call reporting that the Korean War had begun. Being so close to history was a great thrill. She attended political meetings often and enjoyed distributing how-to-vote cards on election days. Judith recounts with relish putting how-to-vote cards into the trembling hands of people rushing back from the races to vote on Saturdays after celebrating a win or drowning a loss. She was almost inebriated by their breath.

Judith described her father as being 'comfortable in his own skin', with no need to exercise authority over his wife and four daughters. Tom White was made a knight in 1952, although Judith does not speak of her parents as Sir Thomas and Lady White. Her heritage has given Judith a sense of social responsibility and a privileged insight into many aspects of life in Australia and around the world, but she is in no way a *grande dame*.

Judith's heritage has also made her the keeper of the family stories. She is often consulted by academics writing about her parents and grandparents and is acknowledged in innumerable books not only for her historical knowledge but also for her hospitality. 'I'm the only grandchild that's still alive, so when people want to know what brand of toothpaste Alfred Deakin used, guess who they ring up?' Judith says that she has felt like a historian since she was a child because she was always being asked about her family history. At school, when she gave her father's occupation as 'parliamentarian', people wanted to know more. She tells me that she remembers going to Canberra for the first time, by train, aged three. Her anecdote recalls a different era: no reliance on commonwealth cars for politicians then. 'My father borrowed Dick Casey's bicycle to ride to Parliament House. He was made Minister for Trade and Customs in 1932, in Joe Lyons' government, and that was when Australia was getting out of the Depression, and it was a very important role.' I knew about Lord Casey as a politician and, later, Australia's Governor-General, but I had never heard about his bicycle. Such personal accounts are intrinsic to Judith's contribution to Australian history. As the repository of family memory, her stories inevitably include entangled personal biography and history.

Contributing to the historical record is important to Judith and she doesn't feel burdened by her role. 'I feel good about myself when, if somebody asks me something like the history of the Navy, I can research that, and I have the family stories. It makes me feel pleased about myself that I'm fulfilling a purpose. Don't you think?'

I can only agree. We all need to feel that we have a purpose in life. This need does not diminish with age.

Other women in this collection who have taken an interest in their family history have had to fossick for facts. Judith has easy access to an abundance of information about her famous forbears. What she adds is an intimate perspective. Perhaps it was inevitable that Judith began writing her own and the Deakin family history.

Judith is a member of the Lyceum Club, one of Melbourne's oldest women-only clubs, designed for tertiary-educated women who have made a significant contribution to Australia's cultural, political or economic life. Members have included Quentin Bryce and Elisabeth Murdoch. Judith became an inaugural member of their Writers' Circle in the 1980s, aged about sixty. She had modestly thought she would attend as an observer but was told that the rules mandated attendance only by writers, so Judith began writing and has never stopped. Until then, she had written nothing more than letters. Judith is grateful for all that she has learnt about writing from people she admires in the group. She is consistently self-deprecating, describing her writing as 'a chance for me to put it down. I have a lazy brain and it's good to function with it.' She also says, with only the hint of a glint in her eye, that a lifetime of listening to speeches has guided her to develop an easy style, 'with a grain of truth and a goal at the end'. Now, at ninety-two, she thinks that she has come of age in her writing.

I borrowed three of the books to which Judith has contributed a chapter. There are others among the stacks of books and papers in her spare room. In these three she writes about Alfred Deakin (2001), her trip to England with her parents (2012) and Pattie Deakin (2018).[25] Judith's writing has the confidence of dates and facts and the warmth of

personal knowledge. Her head is so crowded with stories from her long and full life that I found her writing to be an essential way of untangling the chronology.

If we are lucky enough to have been told family stories as children, have been encouraged to tell stories about our experiences as we grow up and have the good fortune to live a long life, we have been given a valuable means of understanding ourselves and the world. Stories, developed and repeated and embellished, strengthen our sense of self and our relationships and help us to make sense of our lives. Judith has an altogether richer set of stories than most people. I see it not so much as living in the past but as appreciating one's life: delight at having lived so long and through such changing times.

Although Judith doesn't write as an academic historian, she did study history at the University of Melbourne after her schooling at Melbourne Girls Grammar School. She was the youngest of four daughters, all of whom attended the school. 'I was there in the time of the evacuation, in the 1940s. General Macarthur said he wanted our school as his headquarters originally but, in the end, he decided he'd prefer Victoria Barracks. The Air Force took over our school, the art part of the Air Force – the camouflage units and the artists and people like that. So the senior school went to Doncaster, the Eastern Golf Links.

'I was in the junior school. For us, the school took over six boarding houses at Marysville, in lovely bush countryside. I enjoyed the time immensely at Marysville, because I grew up in Walsh Street in South Yarra and I walked to school. I was at school from 1935 to 1947, and I just had to walk around the corner. So it was an eye-opener to me, when I was boarding with other girls, because I never went on trams and trains, because I just lived around the corner. It was widening my horizons.' From 1943, Judith was a weekly boarder at Doncaster. After the war, the school moved back into the old classrooms in South Yarra.

In 1948, Judith began an Arts degree, majoring in History, at a time when only about 21 per cent of university students were women

and tertiary education was a minority activity.[26] The following year she expanded to Arts–Law. Judith worked hard but sacrificed excellence to having fun. She had almost completed her degree when her father was appointed High Commissioner to London. She had only one subject to complete, so went with her parents to England in 1951 and sat for the exam in London.

Judith had travelled beyond Australia with her parents before then. Her trips included, in 1936, sailing to visit ex-servicemen from the First World War who were on plantations in Thursday Island and New Guinea, when her father was the acting Minister for External Territories. Although Judith was only six, the trip made a lasting impression on her. In 1950, they flew in an old Avro Anson aircraft to visit all the Flying Doctor bases in Australia, because her father was instrumental in setting up the Flying Doctor Service. But the trip to England began her international adventures.

Judith sailed with her parents on the maiden voyage of the *Oronsay*. The ship soon became one of the mainstays of Australians seeking adventure overseas. I enjoy picturing Judith on the ship as a vivacious 21-year-old, dining at the captain's table and meeting other passengers, such as Frank Hardy, whose novel *Power Without Glory* had just been banned in Australia; Nancy Wake, hero of the French resistance; and a woman whose fate was to be known as no more than actor Peter Finch's sister. She felt privileged to meet 'so many older, wiser people'. Although she had fun, Judith was sad to be leaving behind her fiancé, Geoff Harley, a medical student. He sent an engagement ring to her a few months later in the diplomatic bag. Long-distance romance has always required adaptation and inventiveness.

The official residence of the High Commissioner is Stoke Lodge in Hyde Park Gate, Kensington. Judith lived there with her parents and acted as her mother's honorary secretary, enrolling at a nearby secretarial school to develop the necessary practical skills. In what could be considered an understatement, she described it as 'a fascinating and varied life'. To give just a hint of that life: Judith and her parents supported Australian artists,

musicians and writers in London, which meant, for example, that they saw Joan Sutherland at the beginning of her career. She accompanied her mother when she shattered champagne bottles on the bow to launch ships in Belfast and the north of England. She met Sir Winston and Lady Churchill at Downing Street. She stood in for her ill mother at a banquet at Buckingham Palace for the King and Queen of Sweden. She encountered Prince Philip, Duke of Edinburgh, at official events so many times he would say, 'Not you again!'

The Queen's coronation was in 1953. Judith looked after the many hundreds of Australians who came to London for the occasion, working hard to ensure they had a wonderful time. Later that year, she travelled with her parents to visit her sister in Southern Rhodesia (now Zimbabwe), then flew on to Melbourne for the Royal Tour of Australia. Geoff met her at the airport. The two attended her university graduation ceremony as well as a ball for the Queen at Government House, and Judith went to her first Melbourne Cup before sailing back to England.

Judith had established herself so well in London that the Dean of Westminster asked if she would like to be married in Westminster Abbey. She was thrilled. She used to tell people that, having been offered the perfect wedding venue, she had to find a husband. Judith and Geoff were married in the Abbey on 29 December 1954 and boarded the ship for Melbourne the same day. Geoff was to begin work as resident medical officer at the Royal Melbourne Hospital in January 1955.

Geoff Harley went on to become a senior ophthalmologist and head of the eye department of the Royal Children's Hospital. He was president of the Royal Australian and New Zealand College of Ophthalmologists, which he helped to establish. He was also committed to improving eye health in Solomon Islands and Kiribati, where he practised as an honorary consultant. Judith was proud to support his work, travelling with him every year to conferences in Australia and around the world. Judith never felt sidelined by Geoff's work, especially because he supported her in pursuing her own interests.

Judith and Geoff had three sons, Tom (born in 1956), Roger (1957) and David (1961). Judith encouraged Geoff and the boys to bring friends home and people warmed to the hospitable, busy household. One day, there were so many visitors that Judith ran out of food. To ensure that there was enough for the family's roast dinner, she resorted to hiding the beef in the dishwasher.

Judith has always been uninterested in cooking but continues to think with pleasure of the gregarious life she led with her husband and children. 'It was inspiring, because Geoff and I had so many friends, and our family learnt about life and people. Geoff's colleagues could come to our house looking for him, and Geoff wouldn't be home, but our family would welcome them. That's what went on all the time.' Judith describes herself as fortunate in having such a full and fulfilling family life.

After Geoff's death in 2004, Judith continued to travel internationally, in groups or on her own, including to Turkey (to visit the site of her father's 1918 escape) and to Jordan, where she was delighted to swim in the Dead Sea. The constancy of her surroundings at home provided a counterpoint to the excitement and variety. She was born in the family's house in South Yarra, spent most of her married life in an intersecting street, and has now lived for more than twenty years in another house a few hundred metres from where she was born. Judith has also had a lifetime's pleasure from the Deakin holiday house, Ballara, in the bush at Point Lonsdale. Her children and grandchildren continue to stay there. Judith paints it often, to express the feelings of belonging and joy she associates with the house.

The Lyceum Club also plays an important role in Judith's sense of connection and wellbeing. It was founded in 1912 to enable women in the professions, the arts and public life to meet and work together. Pattie Deakin was its first president; her three daughters were members, as was Judith's sister Shirley. Judith joined in 1979 and is now an honorary life member. Through the club she finds friends of all ages, intellectual

stimulation, encouragement for her writing and a place to display her paintings (in the club's exhibitions). Judith also takes advantage on occasion of a Melbourne men's club, the Savage Club, which shares some activities with the Lyceum. Their Zoom art classes have been invaluable to her during the pandemic, and she plays Scrabble and chess there whenever she can.

Judith misses Geoff but relishes her independence. It's important to her to be in her own home. Friends her age are in nursing homes; her sons continue to support her so that she can avoid joining them. They have organised a housekeeper, who comes five days a week, and they drive her to significant events, such as the frequent funerals that mark the lives of older people. Judith is privileged not only in the prestige and financial security of her family but also (and more importantly, I think) in the love and support she has received from her grandparents, parents, husband and children. Despite – or because of – her celebrated family history, Judith confesses, to my surprise, that she lacks confidence, which she attributes to being the youngest of four children. She used to rely on Geoff. When he died, she was glad that her sons boosted her confidence and continue to give her the reassurance she needs.

As she ages, Judith depends increasingly on communications technology. She credits Geoff with ensuring that she is tech-literate. 'I've been lucky in my life. Geoff bought a computer in 1980 for his practice, so I learned about computers then, and that's the sort of message I want to get out to people of my age, because I have some friends that don't use computers. They don't like iPhones and things, but it's so important to take those opportunities.'

People born before 1946 have seen an astonishing transformation in technology and communication. I was born in 1947, eighteen years after Judith. During my first year at school, Ripponlea State School in Melbourne, in 1953, I was taught to write with chalk on a slate. We had to bring a fresh slate-cleaning rag every Monday morning. I now ask Siri on my smartwatch to send messages for me. I saw Judith answer

phone calls on her watch. Only a few years ago that would have seemed as plausible as Agent Smart talking on his shoe phone.

It may be an obvious point but it bears repeating: preparations for a healthy and happy old age are made throughout life. Judith exemplifies the truth of this assertion. We need to continue to develop skills, connections and means of communicating with people and with the world at large, and we need to do so before we become resistant to learning new things. Of course, technology is expensive and thus not available to everyone, but perhaps a society that respects and cares for its older members could find ways to ensure that they have access to communication tools and information.

Most of all, though, we should enable women to take time for their own development, whether – like Judith – in creative pursuits such as writing, embroidery and painting, or in any other endeavour that captures their talents and interests. Old women and society as a whole will reap the rewards.

Conclusion
It Takes a Village

A few days before her fifth birthday, my daughter, Alice, came to me looking very troubled. 'I know how to be four,' she said. 'How will I know how to be five?'

Although growing older each year is inevitable, we might not feel confident that we know how to age well, whether we're turning five or eighty-five. The women whose stories are told in this book are among those who can show us the way.

In early discussions with colleagues about researching women born before 1946, the expectation appeared to be that they would have spent most of their adult lives in what used to be called 'home duties'. However, as I located women with achievements originating in late middle age and beyond, it became clear that some women had always been in paid employment, or had always been enabled to fulfil their interests, or had never had family responsibilities, or had experienced barriers and limitations far less benign than a happy marriage and parenthood.

The generation to which these women belong is often called the Silent Generation. This was the title of the formal information sheet and consent form distributed to women considering participating in the research. A few immediately denied being silent; some demonstrated in their stories that they had resolutely spoken up for themselves. Others were aware of having been silent about their needs. The women's attitudes towards feminism, gender discrimination and ageism range from activism through thoughtful appraisal to acceptance of the status quo. As such, they represent women in general.

What they share is that they have successfully challenged the stereotypes of the old woman. Not one is a scary witch, although several are

quite possibly intimidating for their strength and achievements. They are certainly not useless or helpless. Many volunteer their time in every way imaginable. In addition, they paint, write, embroider, sculpt, take photographs, make jewellery. They have been awarded diplomas and degrees at advanced ages. They have run businesses, explored family history, taken up weightlifting. One has built a boat. They have found new forms of employment. They have learned to play musical instruments and joined choirs. They have wrangled all kinds of technology, including the internet, social media and cochlear implants. They are gardeners for business, pleasure and to save the planet. What these diverse women have achieved is impressive.

One of the first responses to stories of achievement is often to ask what characteristics predispose a person to rise to a challenge or carry on when others give up. The main characteristic many of these women share is good-enough health, although some have age-related conditions such as arthritis, macular degeneration and poor hearing. The majority do what exercise they can to maintain their health, despite foggy vision and rusty joints. Most have also sought to pursue lifelong learning, whether formal or informal. They have not been afraid to be educated just because their school days were long ago. These women also show perseverance, resourcefulness, determination and resilience, particularly when faced with apparently insurmountable barriers or even tragedy.

However, it is misleading to suggest that personal characteristics are solely or even primarily responsible for a successful old age. Women may have qualities that help them to live productive and satisfying lives, but they can achieve their potential only in a milieu that enables, rather than inhibits, them. The milieu includes other people (family, friends, workmates, the community), the built environment and social policies. Ageing well is a social responsibility, to be shouldered by everyone – not only because it is the right thing to do but because we all stand to benefit.

It takes much more than a daily walk, lots of vegetables and a sudoku puzzle book to achieve a fulfilling old age. Even those three commonly

recommended practices reveal that ageing is linked to a broader sense of social welfare. A daily walk requires not only an adequate level of health, but safe spaces to walk in and neighbours to walk with. Fresh and healthy meals must be accessible and affordable. Brain exercises entail access to books, newspapers or the internet. They all necessitate not only adequate physical and intellectual skills but also support and encouragement from others.

Well-meaning 'positive ageing' campaigns that place the onus on individuals to manage their own health and wellbeing carry the ominous subtext that it is no one else's responsibility. As Jane Fisher and I know from our research with Baby Boom women, experiences from birth have lifelong effects on wellbeing.[27] Early poverty, disadvantage and unkindness have adverse effects throughout life, including in old age. Old age doesn't suddenly arrive from nowhere. Like a plant that has been nurtured in soil of variable quality, we might flourish or wither as we grow. Preparations for old age begin with care and support for parents and infants and even with preconception healthcare: anything that contributes to physical and mental health and to parents' capacity to nurture children. It includes financial support, adequate housing, early identification and treatment of postnatal depression, good childcare and high-quality education for all. Anti-discriminatory policies, informed and inclusive healthcare, and social structures that support and enhance the lives of girls and women – as well as boys and men – will benefit everyone, not only older women.

And we can't discount the role of chance or luck. My father, Jack, was vigilant about health his whole life. I remember vividly when, as a medical student, he gave up smoking overnight in about 1951 after Richard Doll's seminal paper on smoking and lung cancer had been discussed in a lecture. I was only four, but I remember because of my mother's refusal to stop smoking and the arguments that ensued. Yvonne puffed away for another twenty-five years. Jack exercised, followed the latest dietary recommendations, remained slim and kept his brain active. Yvonne was plump, loved lollies and pastries, drooled over bread and dripping,

developed diabetes and took desultory walks. Jack contracted idiopathic pulmonary fibrosis and died at seventy-six. Yvonne lived to ninety. My mother-in-law, Jessie, told in her seventies that she should exercise, protested indignantly, 'But I go to the market once a week!' Jessie was a month short of one hundred when she died. I present these examples not to suggest that we should all give up, but to acknowledge that, despite our best efforts, we might be stymied by fortune. It's probably wise to assume that old people who are struggling have not been as fortunate as those who are not.

I'm referring to people who live into their seventies, but we all know magnificent women whose lives ended much too soon because of illness or misadventure. Bad luck gave them treacherous genes or put them in the way of accidents, pathogens or villains.

At the age of eighty-nine, Diana Athill wrote in her wonderful memoir *Somewhere Towards the End*:

> How successfully one manages to get through the present depends a good deal more on luck than it does on one's own efforts. If one has no money, ill health, a mind never sharpened by an interesting education or absorbing work, a childhood warped by cruel or inept parents, a sex life that betrayed one into disastrous relationships – if one has any one, or some, or all of those disadvantages, or any one, or some, or all of others that I can't bear to envisage, then whatever is said about old age by a luckier person such as I am is likely to be meaningless, or even offensive.

I emphasise luck to avoid giving the impression that every woman should be expected to age creatively or productively or robustly. The women whose stories I have been privileged to hear have not all had easy lives. Some have overcome exactly the misfortunes named or avoided by Diana Athill. But all, in some way or at some point, have been encouraged or

supported or otherwise enabled to lead meaningful lives, in older age if not before.

I'm also not promoting the value only of those women who contribute to society or demonstrate singular skills. My grandmother, Trudy, was profoundly disabled by a stroke in her eighties but continued to give us love and hugs. If we acknowledge the value of interdependence, we can appreciate how we human beings need each other. Like Trudy, some of us will become frail as we age and need full-time care before we die, whether at home or in a special facility. In *Dear Life*, doctor and author Karen Hitchcock writes movingly about how we must meet the needs of very dependent old people, and I endorse her message.[28] At the same time, I'm urging that we resist thinking in ageist stereotypes, whether of the young, the old or the menopausal. It is disrespectful to those so stereotyped and tends to isolate them.

It is important to most people to feel that they belong, whether that's in the main stream or in a tiny tributary. One might never be aware of a sense of belonging if one has always felt at home. The women in this book include some who had to search for their milieux: receptive people and communities. A few who led, at least at times, peripatetic lives had to learn how to feel at home wherever they went. Almost all had belonged somewhere by the time they reached old age.

What we learn from these women is consistent with what the Baby Boom women told Jane Fisher and me. In addition to being treated with respect, Baby Boomers want purposeful roles for older women in society, adequate services and resources, and sensitive healthcare. Furthermore, they want stereotypes to be challenged. Stereotypes lead to ageism which, in turn, supports discrimination. An Australian survey of more than 2000 people aged over sixty shows that experiences of ageism have an adverse effect on mental health, prompting depression and anxiety.[29]

As researchers Lindsey Cary and Alison Chasteen point out, old people are subject both to benevolent ageism, in which unwanted help

is thrust upon them, and hostile ageism, in which they are excluded and rejected.[30] Neither kind contributes to a sense of agency and purpose.

The year 2022 granted us an apposite illustration of benevolent ageism. A young man, apparently determined to do a good deed, uploaded to TikTok a video of himself coming upon a white-haired woman sitting by herself at a table in a Melbourne food court having a cup of coffee. He held out a bunch of flowers and asked her to mind them. He then went through an elaborate process of removing his backpack and his jacket and putting his jacket in his backpack (I assume to ensure that he had plenty of camera time) before walking away, leaving the woman staring at the discarded flowers. As she told ABC Radio Melbourne, if he'd asked her if she'd like to keep them, she could have declined.[31] Instead, the video went viral and was picked up by the mainstream media, heaping humiliation on someone who had only sought a few minutes of peace. She was depicted as a lonely old woman whose day was brightened by a gallant young man. This young man did not seek her permission before filming her or uploading the video. My interpretation of his actions is that he made a patronising assumption that any woman with white hair who is on her own will be grateful for a tiny bit of attention. Media commentary endorsed his assumption, applying a stereotype to their judgment of her appearance that failed to recognise her as an individual. That is ageist to its core.

Loneliness is real and distressing. It arises especially from social isolation and the exclusion of old people from public life. It can also result from a feeling of not being seen by others, of not being part of an interdependent community.[32] Loneliness can be even more debilitating for those living in residential aged-care facilities if social interaction is limited.[33] Loneliness leads to depression, which discourages physical activity and thus promotes further decline, quite apart from the direct adverse effect it has on wellbeing and quality of life.

The ABC television documentaries *Old People's Home for Four-Year-Olds* and *Old People's Home for Teenagers* demonstrated how the lives of

isolated older people were enlivened by spending time, usually only a few hours a week, with kindergarten children or teenagers. It was also clearly a delight to the children, valuable to the teenagers, and welcomed by their parents. This practice could be expanded to encourage development away from warehousing people who need supported accommodation and towards multi-age communities with vibrant social networks. It's not a new discovery: it takes a village to promote wellbeing not just in children but in people of all ages.

The United Nations has declared the years 2021 to 2030 to be the Decade of Healthy Ageing: a time for worldwide collaboration to promote longer and healthier lives. Physical health is emphasised not as an end but as a necessary condition for full participation in society. This endeavour is part of a magnificent movement towards creating age-friendly neighbourhoods. The World Health Organization has taken the lead through its age-friendly cities framework.[34] The eight areas in the framework are community and healthcare, transportation, housing, social participation, outdoor spaces and buildings, respect and social inclusion, and civic participation and employment. These areas are interconnected. They encompass the physical, psychological and social components of life, all of which are implicated in ageing. We need to develop and maintain a world in which everyone, of any age, feels welcome and is encouraged to participate.

Non-government organisations and groups at all levels of government in Australia have been considering how to create more age-friendly cities. Australian researchers have shown that what have been called 'master-planned communities' are more effective than ordinary suburbs in their walkability.[35] Being able to walk safely in your area is a major contributor to good physical and mental health and promotes an active social life. Australian suburbs tend to be low density and to rely on cars to reach most destinations. Master-planned communities are large-scale, dense housing developments with integrated infrastructure and provision for

community activities, with walking access to shops, schools, medical care and so on. These communities are age-friendly but also friendly to all their members. Master-planned communities are on the horizon for many parts of Australia. There is even an award for the best Australian master-planned community as part of the Property Council of Australia's Innovation and Excellence Awards.

One simple example of structural adaptation that benefits more than its intended beneficiaries is the creation of ramps on the edges of footpaths at intersections and crossings. This was not common before the 1980s. It came about through the activism of people with disabilities. These simple access points that we now take for granted make life easier for parents pushing prams, people with wonky knees or sprained ankles who find steps difficult, those pulling wheely bags and other heavy items, and many others. We no longer consider ramps as an aid only to those in wheelchairs. Applying the same logic, if we adapt the built environment to suit the ageing body – for example, by siting services closer to homes and by separating pedestrian traffic from bikes, scooters and skateboards – we will find that it makes life better for the whole community.

Age-friendly communities place the person at the centre of planning. Communities are then structured by considering how best to fulfil her needs. Decades ago, psychologist Urie Bronfenbrenner described what he called ecological systems theory, elucidating the process by which various levels of society, from the individual to the culture, influenced psychological development.[36] He illustrated his theory with five concentric circles, moving outwards from the individual to encompass family, neighbourhood, cultural influences such as the mainstream media and shared values, laws and beliefs. That's a useful way to consider promoting a good life at any age.

I suggest a simplified version of the ecological system to help us to think about ageing well. In the centre we have the person. The next layer is her family, both of origin and chosen later in life. These people provide love and support to the individual who, in turn, contributes love

and support to others. Beyond that is their immediate community: the people and built environment that enable a fulfilling life that is safe and where daily tasks can be carried out without having to travel too far. The fourth circle is government and policies: decisions that contribute to equity and non-discrimination throughout society. The outer layer is made up of culture: beliefs, symbols, attitudes and ideologies, both national and local. In my modified series of concentric circles, no circle can operate without the others. No level can work independently, although some have more power than others. Each level can make a difference in improving the status of women, life for people at every age, and the built and natural environments.

As I review my decades of research and reflect on my interviews with people of all ages, it's evident that the most important feature of a satisfying life is to have a sense of purpose, to believe that one's life has meaning. The tendency in modern Western societies is to diminish opportunities for older people to contribute to society, which reduces their belief in the value of their lives. It is critical that we as a society do all that we can to make everyone's life meaningful until it ends.

The women in this book have demonstrated the myriad ways in which older women can enrich their own lives and those of their communities. Their experiences should encourage us not to fear old age but to see it as part of the adventure of living. It's tempting to say that these are exceptional women. However, I think they represent what all women are doing or could do, given encouragement and support. If we take the time to look, we will see women like them all around us: women with remarkable stories to tell.

Celebrating Older Women in Popular Culture

There are encouraging signs that older women in popular culture will not always be constrained by simplistic stereotypes. Here are a few examples that give me hope for a more diverse and enriching future.

Grace and Frankie, played by Jane Fonda and Lily Tomlin, are in their seventies in the eponymous show's first season, which aired in 2015. At the outset, their husbands announce that they are in love with each other and will be leaving their wives. Grace and Frankie have never been friends, but through the next ninety-three episodes they become each other's greatest support and comfort. They are portrayed as businesswomen and complex people with romantic partners and sex lives. As they move into their eighties, Grace and Frankie show some of the problems of ageing (arthritis, mini strokes), only occasionally slipping into cliché (vulnerability to scammers). Above all, though, *Grace and Frankie* is a joyful depiction of female friendship.

In 2021, the television show *Hacks* began. It stars Jean Smart as Deborah Vance, a Las Vegas stand-up comedian in her seventies whose career is on the decline. She is paired with an arrogant comedy writer in her late twenties, Ava, played by Hannah Einbinder. Although we see Deborah making efforts to look younger (with a little eyelid work), she is presented in close-up with wrinkles, age spots and a body that reveals the effects of gravity. Jean Smart is definitely glamorous, with enviable cheekbones, but she plays her age, and her character is admired for her accomplishments and desired as a sexual being. Deborah and Ava at first dislike and dismiss each other as too young or too old to be useful or interesting. The story arc of the show is the way each learns to admire and respect the other. Jean Smart thought that her career had ended by 2014: 'I really think it was because of the way I looked ... older than they

remembered me.'[37] It's heartening that, in 2022, she is being celebrated for looking like a successful woman in her seventies.

The film *Poms* (2019) also shows growing understanding and affection across generations. Starring Diane Keaton, Jacki Weaver and Pam Grier, among others, it depicts a group of women who live in a retirement village and form a cheerleading squad. At first their squad is the butt of jokes, including from the teenagers they recruit to help them, but it becomes a catalyst for friendship. *Poms* is unashamedly sentimental while undermining the stereotypes it initially entertains.

The novel *The Thursday Murder Club* by Richard Osman has become a major success since it was published in 2020. Sales for the first volume might have been because Osman is well known on British television, but the popularity of the sequels, *The Man Who Died Twice* (2021) and *The Bullet That Missed* (2022), must be because of the clever, witty retirees who populate the books. They solve crimes, reveal mysterious pasts and make cross-generational friendships. The series' protagonist is an authoritative woman who is a retired MI5 agent. I've heard condemnation of the books, suggesting that they depict transgressions by police and other officials uncritically and that young members of the working class are shown in an unflattering light. Nevertheless, it's a warm delight to have people in their seventies as the heroes with no intrinsic ageism.

The celebrated Australian writer Charlotte Wood challenges ageist stereotypes in her novel *The Weekend* (2019). The three main characters are women in their seventies who meet to clear out the beach house of the fourth member of the friendship group, who has recently died. The three women differ in personality, careers and relationships, portraying the heterogeneity of female ageing. What is notable is that, although their past inevitably plays a role in their present, their focus is on what they want or will do next. These women have futures.

Apart from her controversial comments on cultural appropriation, Lionel Shriver is best known for her epistolary novel *We Need to Talk About Kevin* (2003), an unsettling exploration of the lone-shooter phenomenon

in America. In 2021 she published *Should We Stay or Should We Go*, about a couple who, in their fifties, make a pact to commit suicide at eighty to avoid dementia. They belong to what Shriver calls 'the dismally christened Silent Generation', like the women featured in this book. There are several endings in which one, both or neither carries out their plan, and each scenario shows a different experience of marriage, ageing and a woman's agency. It does, as they say, make you think.

Then there are the delightful memoirs by women in their sixties and beyond. Among the most admired is *Somewhere Towards the End* (2008), written by literary editor Diana Athill when she was eighty-nine. Athill was born in London in 1918 and worked at the publisher André Deutsch with authors such as Simone de Beauvoir, Jean Rhys, Stevie Smith, Margaret Attwood, Philip Roth and Norman Mailer. She tells marvellous stories about her authors, her lovers and her anachronistically liberated life. She wrote of a friend who viewed growing old with resentment and despair that she was 'demonstrating how not to think about getting old'. Athill began writing about her life in 1963 but of her many volumes, *Somewhere Towards the End*, with her perspective on growing old, has won the most awards. Athill died in 2019 aged 101.

Australian author Lily Brett is a Baby Boomer, but only just. In 2021 she published a volume of essays about ageing called *Old Seems to be Other People*. Her observations about diminishing eyesight and the confusion it can produce (is that a woman with grey hair or my husband? A large dog or a fire hydrant?), speed dating for seniors, talking intimacies with strangers, and the idiosyncrasies of her adopted home of New York are charming and amusing. Like so many of us, she doesn't feel old and grapples with the mismatch of body and self, writing in her very distinctive voice.

Biographer Brenda Niall has turned her professional eye on herself to write a comprehensive and engaging autobiography, *My Accidental Career* (2022). Niall was born in 1930 and completed the autobiography at ninety-one. She writes of a time before the women's movement and of her awakening consciousness in the 1950s, when she first began to see

the possibilities of opportunity and equality. She became an academic at the newly established Monash University in the 1960s and asserted her right to be in that male-dominated world. The book amounts to a social history of Australia as well as a witty, reflective account of a remarkable life. Niall has always kept diaries and she quotes from them liberally, conveying a sense of immediacy. Her family, friends and travel feature as prominently as her career.

I frequently re-read Jane Austen's novels for comfort and the delight of journeying once again in her astutely observed world. It was therefore a treat to come across Ruth Wilson's memoir *The Jane Austen Remedy* (2022). Wilson, who was born in 1932, began to feel dissatisfied with her life when she turned sixty. Ten years later, she removed herself to a cottage in the country where she contemplated what she'd like her life to be, drawing on Jane Austen as a way of overcoming her sense of a lack of fulfilment. The outcome was a PhD, conferred in 2021, when she was eighty-eight, and this scholarly reflection on what Jane Austen taught her. Wilson links each novel and its heroine to her own experiences and thus we learn about her long life in this most original way.

Patricia Edgar (born in 1937) is well known in Australia as an educator and the founding director of the Australian Children's Television Foundation. In 2013 she published a book called *In Praise of Ageing*, in which she describes the active lives of four women and four men in their eighties and beyond. It is a valuable precursor of this book.

As our society becomes more accustomed to seeing older women, I'm hopeful that our stories will be increasingly told and celebrated.

Acknowledgements

This book was researched and written on the unceded lands of the Kulin Nation.

Dr Nicholas Dwyer made a generous philanthropic donation to Monash University so that the life and achievements of his mother and other women could be recognised. Without his initiative and support, neither this book nor the research on which it is based would have been possible. I am grateful for the privilege of two years of engaging, exciting work. The research was approved by the Monash University Human Research Ethics Committee, project number 28209.

I thank the women who trusted me with their stories: those who appear in the book; those who told me about their magnificent lives but for whom, to my great disappointment, there just wasn't enough room; and those who volunteered too late to be interviewed. There are many women out there who have fascinating stories to tell and who are still contributing to society and achieving great things in their seventies, eighties and nineties.

Where a woman requested anonymity, names and identities have been changed. May Wood is a pseudonym, as are the names of other people in her chapter.

For the chapter on Anne Hetzel, in addition to the book Anne wrote for her grandchildren, I have drawn on two recorded conversations Anne had with her daughter, Professor Jane Fisher AO (2009 and 2021), and an interview conducted for the State Library of South Australia by June Edwards in 2005 (JD Somerville Oral History Collection: Interview No. OH722). I thank the State Library for permission to make use of the transcript.

For the chapter on Jacqueline Dwyer, Margaret Barrett was an invaluable source. Margaret herself deserves to be acknowledged among the women in this book who have continued to achieve at an advanced

age. She was born in 1936 and became a Master of Philosophy in 2012 at the age of seventy-six. Since then, she has contributed to the *French–Australian Dictionary of Biography* and published other scholarly articles.

The staff and students of Global and Women's Health, Public Health and Preventive Medicine at Monash University have provided intellectual stimulation and made it a pleasure to go to work. Professor Jane Fisher AO has ensured a collegial workplace from which I have benefited for more than two decades.

Journalist Julia Medew volunteered her time to track down several eligible women.

In addition to those named on page 262, I thank all the unnamed photographers, mostly family members and friends of the women, who took the photographs that appear in this book.

My family read chapters and listened generously to my excited accounts of what I was writing. Their comments were invaluable. My daughter, Alice Clarke, writer and technology journalist, and her wife, Karma Clarke, librarian and baker, gave me the benefit of their professional expertise and cake. My husband, Sev Clarke, thinker and inventor, has always supported and encouraged my work and interests, so very different from his own. My little sister, Cynthia Boddington (born 1949), volunteers in the community and enjoys her grandchildren after retiring from her own business. She has been my champion reader. My littler sister, Dr Linda Kirkman (born 1955), became a PhD at sixty, which led to starting her own business as a sexologist focusing on sex therapy and sexuality education. I am fortunate to have family with whom I can share stories of the past, present and future. They are a vital part of the meaning in my life.

I thank the staff at Monash University Publishing for their expert contributions to the publication of *Time of Our Lives*: Joanne Mullins, Sarah Cannon, Leslie Thomas, Sam van der Plank and, especially, Julia Carlomagno.

Notes

1 Perlmutter, M. et al., 'Aging and memory', in K. W. Schaie (ed.), *Annual Review of Gerontology and Geriatrics*, vol. 7, 1987, pp. 57–92.

2 Edström, M., 'Visibility patterns of gendered ageism in the media buzz: a study of the representation of gender and age over three decades', *Feminist Media Studies*, vol. 18, no. 1, 2018, pp. 77–93.

3 'Risk of homelessness in older women', Australian Human Rights Commission, https://humanrights.gov.au/our-work/age-discrimination/projects/ risk-homelessness-older-women.

4 Kirkman, M. and Fisher, J., 'Promoting older women's mental health: insights from Baby Boomers', *PLOS ONE*, vol. 16, no. 1, 2021, https://doi.org/10.1371/ journal.pone.0245186.

5 'Older people: overview', Australian Institute of Health and Welfare, 2022, https://www.aihw.gov.au/reports-data/population-groups/older-people/overview.

6 'Ageing and health', World Health Organization, 1 October 2022, www.who. int/news-room/fact-sheets/detail/ageing-and-health.

7 '4102.0 – Australian social trends, 1998', Australian Bureau of Statistics, 03 June 1998, www.abs.gov.au/ausstats/abs@.nsf/2f762f95845417aeca25706c00 834efa/42e23011aaf49548ca2570ec001971c8!OpenDocument.

8 Bruner, J., *Actual Minds, Possible Worlds*, Harvard University Press, Cambridge, 1986.

9 The boat can be seen on Mig's website: migdann.com.

10 'Indigenous health and wellbeing', Australian Institute of Health and Welfare, 2022, www.aihw.gov.au/reports/australias-health/ indigenous-life-expectancy-and-deaths.

11 Das, S., 'Fact check: were Indigenous Australians classified under a flora and fauna act until the 1967 referendum?', *ABC News*, 20 March 2018, www.abc. net.au/news/2018-03-20/fact-check-flora-and-fauna-1967-referendum/9550650.

12 'Indigenous health and wellbeing', op. cit.

13 Jones, H.G. and Kirkman, M. (eds), *Sperm Wars: The Rights and Wrongs of Reproduction*, ABC Books, Sydney, 2005.

14 Hayward Baker, S. N., 'Looking for Lola: Spanish women and historical memory', Monash University, 2015. https://figshare.com/articles/thesis/ Looking_for_Lola_Spanish_women_and_historical_memory/4720216.

15 Kirkman, M., 'Genetic connection and relationships in narratives of donor-assisted conception', *Australian Journal for Emerging Technologies and Society*, vol. 2, no. 1, 2004, www.swin.edu.au/ajets.

16 Quoted in www.lecourrieraustralien.com/ discours-remise-des-insignes-de-chevalier-de-l-ordre-du-merite.

17 'At 90, graduate shows it is never too late for education', Australian National University, 15 December 2015, https://www.anu.edu.au/news/all-news/ at-90-graduate-shows it is-never-too-late-for-education.

18 Peter Browne, 'Jacqueline Dwyer: a tribute', 2020, https://www.isfar.org.
 au/wp-content/uploads/2020/08/68_PETER-BROWN-Jacqueline-Dwyer-
 Tribute.pdf.
19 'Attendance' in 'History of New South Wales government schools', New
 South Wales government, 2019, https://education.nsw.gov.au/about-us/
 our-people-and-structure/history-of-government-schools/facts-and-figures/
 attendance.
20 Theobald, M. and Swain, S., 'Education, primary', eMelbourne,
 www.emelbourne.net.au/biogs/EM00506b.htm.
21 Sawer, M., 'The long, slow demise of the "marriage bar"', *Inside Story*, 8 December
 2016, https://insidestory.org.au/the-long-slow-demise-of-the-marriage-bar.
22 Osman, C., 'The story of women and super', *Tilly Money*, https://tillymoney.
 com.au/the-story-of-women-and-super.
23 'Chronology of superannuation and retirement income in Australia',
 Parliament of Australia, 2010, https://www.aph.gov.au/About_Parliament/
 Parliamentary_Departments/Parliamentary_Library/pubs/BN/0910/
 ChronSuperannuation.
24 Woods, C., *Vera Deakin and the Red Cross*, Royal Historical Society of Victoria,
 Melbourne, 2020.
25 Australian Broadcasting Society, *The Alfred Deakin Lectures: Ideas for the Future
 of a Civil Society*, ABC Books, Sydney, 2001; Lyceum Club, *Lyceum Ink: Years of
 Writing: Celebrating the Centenary of the Lyceum Club*, Melbourne, Grey Thrush
 Publishing, Melbourne, 2012; Vines, A. and Wischer, T., *Ring of Words: Lyceum
 Club Writers' Circle Anthology*, Grey Thrush Publishing, Melbourne, 2018.
26 Booth, A.L. and Kee, H.J., 'A long-run view of the university gender gap in
 Australia', 2010, Discussion Paper No. 4916, April 2010,
 https://melbourneinstitute.unimelb.edu.au/assets/documents/hilda-
 bibliography/working-discussion-research-papers/2010/Booth_etal_Long_
 Run_View.pdf.
27 Kirkman, M. and Fisher, J., 'Promoting older women's mental health: insights
 from Baby Boomers', *PLOS ONE*, vol. 16, no. 1, 2020, https://journals.plos.org/
 plosone/article?id=10.1371/journal.pone.0245186.
28 Hitchcock, K., 'Dear life: on caring for the elderly', *Quarterly Essay*, no. 57,
 2015, pp. 1–78.
29 Lyons, A. et al., 'Experiences of ageism and the mental health of older
 adults', *Aging & Mental Health*, vol. 22, no. 11, 2018, pp. 1456–64.
30 Chasteen, A. L. and Cary, L. A., 'Age stereotypes and age stigma: connections
 to research on subjective aging', *Annual Review of Gerontology & Geriatrics*,
 vol. 35, no. 1, 2015, pp. 99–119.
31 Chwasta, M., 'Melbourne woman featured in viral TikTok video without
 consent says she feels "dehumanised"', *ABC News*, 14 July 2022, www.abc.net.
 au/news/2022-07-14/tiktok-video-maree-melbourne-flowers/101228418.
32 Stanley, M. et al., '"Nowadays you don't even see your neighbours": loneliness in
 the everyday lives of older Australians', *Health and Social Care in the Community*,
 vol. 18, no. 4, 2010, 10.1111/j.1365-2524.2010.00923.x.

33 Neves, B. B., Sanders, A. and Kokanović, R., '"It's the worst bloody feeling in the world": experiences of loneliness and social isolation among older people living in care homes', *Journal of Aging Studies*, vol. 49, 2019, pp. 74–84, doi:10.1016/j.jaging.2019.100785.

34 'The WHO age-friendly cities framework', *Age-friendly World*, 2022, https://extranet.who.int/agefriendlyworld/age-friendly-cities-framework.

35 Alidoust, S., Bosman, C. and Holden, G., 'Talking while walking: an investigation of perceived neighbourhood walkability and its implications for the social life of older people', *Journal of Housing and the Built Environment*, vol. 33, 2018, pp. 133–150, 10.1007/s10901-017-9558-1.

36 Bronfenbrenner, U., *The Ecology of Human Development: Experiments by Nature and Design*, Harvard University Press, Cambridge, 1979.

37 'Jean Smart quotes', *Internet Movie Database*, accessed 8 December 2022, https://m.imdb.com/name/nm0005443/quotes.

Photograph Credits

Mig Dann: Brian Albers
Bea Toews: personal collection
Miriam Rose Ungunmerr Baumann: Eleesa Zlatic
Olive Trevor: Neil Kendall
Anne Hetzel: family collection
Sally Baker: Meredith Graham
Annie Young: personal collection
Jacqueline Dwyer: Dominic Dwyer
Pauline Laurenzen: family collection
Ann Druett: family collection
Sharron Pfueller: Blue Tulips Creative
Robina Rogan: personal collection
Jo Rodger: personal collection
Kath Clune: Fiona Basile
Val Leiper: Susan Davie
Lester Jones: photograph taken for Cochlear Limited
Rosemary Salvaris: personal collection
Raylee George: personal collection
May Wood: personal collection
Judith Harley: family collection